THE ART OF
Hammer

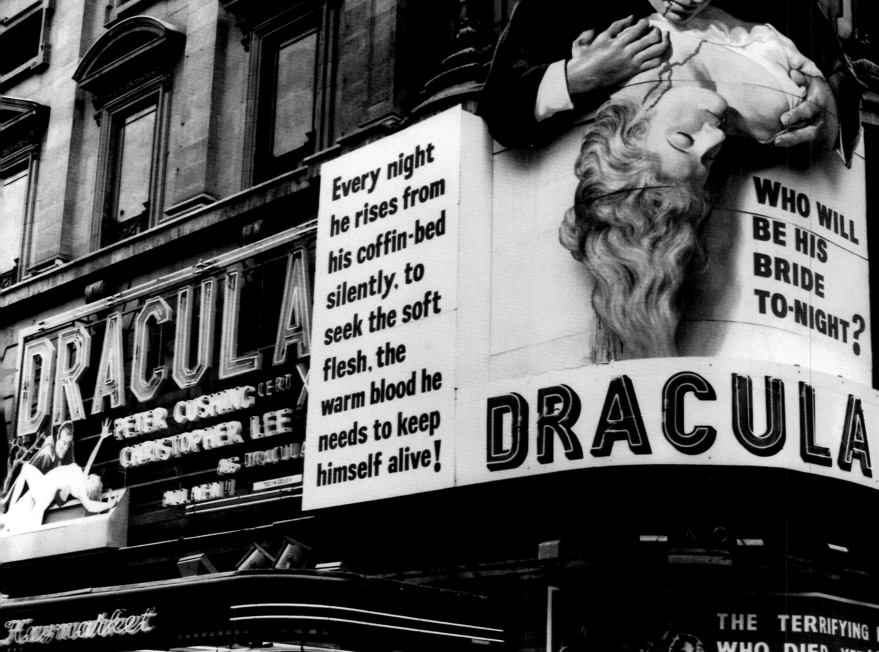

THE ART OF Hammer

POSTERS FROM THE ARCHIVE OF HAMMER FILMS

MARCUS HEARN

TITAN BOOKS

For Peri, who always makes it better

THE ART OF
HAMMER

ISBN 9781785654466

Published by
Titan Books
A division of
Titan Publishing Group Ltd
144 Southwark St
London
SE1 0UP

First edition October 2010
10 9 8 7 6 5 4 3 2

HAMMER™ is a registered trademark.

Designed by Peri Godbold.
Dustjacket designed by Rudolfo Muraguchi.

Visit our websites:
www.titanbooks.com
www.hammerfilms.com

Did you enjoy this book? We love to hear from our readers.
Please e-mail us at: **readerfeedback@titanemail.com** or write to
Reader Feedback at the above address.

Printed and bound in China by C&C Offset Printing Co., Ltd.

ACKNOWLEDGEMENTS

The images in this book were scanned and restored by Peri Godbold, myself
and Steve Reed. Special thanks to Steve for also supplying many posters from
his own collection.

Hammer Film Productions allowed access to posters held in their archive,
and the following collectors helped to fill the gaps: David Barraclough,
Steve Chibnall, Max Décharné, Don Fearney, Stephen Jones, Wayne Kinsey
and Joe McIntyre. I am especially grateful to Richard Golen for contributing
some of the rarest items in this book.

Janet Woodward brought me back to Titan Books, and Lizzie Bennett,
Sim Branaghan, Jonathan Rigby and my editor Adam Newell made useful
comments on the manuscript. Thanks also to Sharon Ankin, who happily
allowed posters to pile up on our dining room table.

The latest edition of this book was made possible by Simon Oakes,
Marc Schipper, Nic Ransome and David Girvan at Hammer.

The websites www.hammerhorrorposters.com, www.learnaboutmovieposters.
com and www.postersandstuff.co.uk are recommended for scholars and
collectors. Further background can be found in Sim Branaghan's excellent
book *British Film Posters: An Illustrated History* (British Film Institute, 2006).

Finally, my thanks to the late Tom Chantrell, who shared his memories
with me in 1995, and to all the other artists (credited and unknown)
whose posters are such an important part of Hammer's legacy.

UK poster artwork for *Blood From the Mummy's Tomb*, *Demons of the
Mind*, *Dr Jekyll & Sister Hyde*, *Fear in the Night*, *Hell is a City*, *The Horror of
Frankenstein*, *Lust for a Vampire*, *Man at the Top*, *Scars of Dracula*, *Straight
on Till Morning* and *To the Devil a Daughter* courtesy of Canal + Image UK
Limited. Worldwide © 1960-1976 Canal + Image UK Limited.
All rights reserved.

UK poster artwork for *The Anniversary*, *The Brigand of Kandahar*, *The Devil
Rides Out*, *The Devil-Ship Pirates*, *Dracula Prince of Darkness*, *Frankenstein
Created Woman*, *The Lost Continent*, *The Mummy's Shroud*, *The Nanny*, *One
Million Years B.C.*, *The Plague of the Zombies*, *Quatermass and the Pit*, *Rasputin
the Mad Monk*, *The Reptile*, *The Scarlet Blade*, *She*, *Slave Girls*, *The Vengeance
of She*, *The Viking Queen* and *The Witches* courtesy of Canal + Image UK
Limited. UK © 1963-1968 Canal + Image UK Limited. All rights reserved.

JACKET FRONT: *Dracula A.D. 1972* (by Renato Casaro).
JACKET BACK: *Rasputin the Mad Monk/The Reptile* (Tom Chantrell),
Frankenstein Must Be Destroyed, *Dracula Has Risen From the Grave*
and *One Million Years B.C./She* (Tom Chantrell).

CASE FRONT: *Frankenstein and the Monster From Hell* (Bill Wiggins).
CASE BACK: *The Two Faces of Dr Jekyll*.

FRONTISPIECE: *Dracula* at the Gaumont cinema in London's
Haymarket, May 1958.

CONTENTS

INTRODUCTION

"Only a sick society could bear the hoardings, let alone the films."

DEREK HILL, *SIGHT AND SOUND*, WINTER 1958-59

Although many of the Hammer horrors are now regarded as classics, their commercial success was rarely accompanied by critical acclaim. Derek Hill's opinion was expressed during the company's heyday, but even then some of Hammer's finest productions were widely dismissed by newspapers for their vulgarity and corrupting influence.

Given that contemporary reviewers regarded Hammer with such scorn, it is not surprising that connoisseurs of popular culture paid little attention to the company's posters. Fortunately, Hammer's critical rehabilitation has been accompanied by a burgeoning interest in these fascinating relics.

For Hammer and its enterprising managing director James Carreras, a poster served a dual purpose. Aside from publicising a film on its release, it was a valuable tool for getting a film made. Carreras was a charismatic salesman, and the only British producer to strike distribution deals with every major American studio. He was often able to do this without a script or the promise of major stars, but he rarely went into negotiations without provisional poster artwork and a title.

Producer and writer Brian Clemens remembers how important this approach was when he pitched *Dr Jekyll & Sister Hyde* in 1970. "I mentioned it to Jimmy and he said, 'Come up and see me in two days at Hammer House.' When I arrived for the appointment he'd already had the poster made. So I knew I had a deal."

Despite the remarkable number of films produced by Hammer following its international breakthrough in the mid-1950s, the company's British posters were created by relatively few artists from London-based advertising agencies. The first artist to make an impact at Hammer was Bill Wiggins, whose early work included *Dracula, The Mummy* and *The Curse of the Werewolf*. These were all pictures distributed by Rank in the UK, and Wiggins worked for Downton Advertising, the agency that held the Rank account. Another Hammer film distributed by Rank was *The Phantom of the Opera*. This poster was illustrated by Renato Fratini, one of Wiggins' colleagues at Downton.

Hammer's main distribution partner from 1958 to 1964 was Columbia Pictures. The British account for Columbia's films was held by the Arthur S. Dixon agency, and one of their young artists was given the Columbia/Hammer commissions. John Stockle preferred working on posters for comedies, but he produced such diverse designs as *The Revenge of Frankenstein, The Terror of the Tongs* and *The Damned*. For the latter he put away his paint brushes and supervised his own photography, making no effort to reference any scenes from the film. Stockle's gruesome poster for *The Camp On Blood Island* was banned in London, and it's hard to believe it was the work of the same man who created the cartoon stylings of *I Only Arsked*.

The most prolific, and collectable, of all Hammer's British commercial artists was Tom Chantrell. During the 1960s Chantrell was an employee of the Allardyce Palmer agency and worked from an office in Wardour Street, just a few doors down from James Carreras at Hammer House. Allardyce Palmer's accounts included Warner-Pathé who, through their shareholding in the Associated British Picture Corporation, were ultimately responsible for Hammer's British and Commonwealth distribution in the second half of the 1960s. Chantrell enjoyed a good relationship with Carreras and illustrated the British posters for every Hammer release from mid-1965 to mid-1970. The highlight among many outstanding designs from this period is *One Million Years B.C.*, in which Chantrell sidelined the film's dinosaurs in favour of the relatively unknown Raquel Welch.

Chantrell stepped down when ABPC were bought by EMI, but he returned to Hammer for a handful of Warner-distributed titles, and continued to create impressive pre-production artwork for Carreras. Chantrell's subsequent work includes the classic poster for the British release of *Star Wars* in late 1977. It's no coincidence that his *Star Wars* poster was the only one out of all the international designs to include a portrait of former Hammer star Peter Cushing.

Prominent among Hammer's posters in the 1970s include

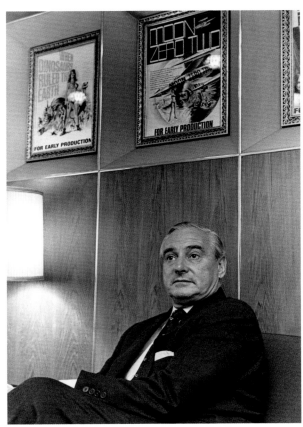

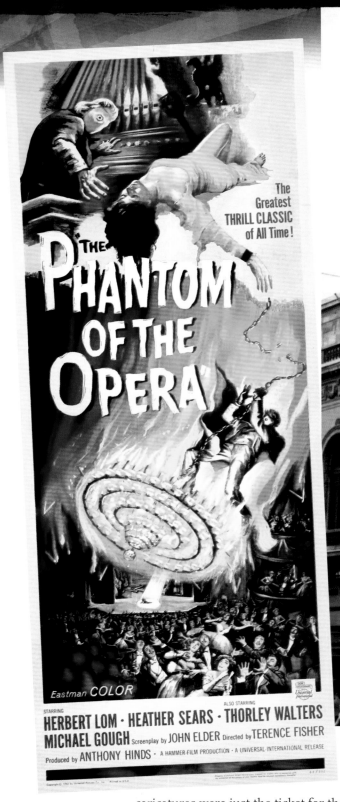

ABOVE: This 'insert' poster for *The Phantom of the Opera* was issued for the film's US release in August 1962 and features radically different artwork from the British original.

ABOVE RIGHT: *The Man Who Could Cheat Death* shared a bill with the French film *The Evil That Is Eve* when it premièred at the Plaza in London's Lower Regent Street on 30 November 1959.

those illustrated by Arnaldo Putzu, a Downton artist whose caricatures were just the ticket for the *On the Buses* films that marked Hammer's return to comedy. Another prolific artist of the 1970s was freelancer Mike Vaughan, who adopted a garish style for *The Vampire Lovers* and a number of subsequent Hammer films produced for EMI. Vic Fair made an impact with two similarly bold and iconoclastic posters promoting films released by Rank: *Countess Dracula* and the highly suggestive *Vampire Circus*. By and large, however, the 1970s saw a decline in the quality of Hammer's film posters. The increasing use of photo-montages anticipated the computer-aided techniques that would all but abolish the tradition of painted poster artwork in the 1980s.

The diversity of Hammer's subjects, and the variety of different distributors, means that there is no consistent style for the posters collected in this book. Very little is known about the company's marketing activity in the 1930s, and sadly no examples of posters from that era are preserved in its archive. This book picks up the story from the early 1950s, when Hammer was revitalised by James Carreras and executive producers Anthony Hinds and Michael Carreras. The films from this decade were initially unremarkable, and the *noir* influence now attributed to them is more prevalent in the posters than the actual productions.

The arrival of Gothic horror with *The Curse of Frankenstein* initiated a new design theme of 'women in peril', with numerous posters from all over the world showing girls (often anonymous models) shrinking away from vampires, mummies and werewolves. *Dracula* was the first poster created in a style that complemented the elegance of the films, and although many similarly beautiful posters would follow, the posters created by John Stockle were designed to make a

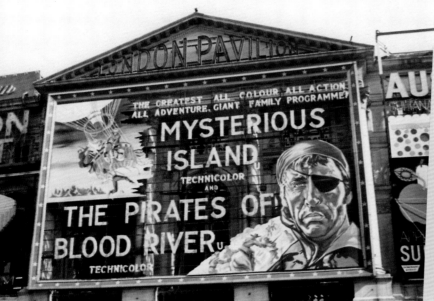

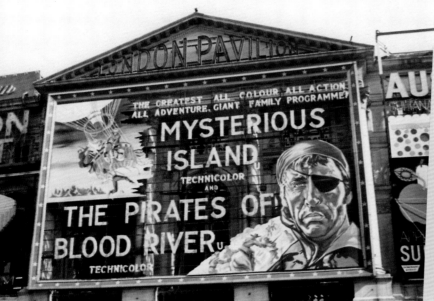

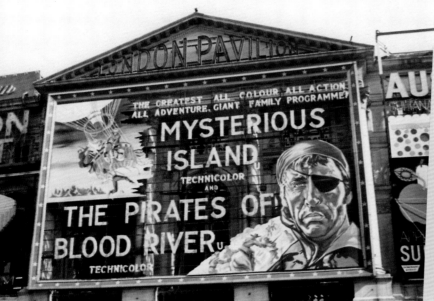

La 20th Century-Fox Film presenta

la Morte
ARRIVA
STRISCIANDO

NOEL WILLMAN
RAY BARRETT
con

e con
JENNIFER DANIEL
JACQUELINE PEARCE

Prodotto da
ANTHONY NELSON KEYS
Regia di
JOHN GILLING
Scenegg. di
JOHN ELDER
Una Produzione SEVEN ARTS
HAMMER PRODUCTION

Colore De Luxe

more immediate impact. The Tom Chantrell era was the most consistently accomplished, although even here the artist's versatility means that there is little common ground between *The Anniversary*, *The Lost Continent* and *Moon Zero Two*.

Another recurrent feature of Hammer's posters was a high degree of artistic license, producing such memorable exaggerations as giant bats (*The Kiss of the Vampire*) and a colossal mummy (*The Curse of the Mummy's Tomb*). Chantrell's British poster for *Frankenstein Created Woman* inspired numerous international designs which similarly misinterpreted its title by depicting someone actually being created inside a cylindrical machine.

Also characteristic were the lurid taglines designed to tempt customers into cinemas. *Dracula* delivered on its promise of "The terrifying lover who died – yet lived!" but it's likely that anyone intrigued by *The Lost Continent*'s "Helpless beauties attacked by crazed kelp-monsters!" would have been a little disappointed by what they saw. The best taglines functioned like advertising slogans: "From Hammer, the House of Horror!" (*Rasputin the Mad Monk*/*The Reptile*) and "Beware the beat of the cloth-wrapped feet!" (*The Mummy's Shroud*) still resonate today.

The market for Hammer horror was global, and territories around the world produced hundreds of designs to promote the films from the 1950s to the 1970s. In selecting the images for this book, priority has been given to British posters as a film's country of origin is an important consideration for collectors and dealers. Then, as now, the predominant size for British posters was the landscape 'Quad Crown' (30 x 40 inches, 76 x 102 centimetres), although other types of poster are reprinted here as well.

Hammer's films were usually co-productions with American distributors, so American posters feature prominently. The most common size is the 'one-sheet' (41 x 27 in, 104 x 69 cm), though this book also features examples of the landscape format 'half-sheet' (22 x 28 in, 56 x 71 cm) and the taller 'insert' (36 x 14 in, 91 x 36 cm). The other items presented here come from a wide variety of countries, but an emphasis has been placed on Belgian, Italian and French posters, which feature superior artwork to many of their international counterparts.

Films are presented in the order in which they received a general release in British cinemas. Where there are double-bills, foreign posters and subsequent rereleases, these are gathered together so that, where possible, each film is represented in one discrete section. Alternative titles are only given for English language posters, and all dimensions are approximate.

Primary credit has been given to illustrators, although in many instances these illustrators also designed their posters.

The Art of Hammer is intended neither as a guide to rarity nor as an exhaustive catalogue. It does, however, offer examples from some of the most inventive and controversial marketing campaigns in post-war film history. And it celebrates the largely lost art of the painted film poster with some of the finest examples of their type. These are items that were considered entirely disposable once a film's run had ended, but which are now fought over in the world's most prestigious auction houses.

To quote the poster for *Creatures the World Forgot*: "They don't make them like this anymore."

ABOVE LEFT: The London Pavilion played host to younger audiences when Hammer's *The Pirates of Blood River* was screened alongside *Mysterious Island* in the summer of 1962.

ABOVE: An Italian 'foglio' format poster for *The Reptile* (39 x 28 inches, 99 x 71 centimetres), issued in April 1966.

1950-1959

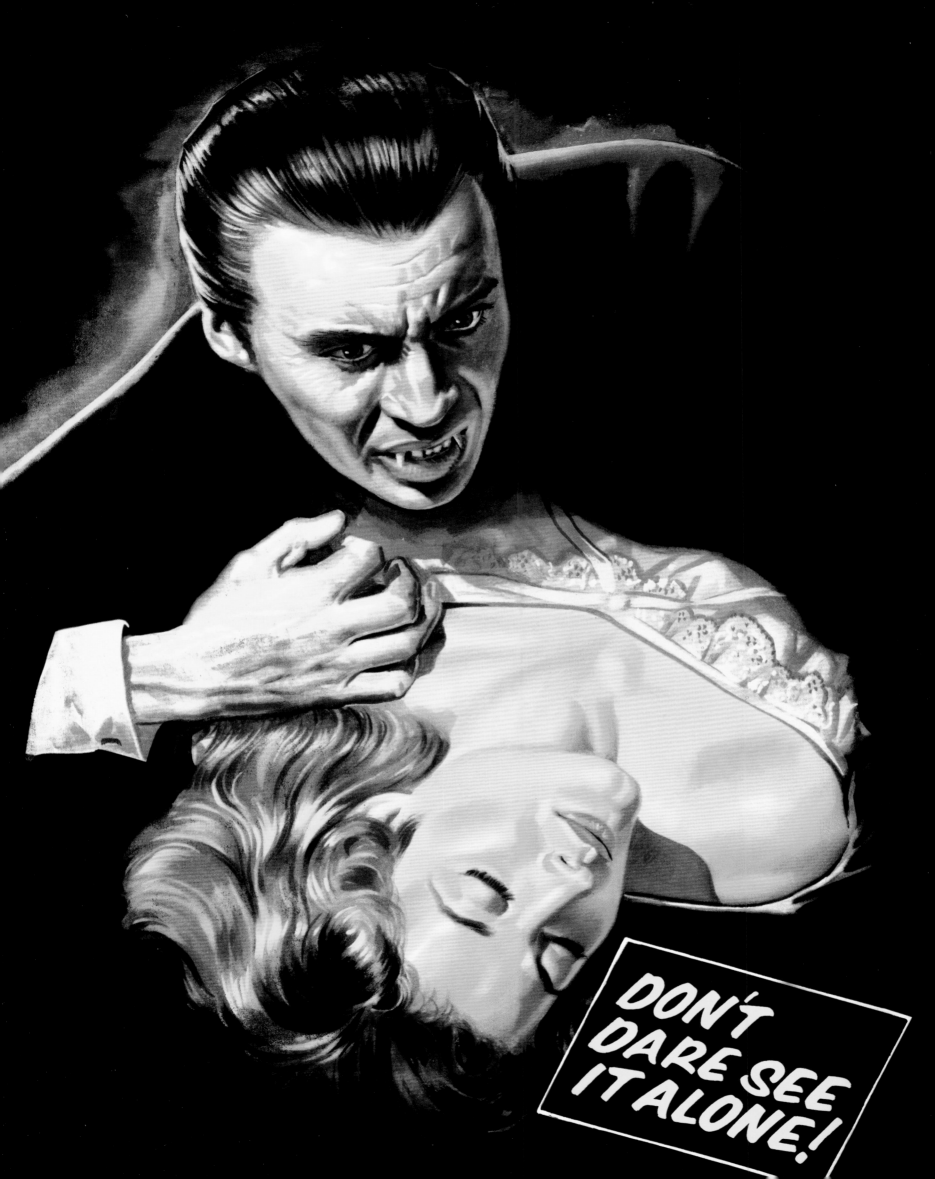

DON'T DARE SEE IT ALONE!

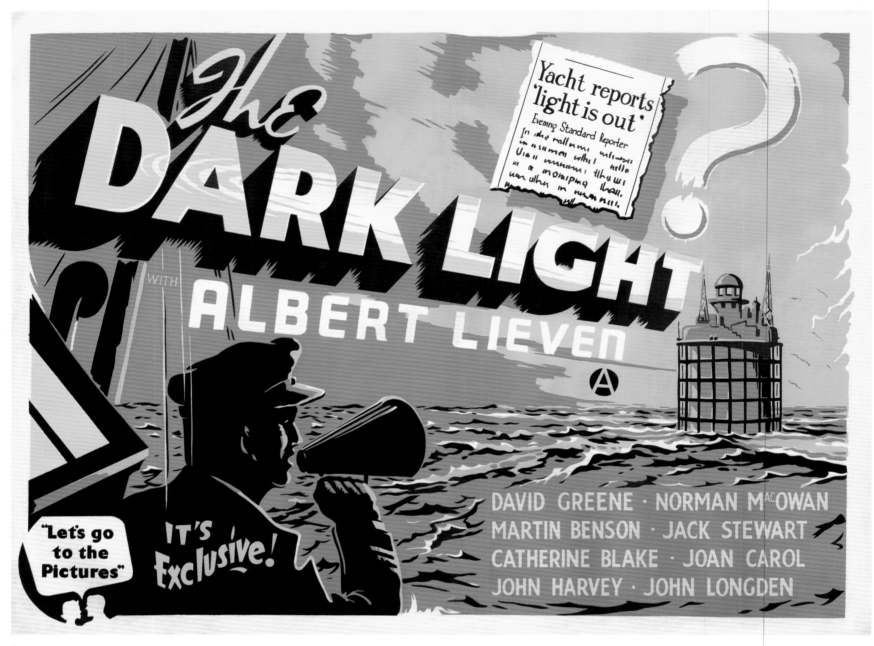

✝ **The Dark Light**
BRITISH 30 x 40 in (76 x 102 cm)

Prior to Exclusive/Hammer's international
breakthrough the company produced B pictures.
British Quad Crown posters, of the type seen on this
spread, were screen-printed in very limited numbers.

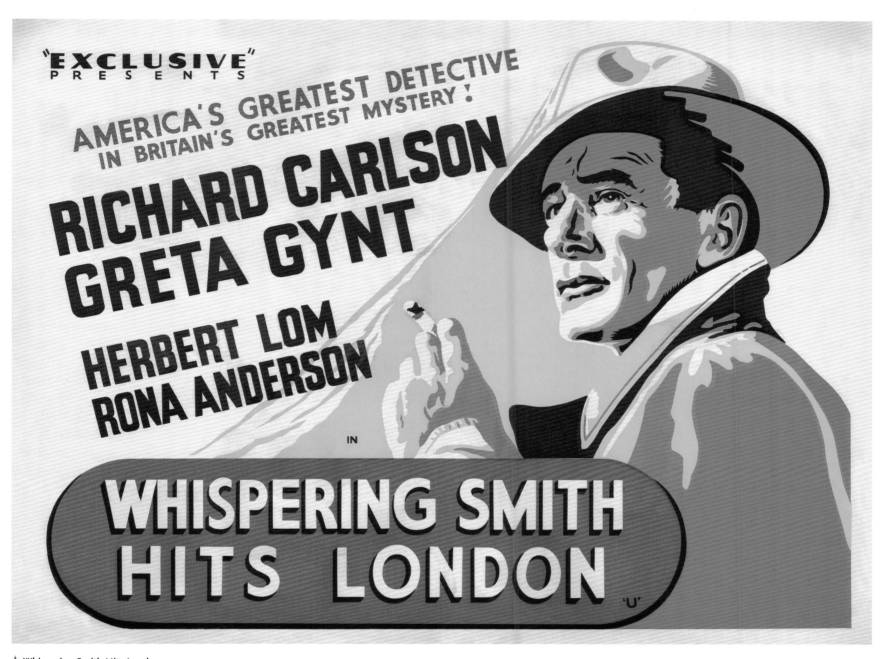

✝ **Whispering Smith Hits London**
BRITISH 30 x 40 in (76 x 102 cm)

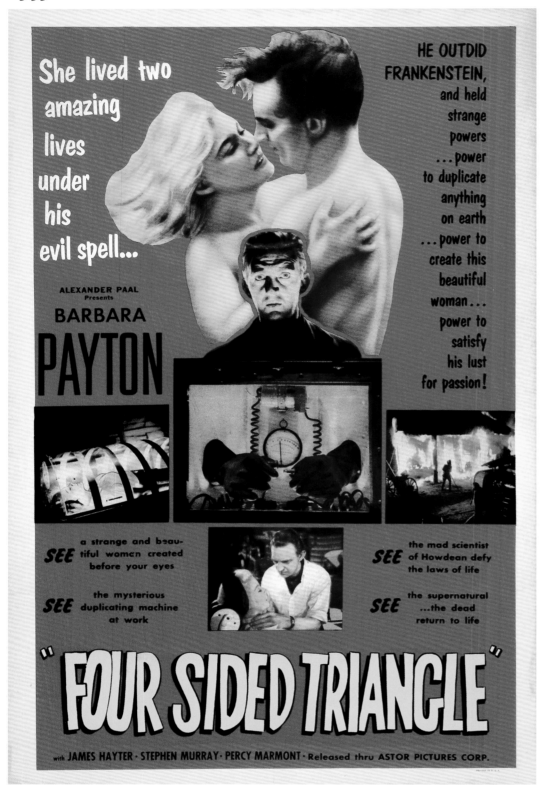

✝ **Four Sided Triangle**
US 41 x 27 in (104 x 69 cm)

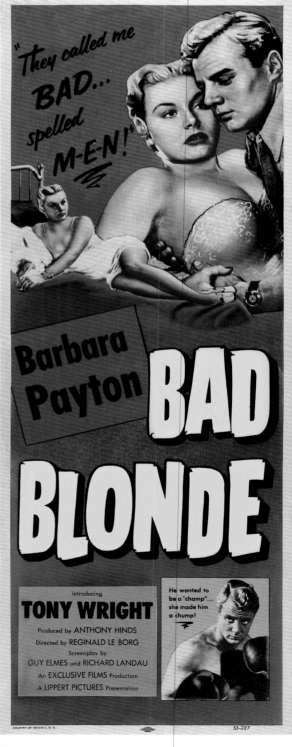

✝ **The Flanagan Boy** (aka **Bad Blonde**)
US 36 x 14 in (91 x 36 cm)

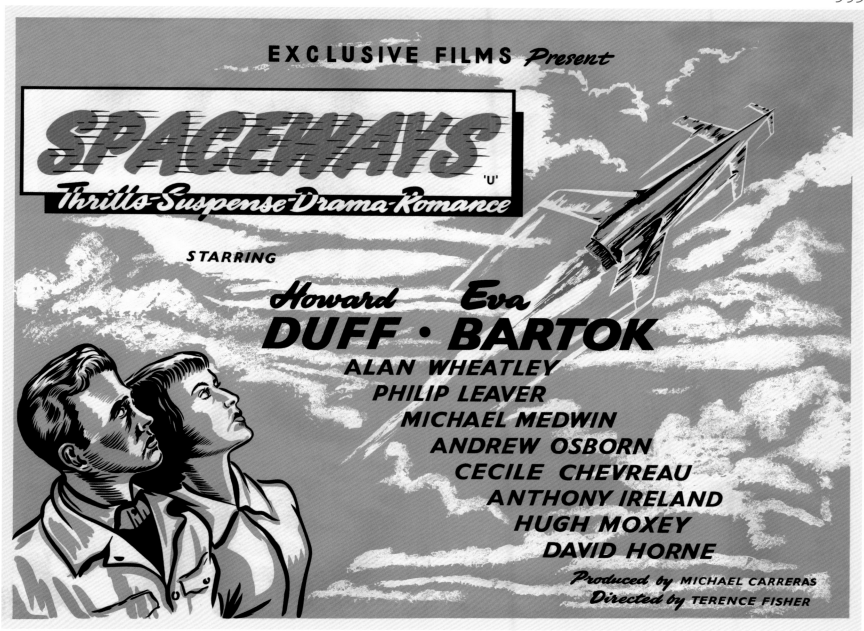

† **Spaceways**
BRITISH 30 x 40 in (76 x 102 cm)

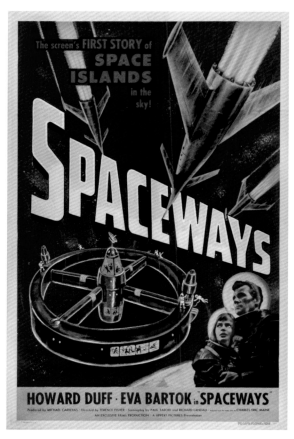

Spaceways ✈
US 41 x 27 in (104 x 69 cm)

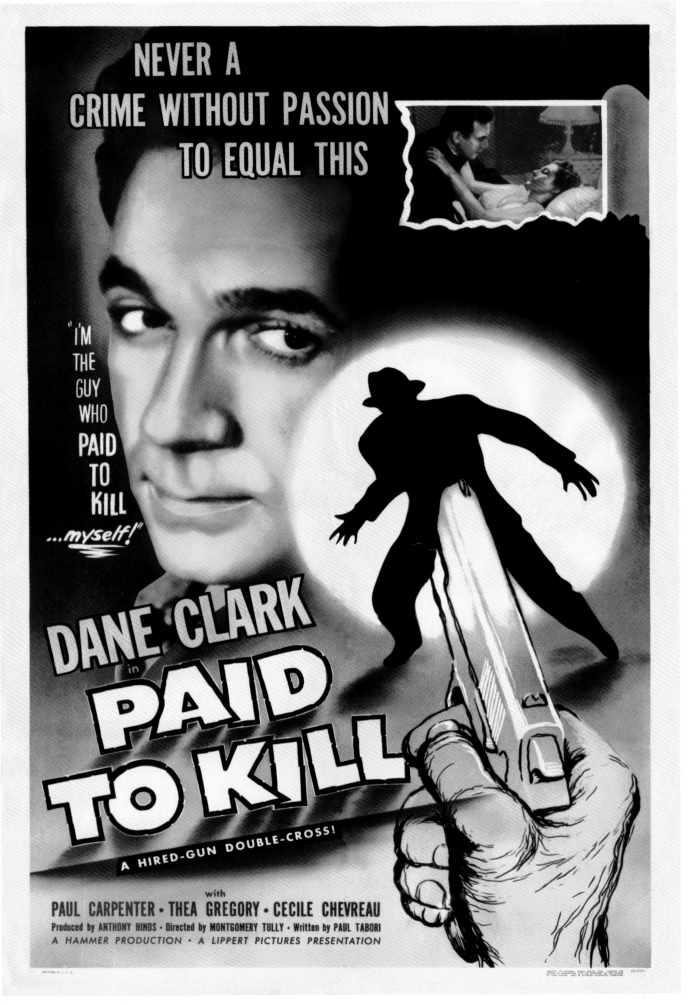

† **Five Days** (aka **Paid to Kill**)
US 41 x 27 in (104 x 69 cm)

The Men of Sherwood Forest →
US 41 x 27 in (104 x 69 cm)

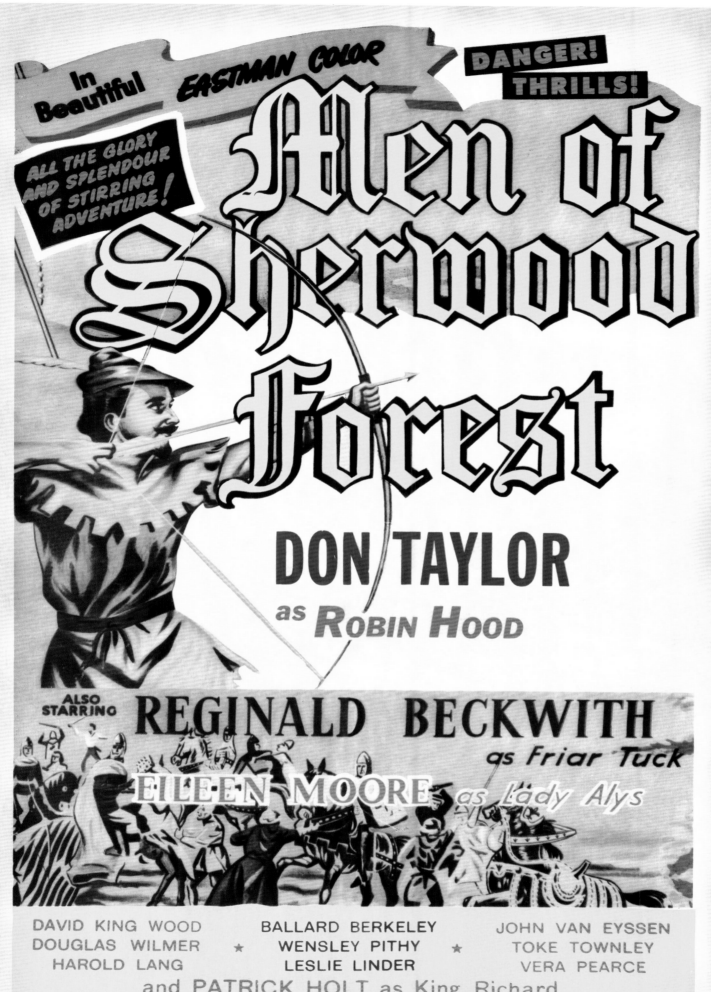

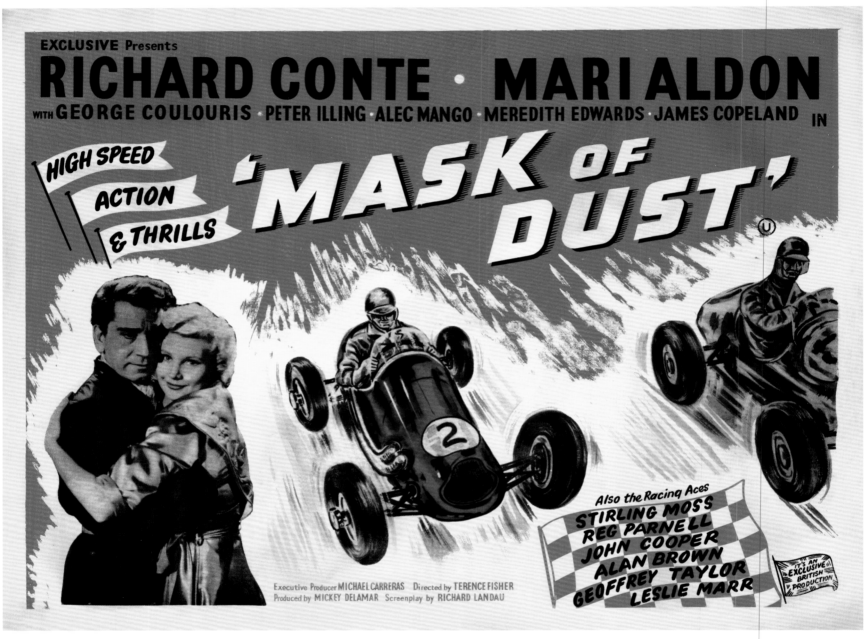

✟ **Mask of Dust**
Bʀɪᴛɪsʜ 30 x 40 in (76 x 102 cm)

Murder By Proxy (aka **Blackout**) ⇥
US 41 x 27 in (104 x 69 cm)

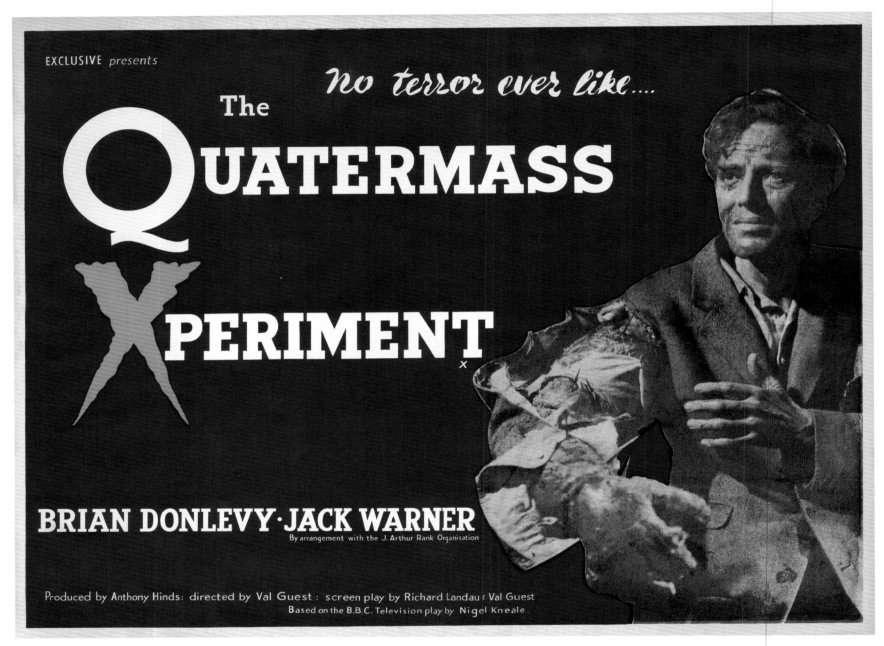

✝ **The Quatermass Xperiment**

BRITISH 30 x 40 in (76 x 102 cm)

The second issue of the Quad Crown poster for this film (pictured above) was virtually identical to the first, but printed in a slightly darker green. The picture of the film's tragic astronaut Victor Carroon (Richard Wordsworth) was by unit photographer John Jay.

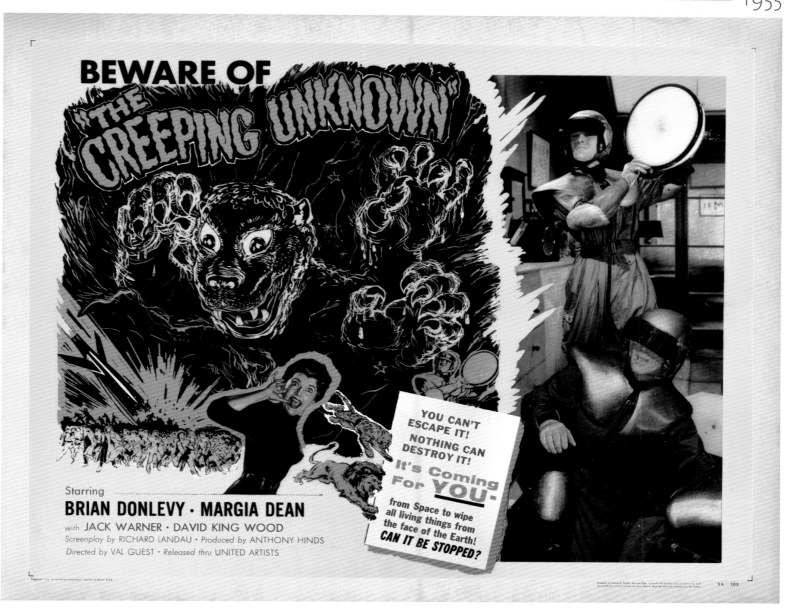

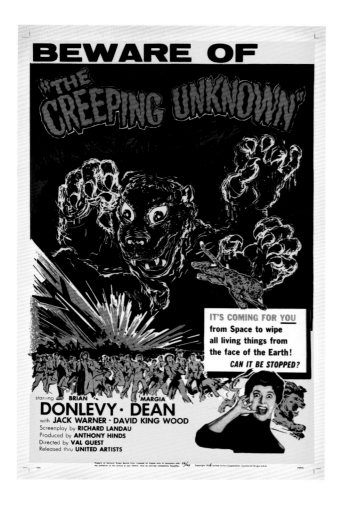

✠ **The Quatermass Xperiment**
(aka **The Creeping Unknown**)
US 22 x 28 in (56 x 71 cm)

✠ ✠ ✠ **The Quatermass Xperiment**
(aka **The Creeping Unknown**)
US 41 x 27 in (104 x 69 cm)

✠ **The Quatermass Xperiment**
BELGIAN 21 x 14 in (54 x 36 cm)

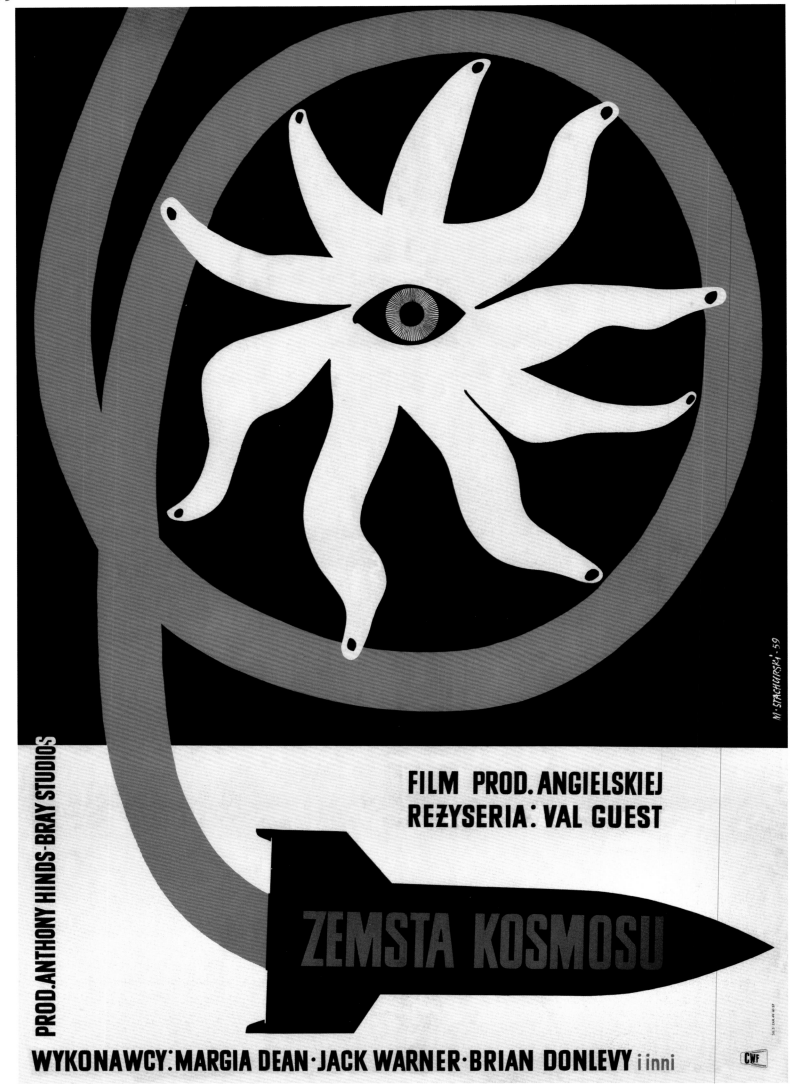

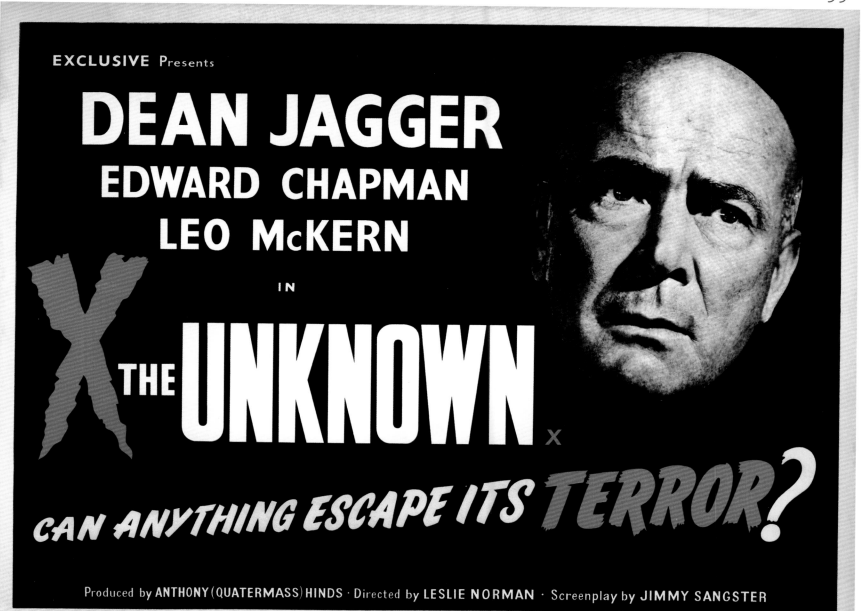

X the Unknown ☩
BRITISH 30 x 40 in (76 x 102 cm)

The last of the posters produced in the relatively crude style common to the Exclusive releases, this design featured a portrait of star Dean Jagger by unit photographer Tom Edwards.

X the Unknown ⤌
US 22 x 28 in (56 x 71 cm)

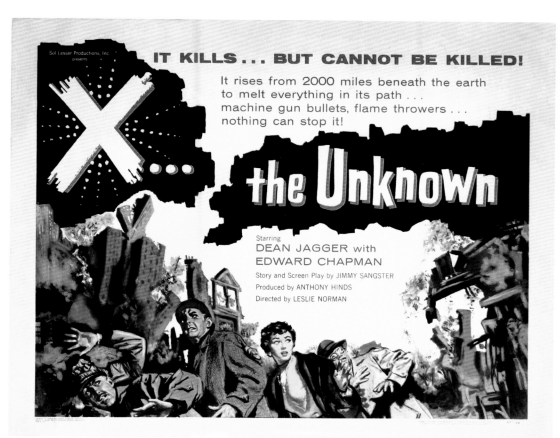

⤞ **The Quatermass Xperiment**
POLISH 33 x 23 in (84 x 58 cm)
Illustration by Marian Stachurski

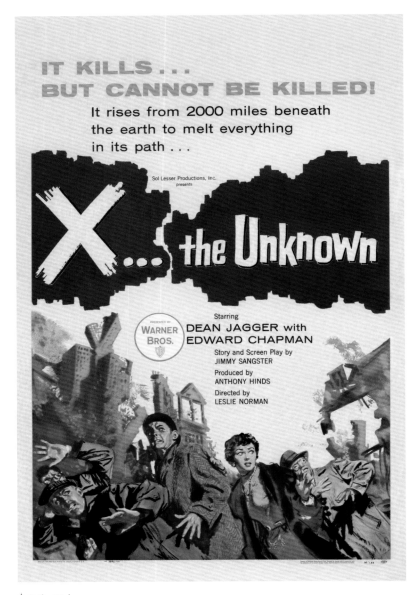

⚓ X the Unknown
US 41 x 27 in (104 x 69 cm)

The US posters for this film were printed when Sol Lesser was due to handle distribution. When Warner Bros. took over, circular stickers were added to the existing stock and the Sol Lesser credit was often scribbled out.

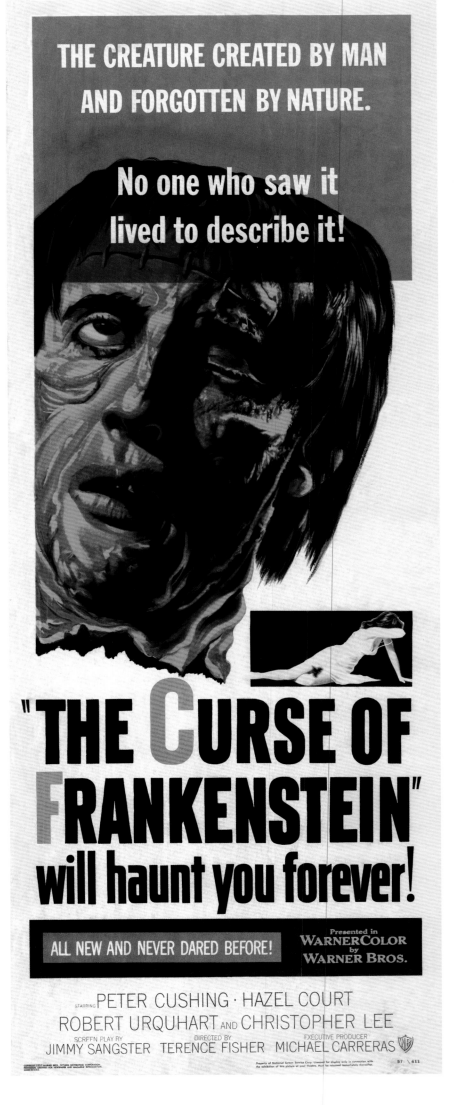

The Curse of Frankenstein ⚓
US 36 x 14 in (91 x 36 cm)

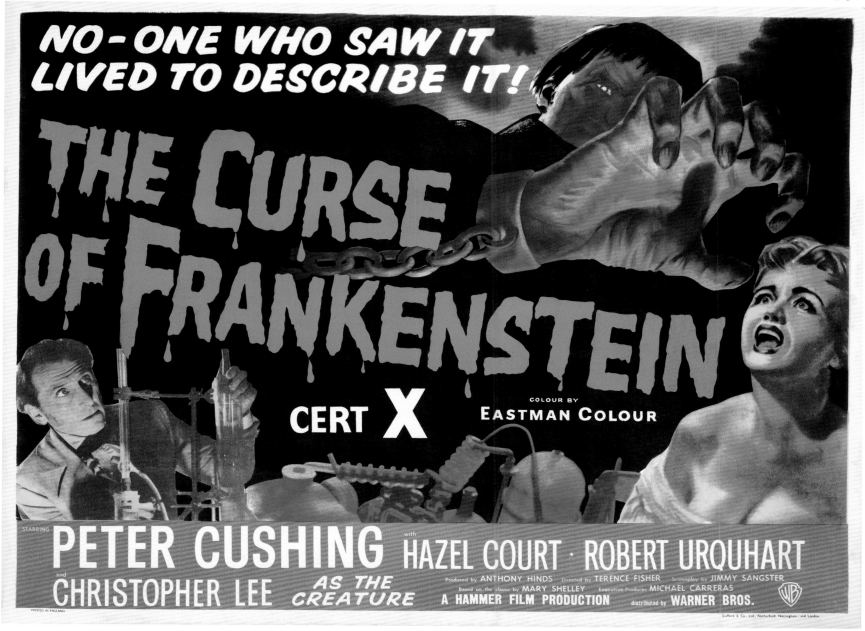

✝ The Curse of Frankenstein
BRITISH 30 x 40 in (76 x 102 cm)

The British Quad Crown poster for Hammer's
first Gothic horror film is now highly collectable,
although its aesthetic qualities are perhaps
outweighed by its historical significance. The
artist is unknown, although it is probable that
Jock Hinchcliffe made a contribution.
In 2008 the Royal Mail carefully adapted the
design of this poster for a 56p stamp.

The Curse of Frankenstein ⤙
ITALIAN 78 x 55 in (198 x 140 cm)
Illustration by Luigi Martinati

† **The Curse of Frankenstein**
BRITISH 30 x 20 in (76 x 51 cm)

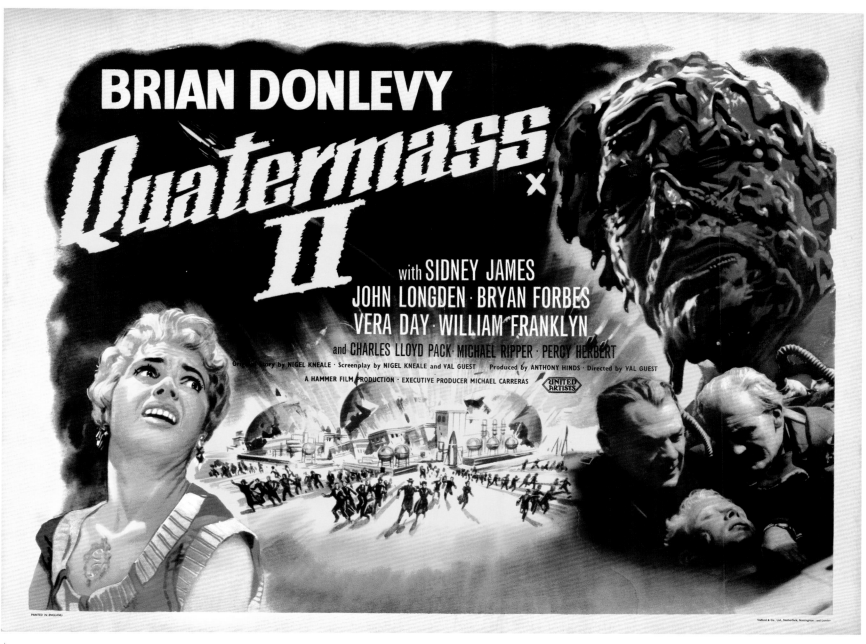

✝ **Quatermass 2**
BRITISH 30 x 40 in (76 x 102 cm)
Illustration by Bill Wiggins

✝ **Quatermass 2**
ITALIAN 78 x 55 in (198 x 140 cm)

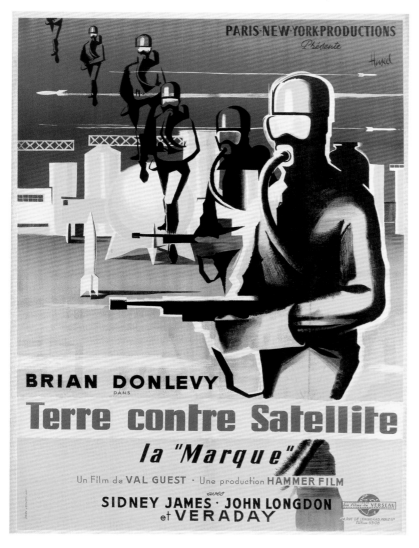

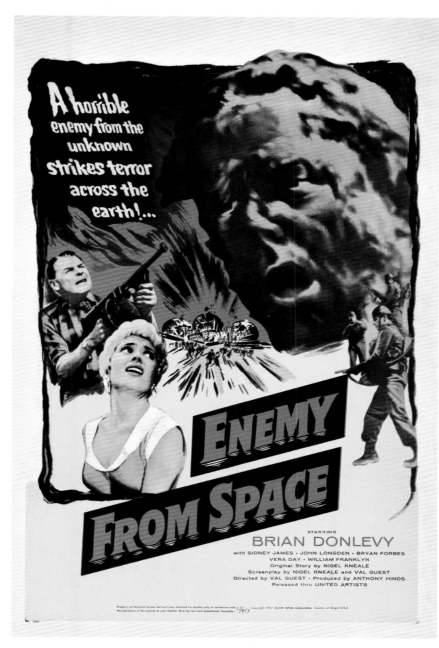

✈ **Quatermass 2**
FRENCH 32 x 24 in (80 x 60 cm)
Illustration by Clement Hurel

✝ **Quatermass 2** (aka **Enemy From Space**)
US 41 x 27 in (104 x 69 cm)

The illustration of Brian Donlevy that
appears on the left of this one-sheet poster
was created by superimposing a picture of
the actor's head onto the shoulders of his
co-star Percy Herbert.

✈ **Quatermass 2**
FRENCH 47 x 63 in (120 x 160 cm)

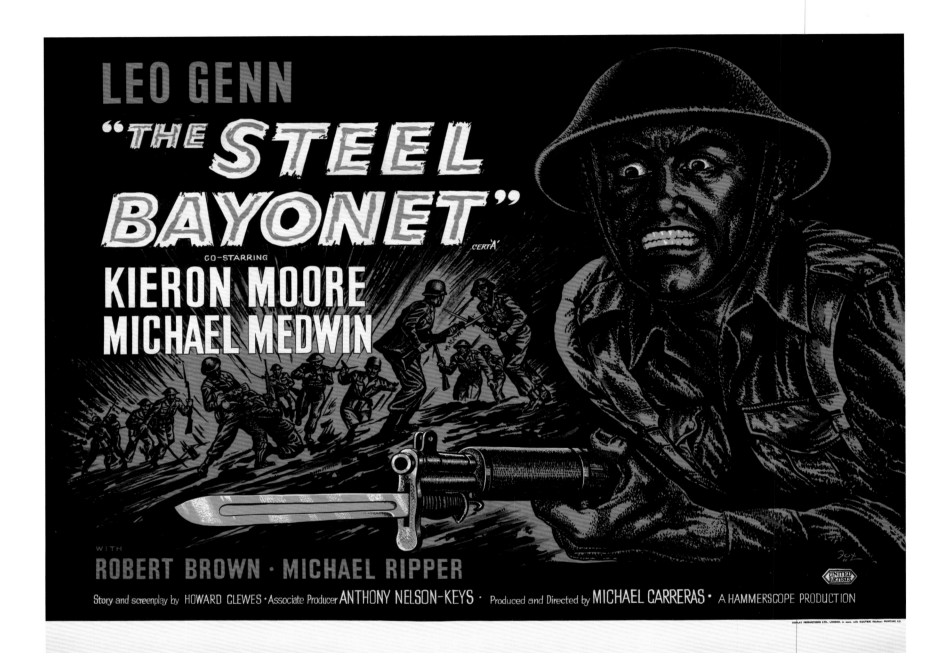

✣ **The Steel Bayonet**
BRITISH 30 x 40 in (76 x 102 cm)
Illustration by Henry Fox

This film was released by United Artists in 1957.
The poster bears a striking resemblance to the
design for UA's *Attack*, which was released the
previous year.

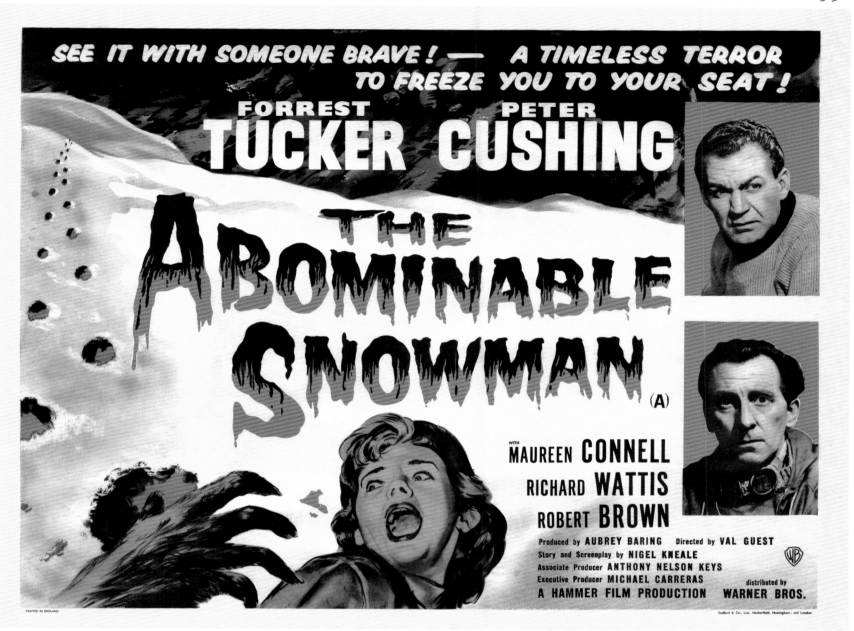

✝ **The Abominable Snowman**
BRITISH 30 x 40 in (76 x 102 cm)

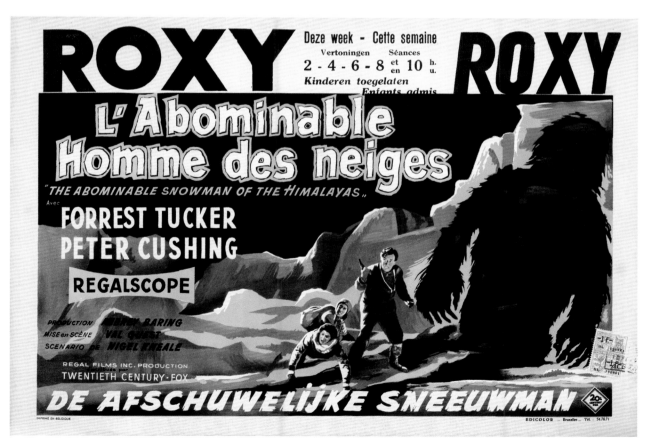

The Abominable Snowman ✢
BELGIAN 14 x 20 in (35 x 51 cm)

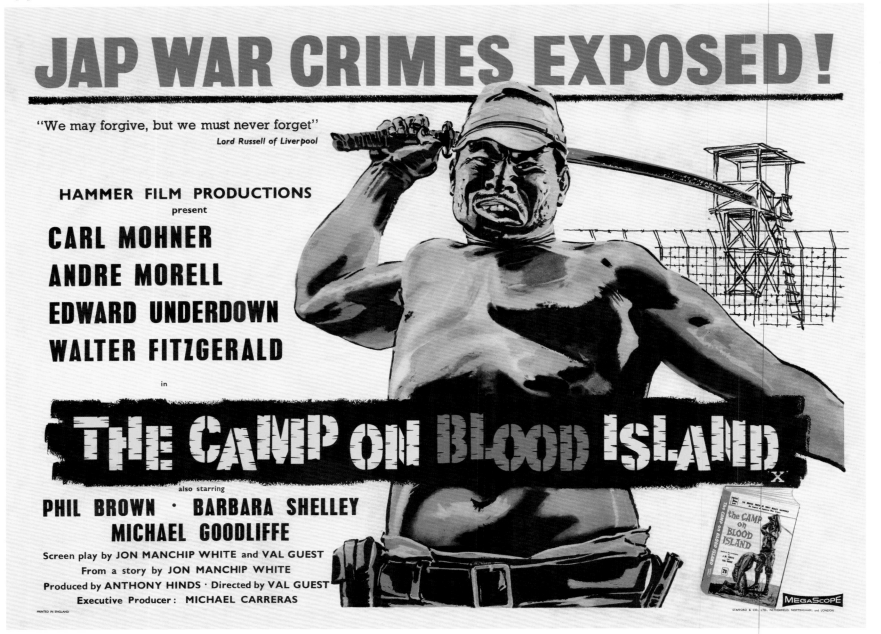

JAP WAR CRIMES EXPOSED!

"We may forgive, but we must never forget"
Lord Russell of Liverpool

HAMMER FILM PRODUCTIONS
present

CARL MOHNER
ANDRE MORELL
EDWARD UNDERDOWN
WALTER FITZGERALD

in

THE CAMP ON BLOOD ISLAND

also starring

PHIL BROWN · BARBARA SHELLEY
MICHAEL GOODLIFFE

Screen play by JON MANCHIP WHITE and VAL GUEST
From a story by JON MANCHIP WHITE
Produced by ANTHONY HINDS · Directed by VAL GUEST
Executive Producer : MICHAEL CARRERAS

⚓ The Camp On Blood Island
BRITISH 30 x 40 in (76 x 102 cm)
Illustration by John Stockle

This film's original Quad Crown poster was obviously designed to make an impact, but it became clear that John Stockle had gone too far when the London Poster Advertising Association Censorship Committee banned it from appearing in any outdoor locations in the capital. The British Transport Association also blocked it from display in buses, the Underground and railway stations.

The Camp On Blood Island ✈
BRITISH 30 x 40 in (76 x 102 cm)

The Camp On Blood Island was a great commercial success, but it was perceived as a cynical and exploitative exercise by the British press. The negative reviews would damage Hammer's reputation for many years to come. The company's first act of appeasement was to commission a new poster to replace the Quad Crown that had been banned in London.

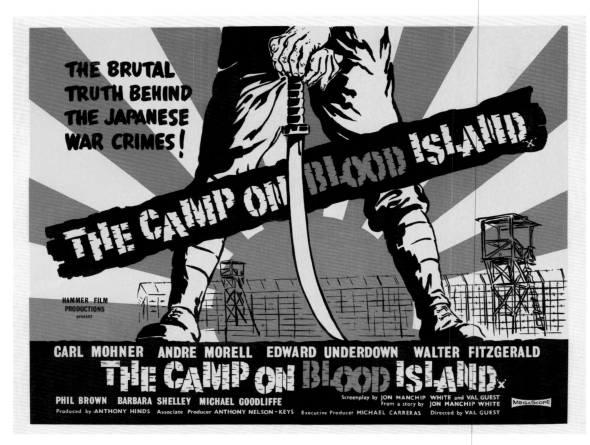

THE BRUTAL
TRUTH BEHIND
THE JAPANESE
WAR CRIMES!

THE CAMP ON BLOOD ISLAND

HAMMER FILM
PRODUCTIONS
present

CARL MOHNER ANDRE MORELL EDWARD UNDERDOWN WALTER FITZGERALD

THE CAMP ON BLOOD ISLAND

PHIL BROWN BARBARA SHELLEY MICHAEL GOODLIFFE

Screenplay by JON MANCHIP WHITE and VAL GUEST
From a story by JON MANCHIP WHITE

Produced by ANTHONY HINDS Associate Producer ANTHONY NELSON-KEYS Executive Producer MICHAEL CARRERAS Directed by VAL GUEST

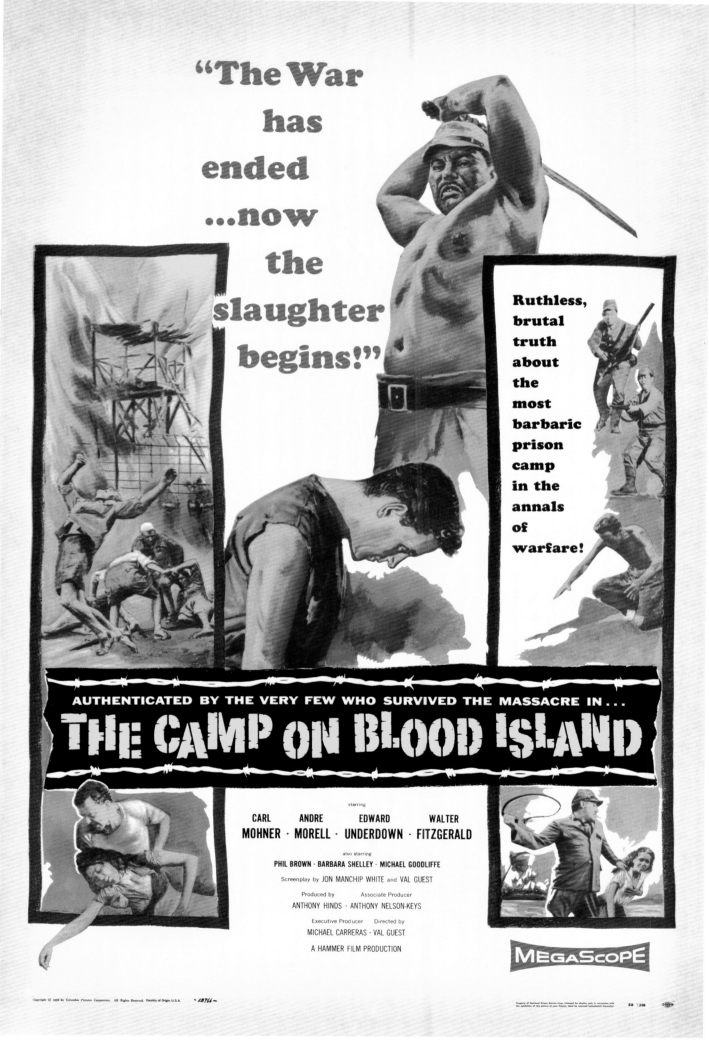

✝ The Camp On Blood Island
US 41 x 27 in (104 x 69 cm)

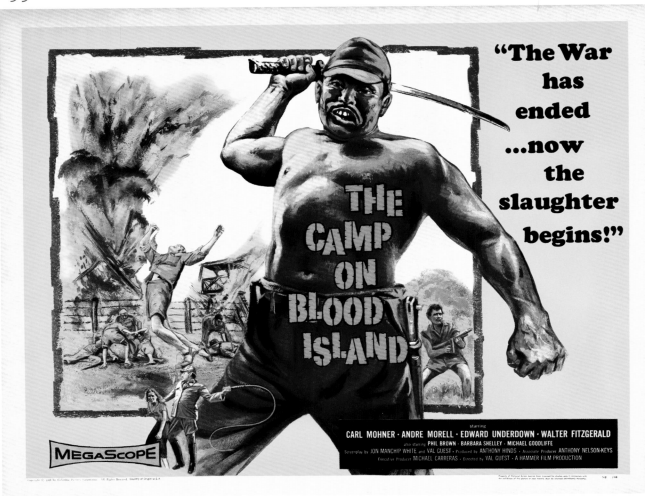

‎⚜ The Camp On Blood Island
US 22 x 28 in (56 x 71 cm)

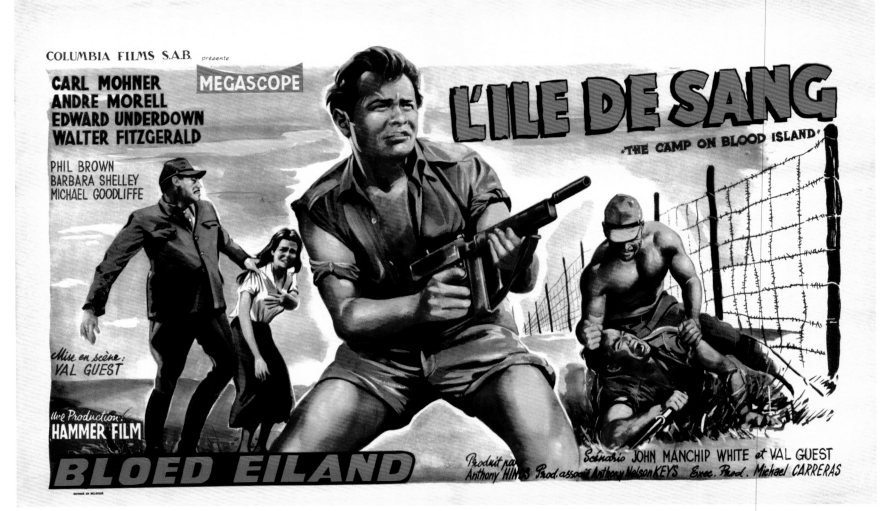

‎⚜ The Camp On Blood Island
BELGIAN 14 x 22 in (35 x 56 cm)

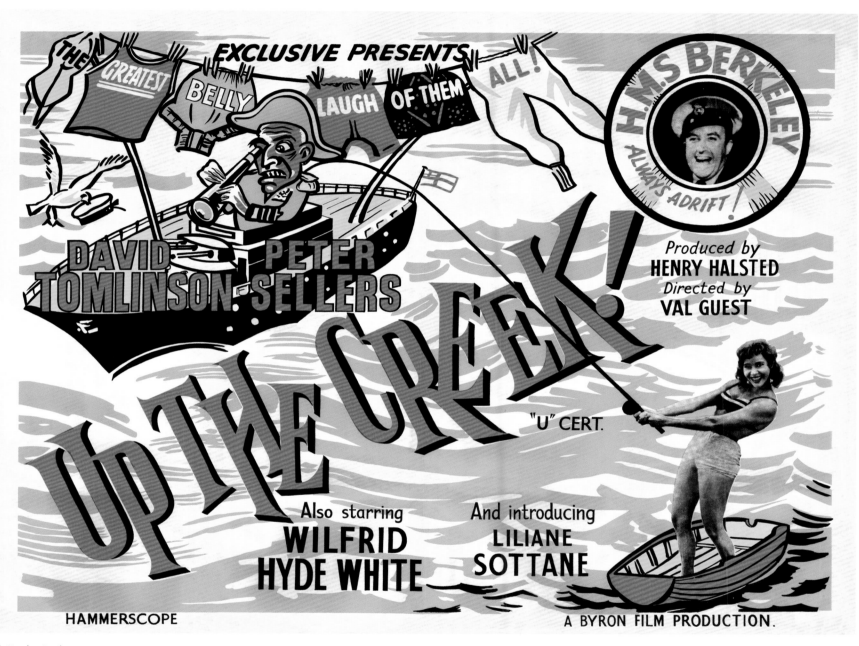

✠ **Up the Creek**
Bʀɪᴛɪsʜ 30 x 40 in (76 x 102 cm)

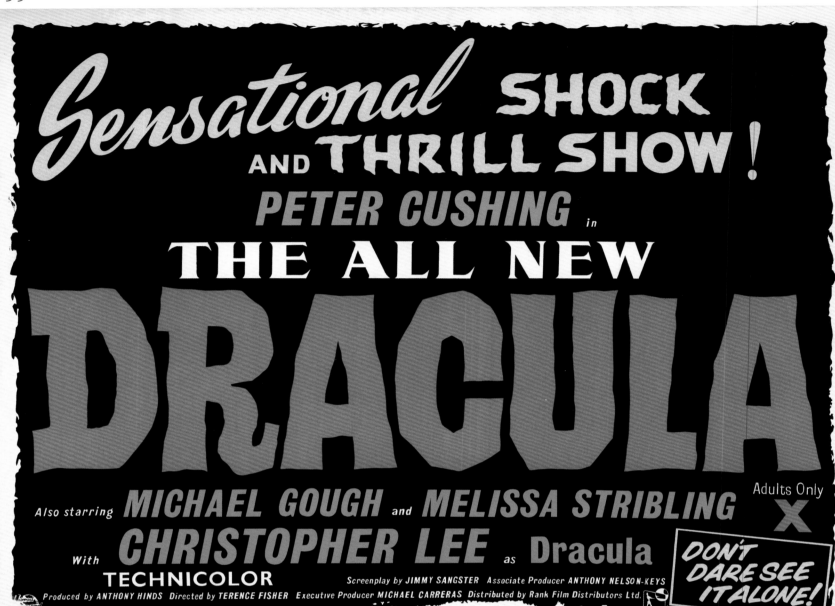

† **Dracula**
BRITISH 30 x 40 in (76 x 102 cm)

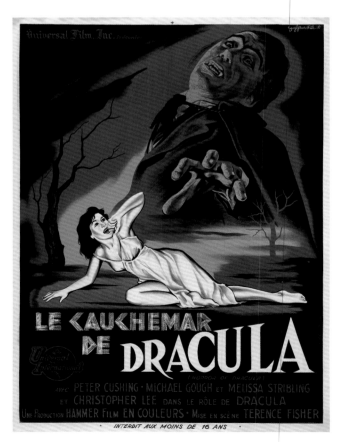

Dracula ⚓
FRENCH 32 x 24 in (80 x 60 cm)
Illustration by Guy Gerard Noel

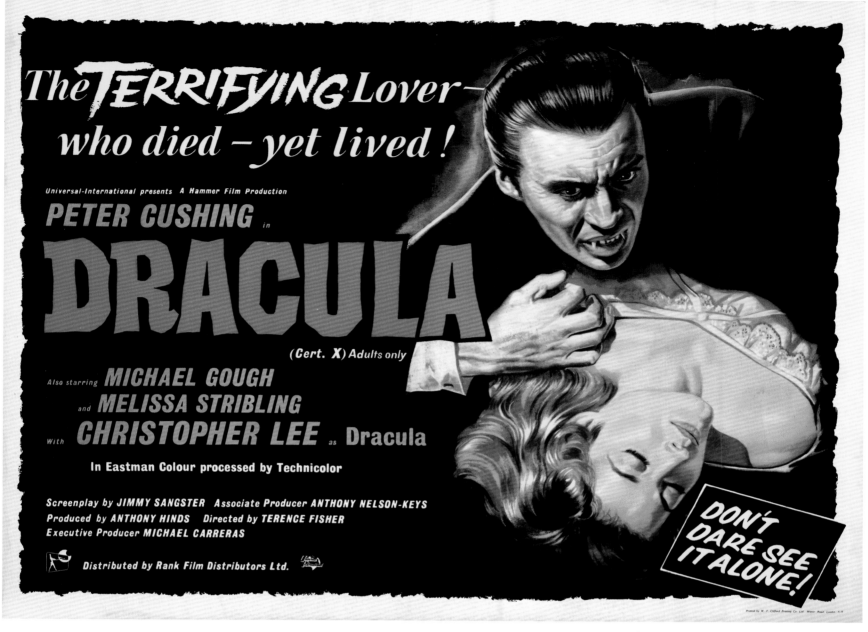

The TERRIFYING Lover – who died – yet lived!

Universal-International presents A Hammer Film Production

PETER CUSHING in

DRACULA

(Cert. **X**) Adults only

Also starring MICHAEL GOUGH and MELISSA STRIBLING With CHRISTOPHER LEE as Dracula

In Eastman Colour processed by Technicolor

Screenplay by JIMMY SANGSTER Associate Producer ANTHONY NELSON-KEYS
Produced by ANTHONY HINDS Directed by TERENCE FISHER
Executive Producer MICHAEL CARRERAS

Distributed by Rank Film Distributors Ltd.

DON'T DARE SEE IT ALONE!

✝ **Dracula**
BRITISH 30 x 40 in (76 x 102 cm)
Illustration by Bill Wiggins

Eddie Paul's design for the *Dracula* poster emphasised an erotic element that would become an integral part of Hammer horror.

Bill Wiggins' painting was inspired by a posed publicity photograph taken by unit photographer Tom Edwards. In 1995 Edwards remembered staging the shot: "I had a bed assembled in the stills studio, and placed Melissa Stribling lying on it, with her head hanging over the edge towards camera, and blood on her neck. Christopher Lee was on top of her, with blood coming from his mouth. It must have been extremely uncomfortable for the artistes, but they did it without fuss."

Now the most sought-after of all Hammer posters, its importance was acknowledged in 2008 when the Royal Mail subtly modified the design for use on a 48p stamp.

Every night he rises from his coffin-bed silently to seek the soft flesh, the warm blood he needs to keep himself alive!

Dracula

Adults only **X**

DON'T DARE SEE IT ALONE!

T. P. LTD. PRINTED IN ENGLAND

✠ **Dracula**
BRITISH 30 x 20 in (76 x 51 cm)

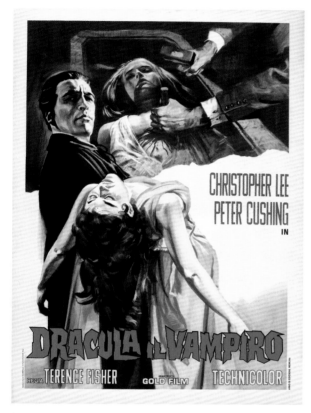

✟ **Dracula**
ITALIAN 39 x 28 in (99 x 71 cm)

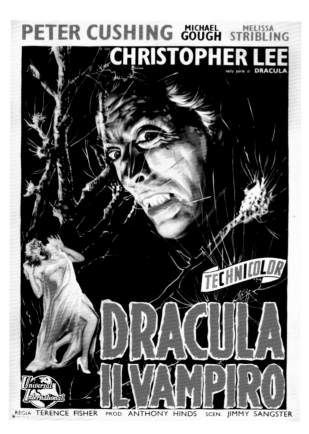

✠ **Dracula**
ITALIAN 39 x 28 in (99 x 71 cm)

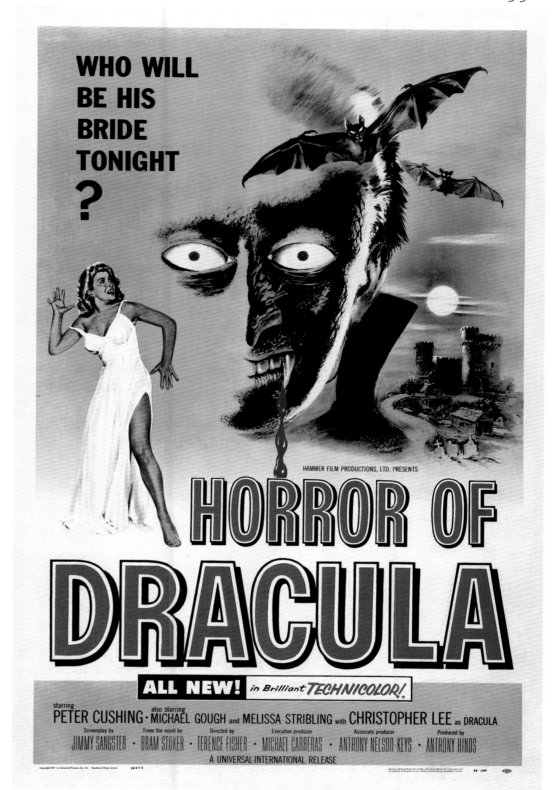

✟ **Dracula**
US 41 x 27 in (104 x 69 cm)

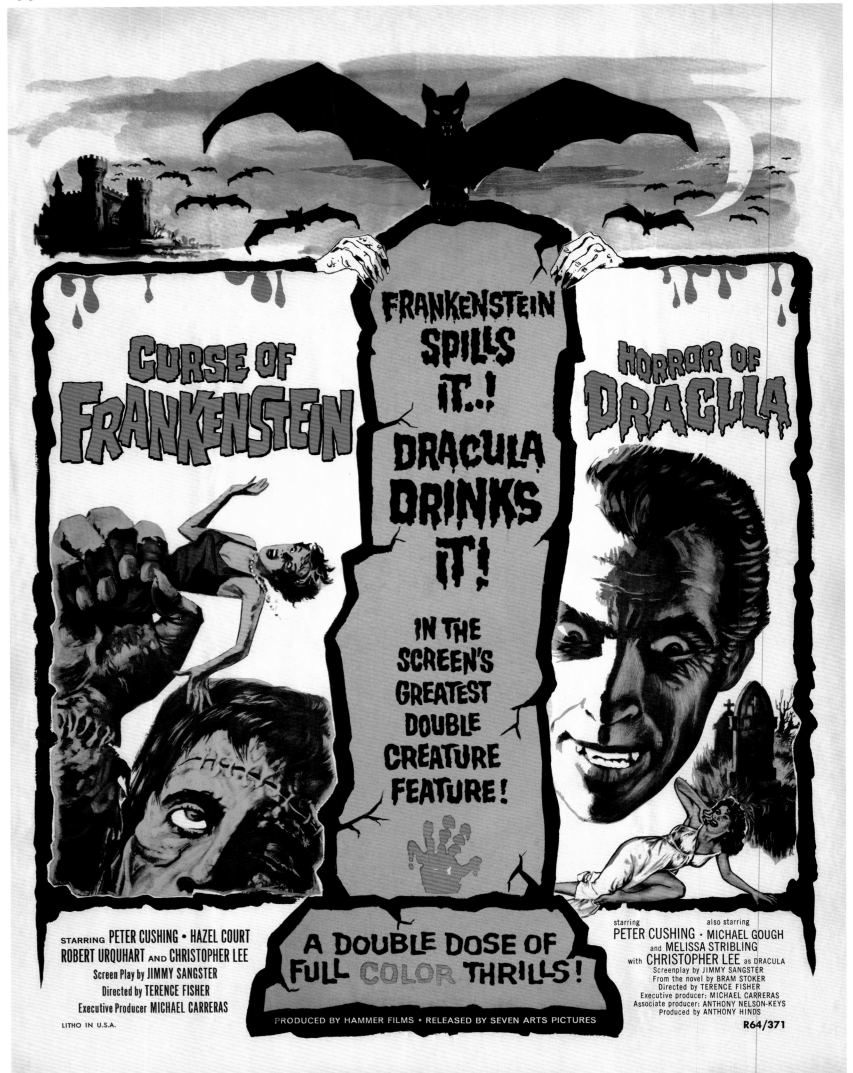

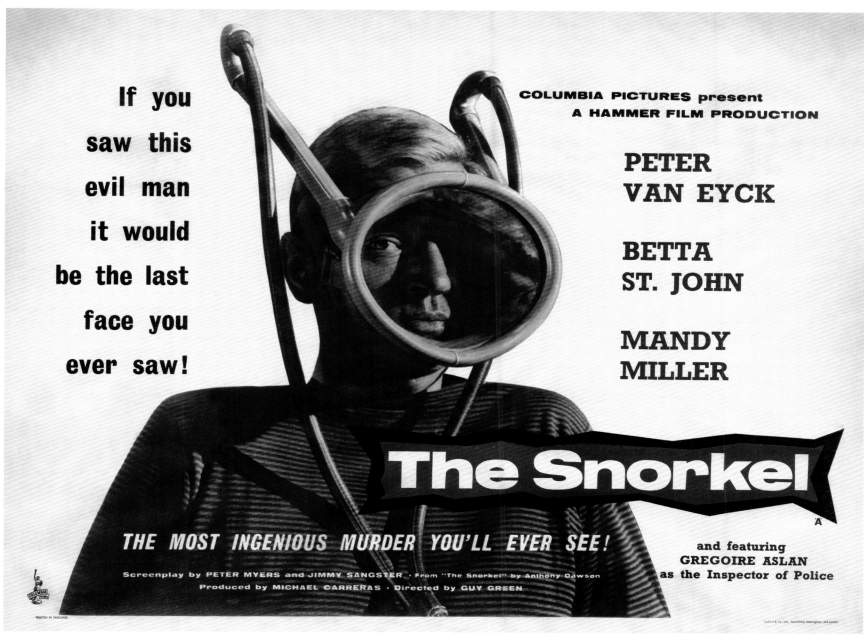

If you
saw this
evil man
it would
be the last
face you
ever saw!

COLUMBIA PICTURES present
A HAMMER FILM PRODUCTION

PETER
VAN EYCK

BETTA
ST. JOHN

MANDY
MILLER

The Snorkel

THE MOST INGENIOUS MURDER YOU'LL EVER SEE!

and featuring
GREGOIRE ASLAN
as the Inspector of Police

Screenplay by PETER MYERS and JIMMY SANGSTER · From "The Snorkel" by Anthony Dawson
Produced by MICHAEL CARRERAS · Directed by GUY GREEN

☦ **The Snorkel**
BRITISH 30 x 40 in (76 x 102 cm)
Design by John Stockle

✠ **The Curse of Frankenstein/Dracula**
US 41 x 27 in (104 x 69 cm)

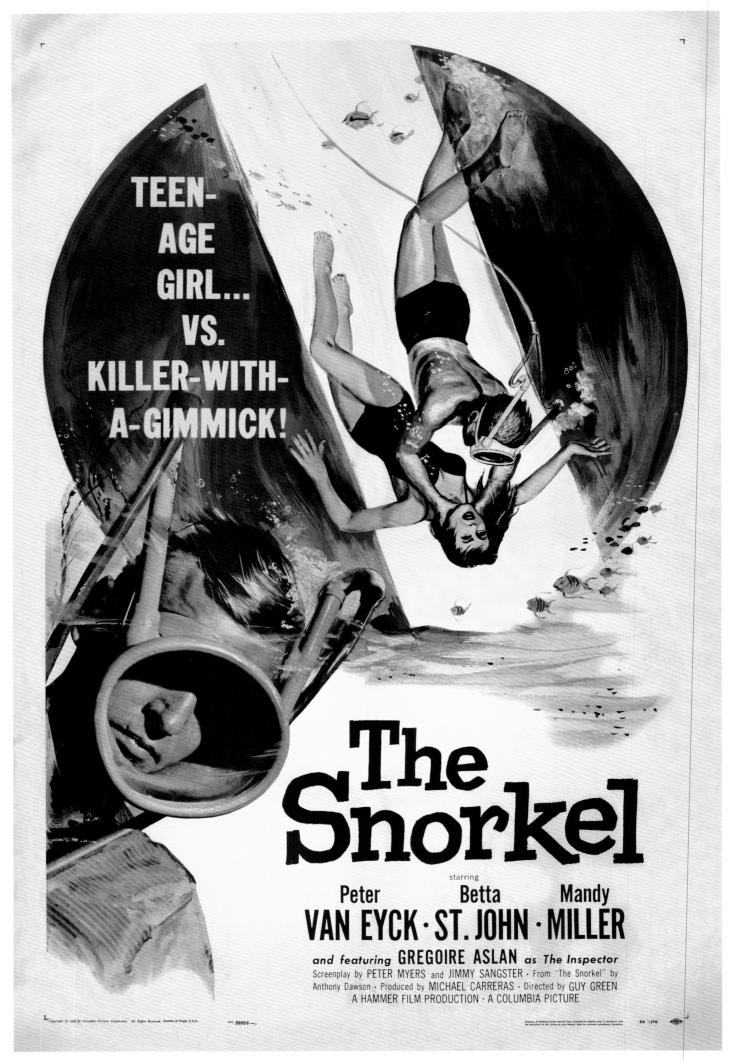

⚜ The Snorkel
US 41 x 27 in (104 x 69 cm)

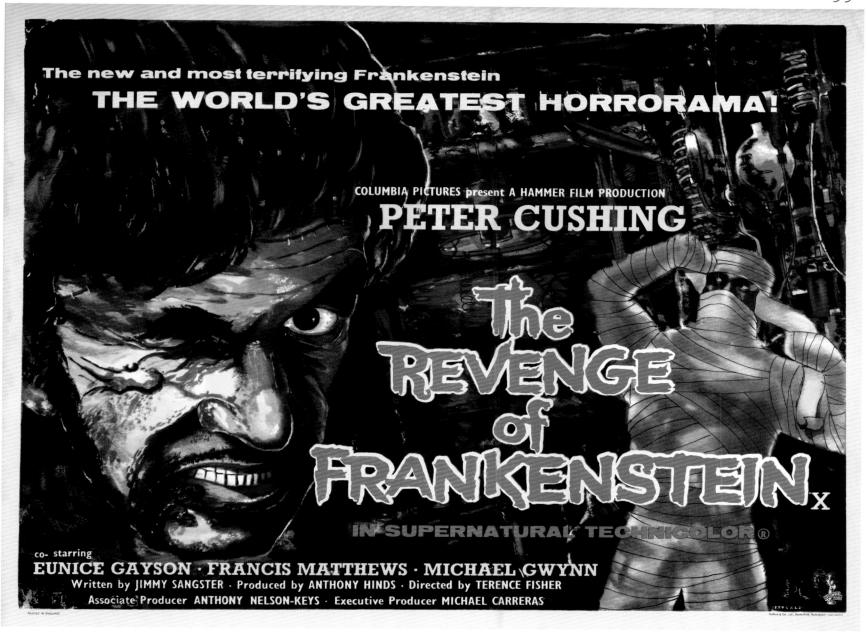

† The Revenge of Frankenstein
BRITISH 30 x 40 in (76 x 102 cm)
Illustration by John Stockle

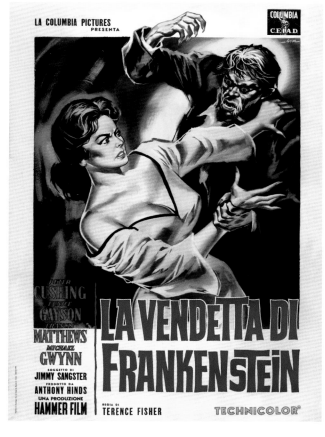

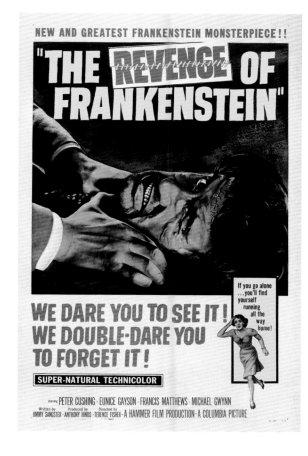

⊞ ⊞ The Revenge of Frankenstein
ITALIAN 39 x 28 in (99 x 71 cm)

⊞ The Revenge of Frankenstein
US 41 x 27 in (104 x 69 cm)

The Revenge of Frankenstein ⚔
BRITISH 30 x 20 in (76 x 51 cm)

This Double Crown poster was produced for the ABC (Associated British Cinemas) chain, and misspells the surname of the film's executive producer Michael Carreras as 'Correras'. Josh Kirby's illustration also appeared on the cover of the film's paperback tie-in.

Further Up The Creek ⚔ ⚔
AUSTRALIAN 41 x 27 in (104 x 69 cm)

✠ The Revenge of Frankenstein
BRITISH 30 x 40 in (76 x 102 cm)
Illustration by Josh Kirby

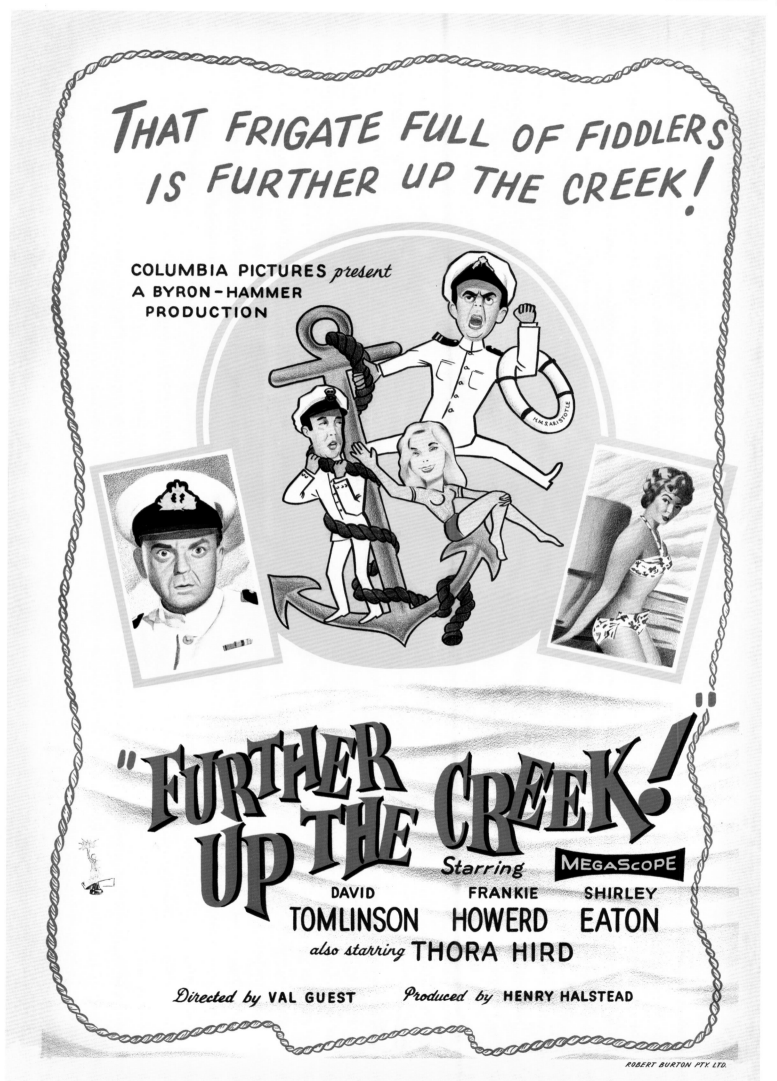

THAT FRIGATE FULL OF FIDDLERS IS FURTHER UP THE CREEK!

COLUMBIA PICTURES *present* A BYRON-HAMMER PRODUCTION

H.M.S. ARISTOTLE

"FURTHER UP THE CREEK!"

Starring MEGASCOPE

DAVID TOMLINSON FRANKIE HOWERD SHIRLEY EATON

also starring THORA HIRD

Directed by VAL GUEST *Produced by* HENRY HALSTEAD

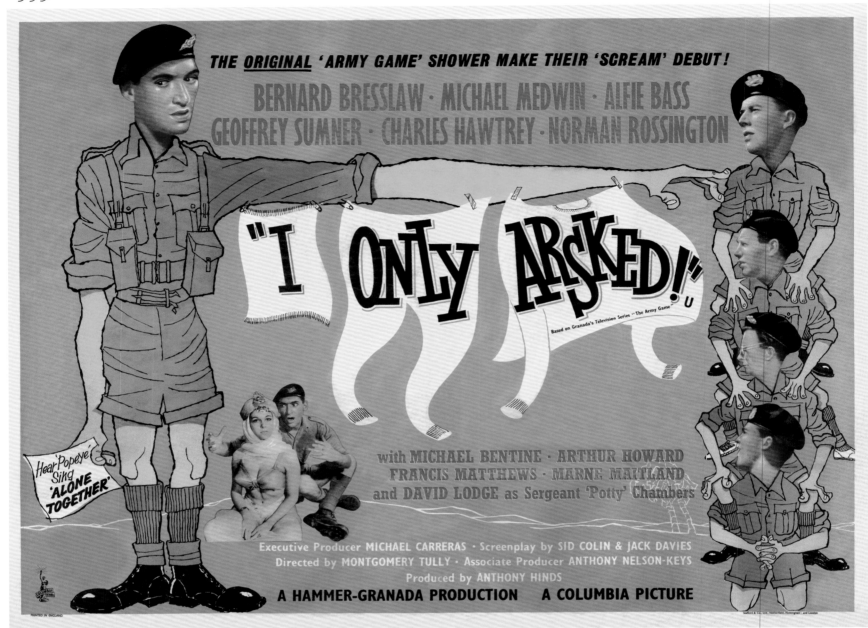

✣ **I Only Arsked**
BRITISH 30 x 40 in (76 x 102 cm)
Illustration by John Stockle

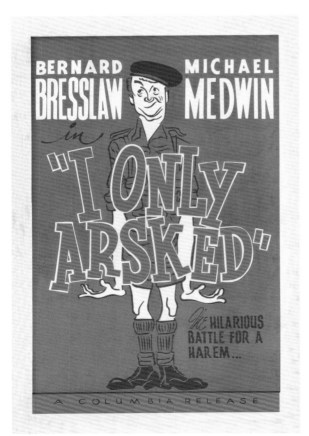

⚔ **I Only Arsked**
AUSTRALIAN 41 x 27 in (104 x 69 cm)

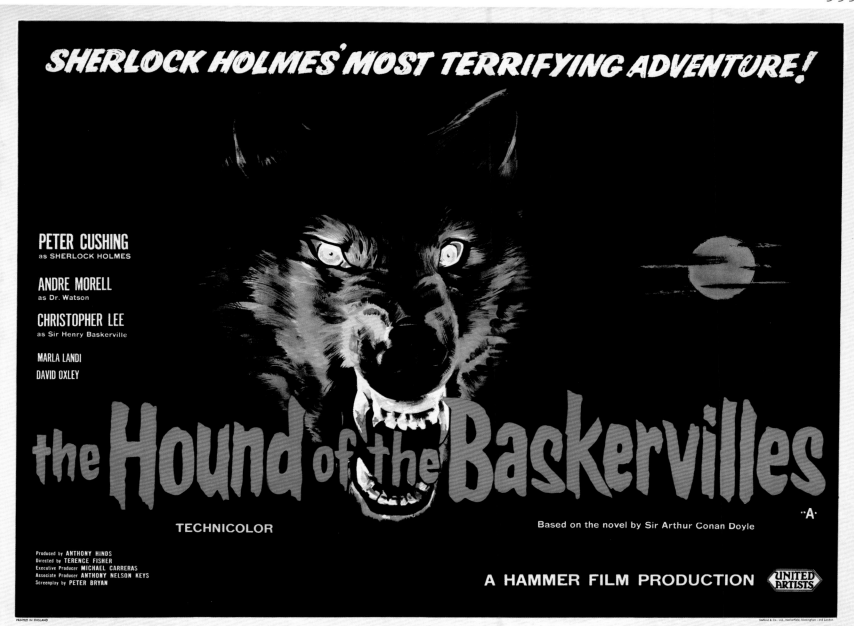

⚜ **The Hound of the Baskervilles**
BRITISH 30 x 40 in (76 x 102 cm)

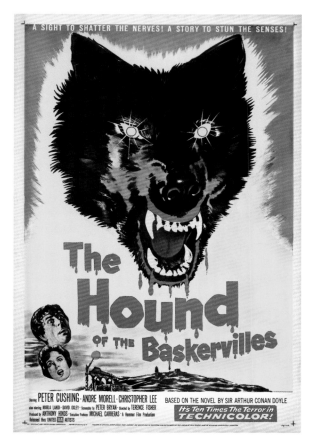

The Hound of the Baskervilles ✈
US 41 x 27 in (104 x 69 cm)

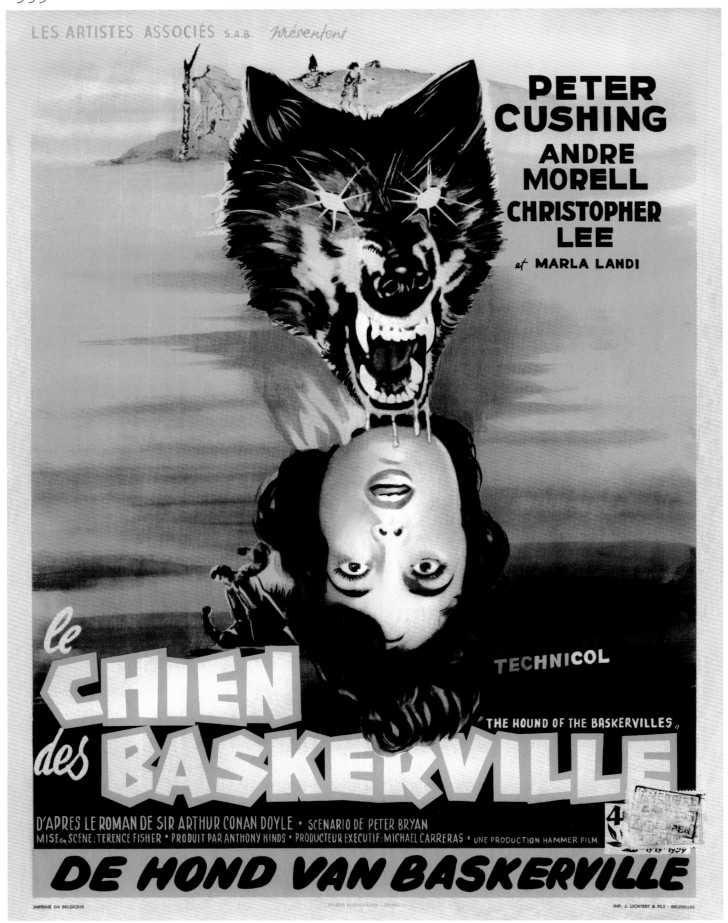

✝ The Hound of the Baskervilles
BELGIAN 21 x 14 in (53 x 36 cm)

The Hound of the Baskervilles ✝
ROMANIAN 28 x 20 in (70 x 50 cm)

O PRODUCŢIE
A STUDIOURILOR ENGLEZE

Scenariul : PETER BRYAN
după romanul lui SIR ARTHUR CONAN DOYLE

Regia : TERENCE FISHER

Imaginea : JACK ASHER

Muzica : JAMES BERNARD

cu :
Peter Cushing, André Morell,
Christopher Lee, Maria Landi,
David Oxley, Elisabeth Dott

CÎINELE
DIN
BASKERVILLE

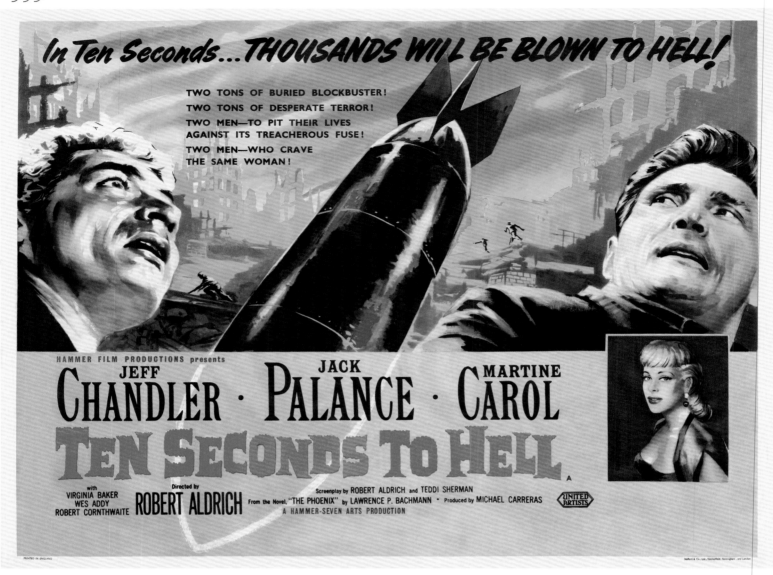

✝ **Ten Seconds to Hell**
BRITISH 30 x 40 in (76 x 102 cm)

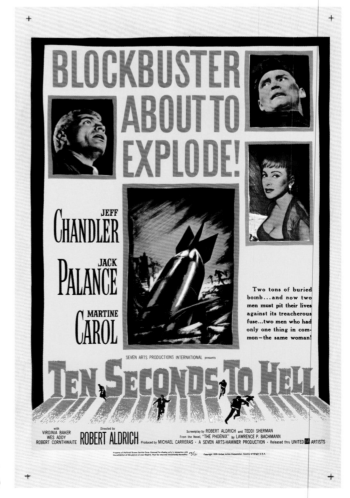

Ten Seconds to Hell ✈
US 41 x 27 in (104 x 69 cm)

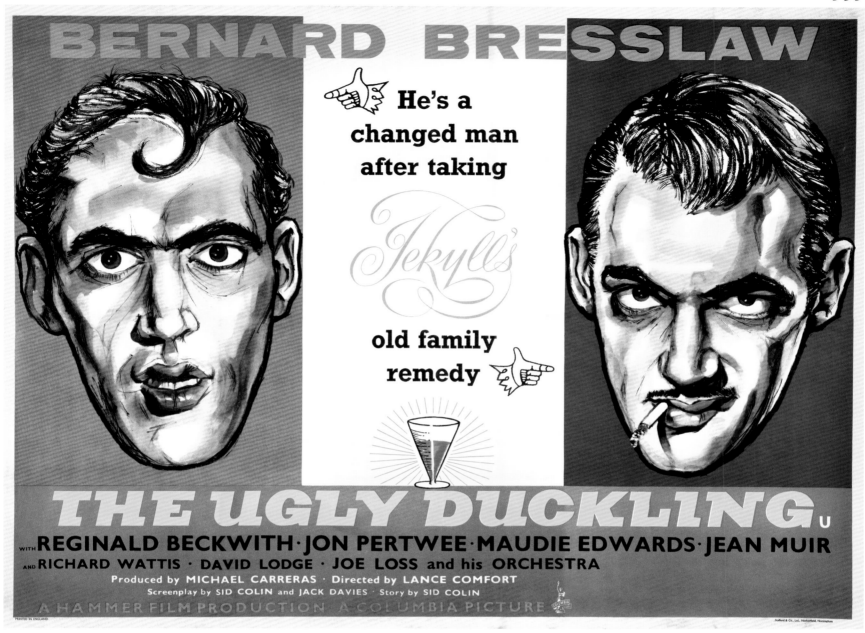

✠ **The Ugly Duckling**
BRITISH 30 x 40 in (76 x 102 cm)

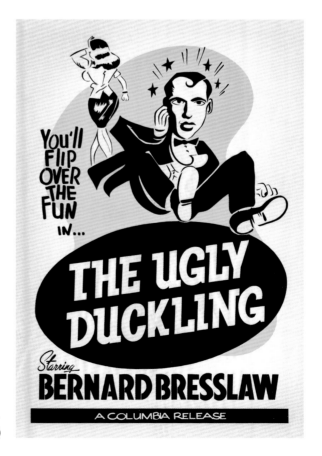

The Ugly Duckling ✈
AUSTRALIAN 41 x 27 in (104 x 69 cm)

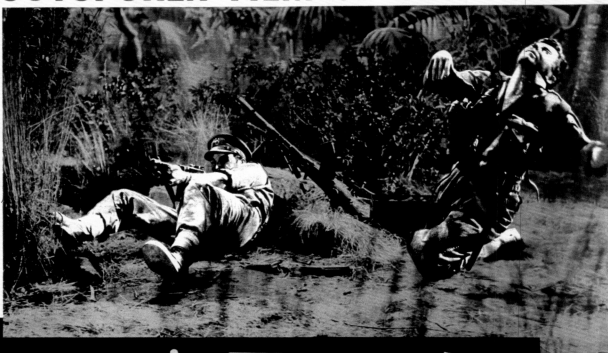

THE MOST OUTSPOKEN FILM OF OUR TIME!

STANLEY
BAKER
GUY
ROLFE
LEO
McKERN
GORDON
JACKSON

Yesterday's Enemy

ALSO STARRING **DAVID OXLEY · RICHARD PASCO · PHILIP AHN** WITH **BRYAN FORBES · WOLF MORRIS · DAVID LODGE · PERCY HERBERT**

Produced by Michael Carreras · Directed by Val Guest · Screenplay adapted from his own play by Peter R. Newman

A HAMMER FILM PRODUCTION · A COLUMBIA PICTURE MEGASCOPE

✝ **Yesterday's Enemy**
BRITISH 30 x 40 in (76 x 102 cm)

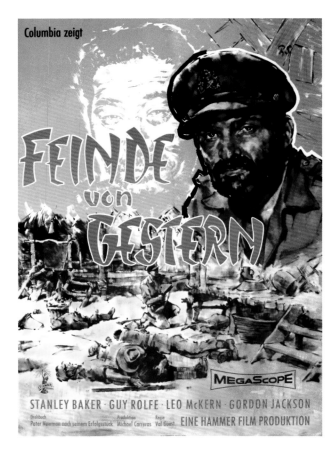

✤ **Yesterday's Enemy**
GERMAN 34 x 22 in (85 x 56 cm)

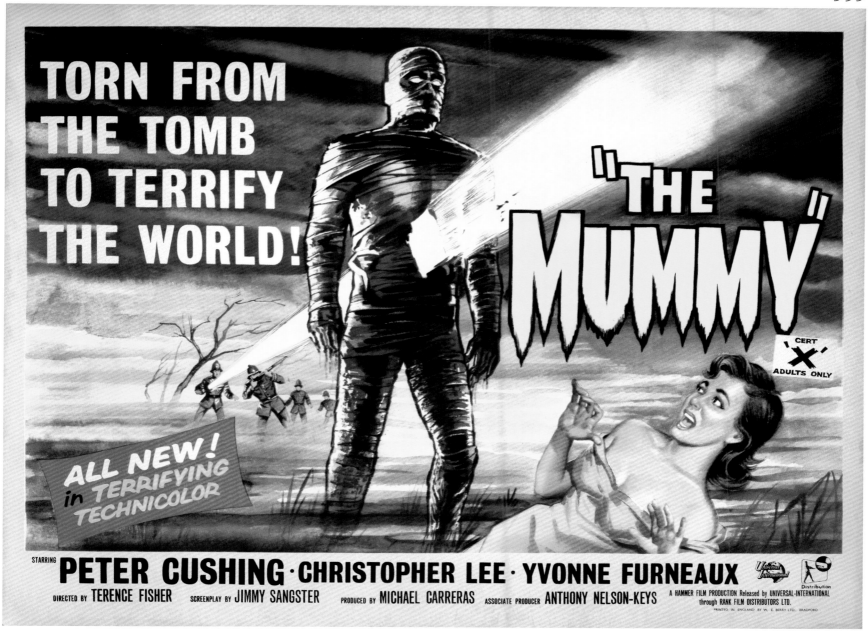

✝ **The Mummy**
BRITISH 30 x 40 in (76 x 102 cm)
Illustration by Bill Wiggins

The Mummy was still in production when Peter Cushing first saw Bill Wiggins' painting. Concerned that it misrepresented the film, Cushing asked director Terence Fisher if he could add a scene where his character drove a harpoon through the mummy's body. "And that's what I did," he remembered, "thus giving some sort of logic to the illuminated gap depicted on the posters."

In 2008 the Royal Mail adapted this design for use as an 81p stamp.

EXISTE-T-IL UNE **MALÉDICTION DES PHARAONS?**
Dix-neuf personnes assistèrent en 1923 à l'ouverture du tombeau de TOUTANKHAMON; une seule est décédée de mort naturelle, dix-sept autres ont disparu dans des conditions MYSTÉRIEUSES, et il reste vivant un archéologue allemand. Sera-t-il l'ultime victime d'une MALÉDIC-TION qui aurait frappé, par delà **33** siècles, dix-sept de ses compagnons ?
Plusieurs solutions ont été proposées à cette ÉNIGME, mais **OÙ EST LA VÉRITABLE EXPLICATION ?**

Jean Jouquet
(LE PARISIEN LIBÉRÉ)

Cette terrifiante énigme vous sera dévoilée dans le film :

LA MALÉDICTION DES PHARAONS

Une production **HAMMER FILM** Distribuée par **UNIVERSAL FILM** inc.

✦ **The Mummy**
FRENCH 46 x 32 in (117 x 80 cm)

This poster contains a lengthy quote from French journalist Jean Jouquet:

Is there such a thing as the Curse of the Pharaohs? In 1923, nineteen people were present at the opening of Tutankhamun's tomb; only one died of natural causes, seventeen others have disappeared under mysterious circumstances and only one German archaeologist is still alive. Will he be the last victim of this curse which has lasted for 33 centuries and which could have wiped out seventeen of his companions?

Many answers have been proposed for this enigma, but what is the real explanation?

The terrifying enigma will be revealed to you in the film The Curse of the Pharaohs.

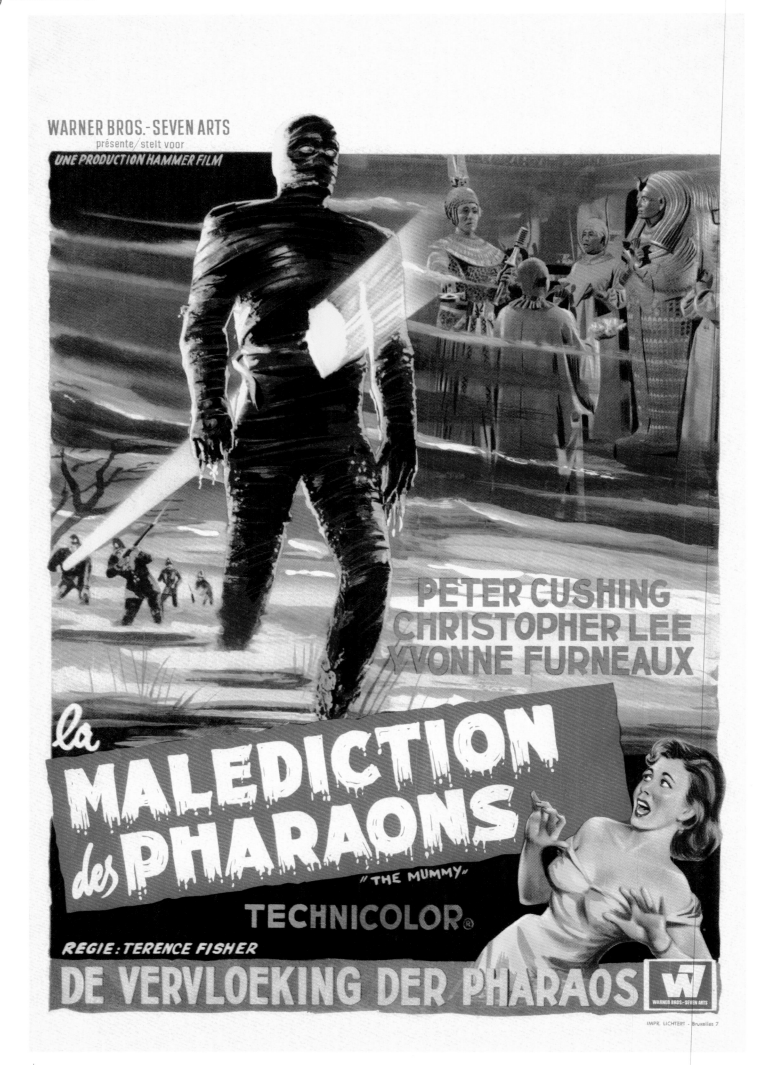

✟ **The Mummy**
BELGIAN 21 x 14 in (53 x 36 cm)

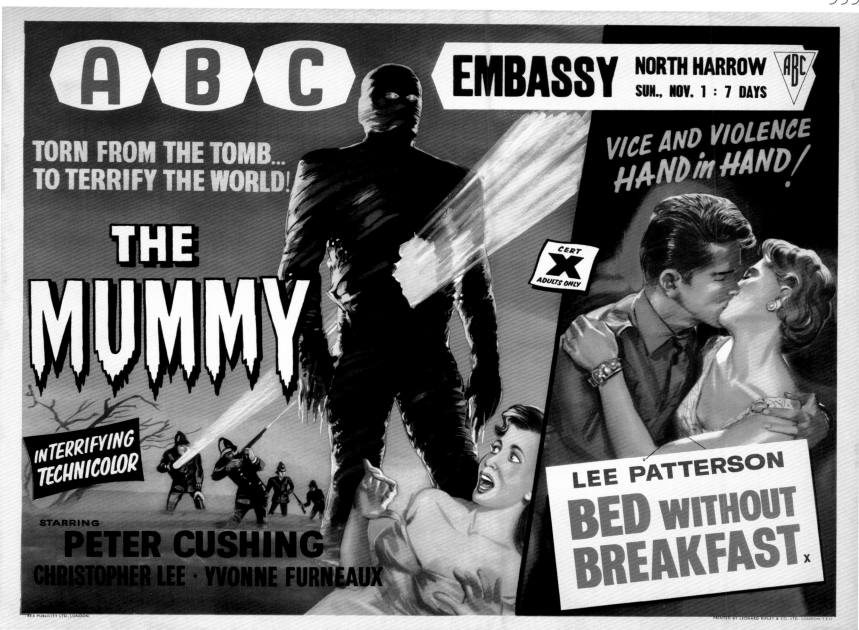

✝ The Mummy/Bed Without Breakfast
British 30 x 40 in (76 x 102 cm)

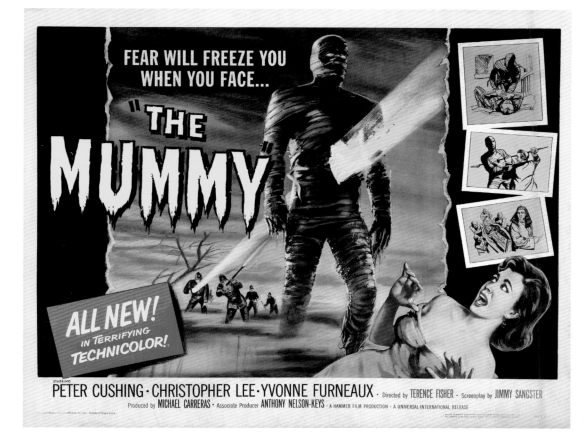

⇥ The Mummy
US 41 x 27 in. (104 x 69 cm)

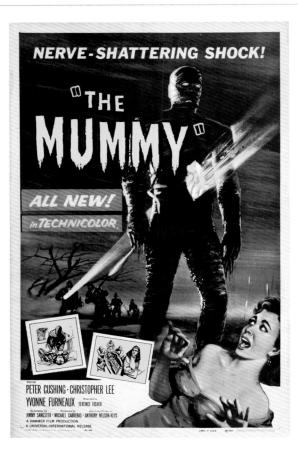

The Mummy
AUSTRALIAN 41 x 27 in (104 x 69 cm)

The Mummy
US 41 x 27 in (104 x 69 cm)

The Curse of Frankenstein/The Mummy
BRITISH 30 x 40 in (76 x 102 cm)

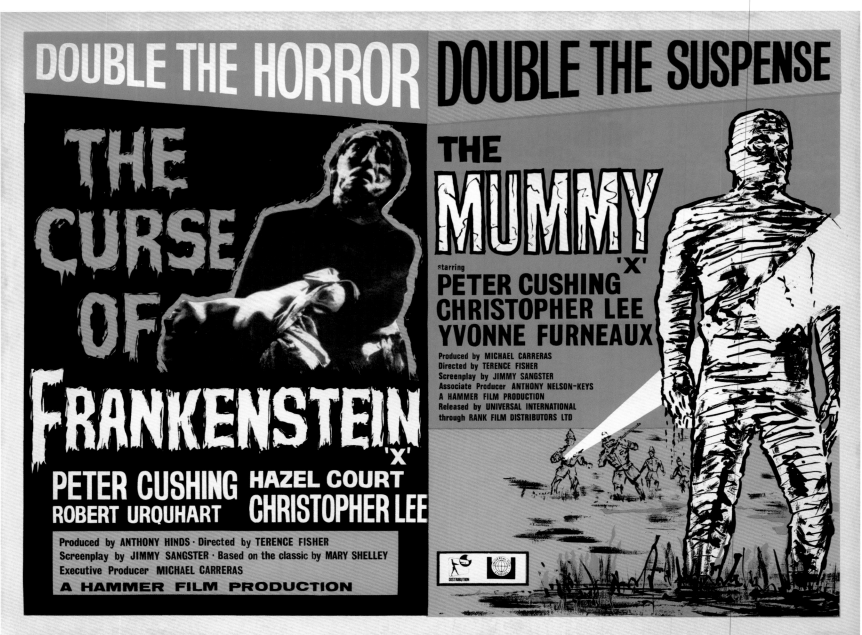

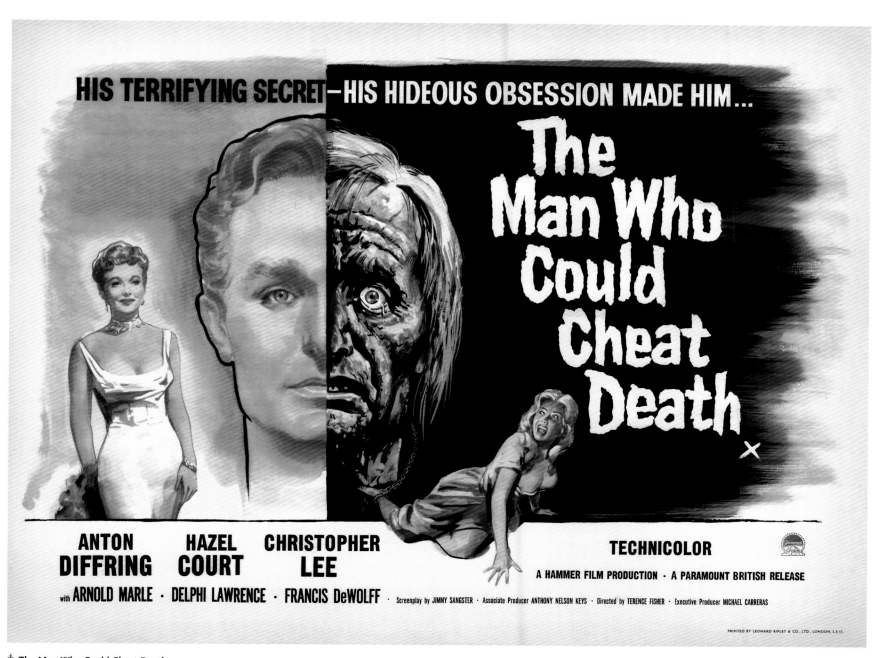

✝ **The Man Who Could Cheat Death**
BRITISH 30 x 40 in (76 x 102 cm)

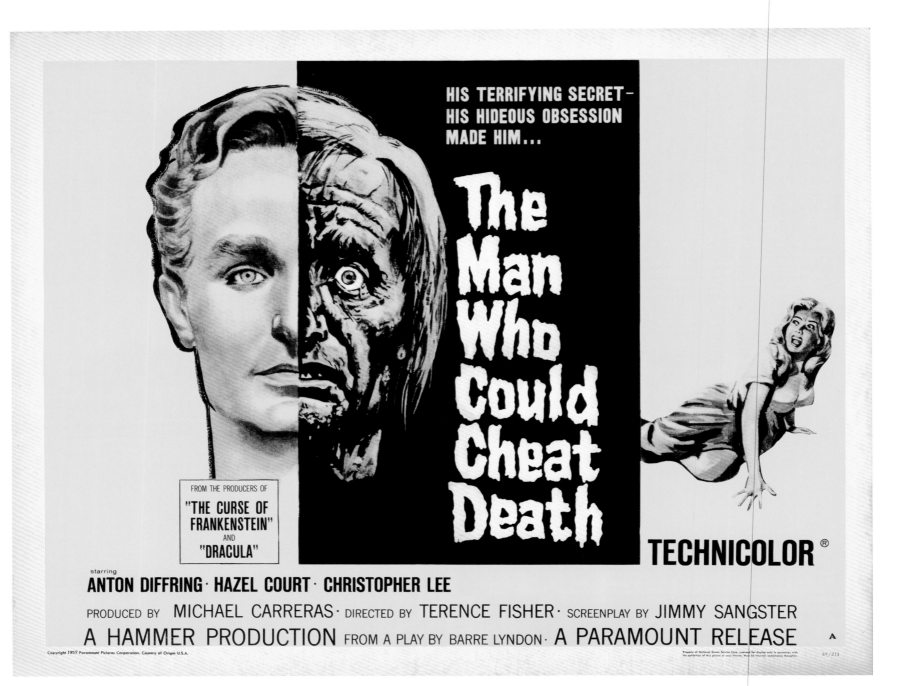

✠ **The Man Who Could Cheat Death**
US 22 x 28 in (56 x 71 cm)

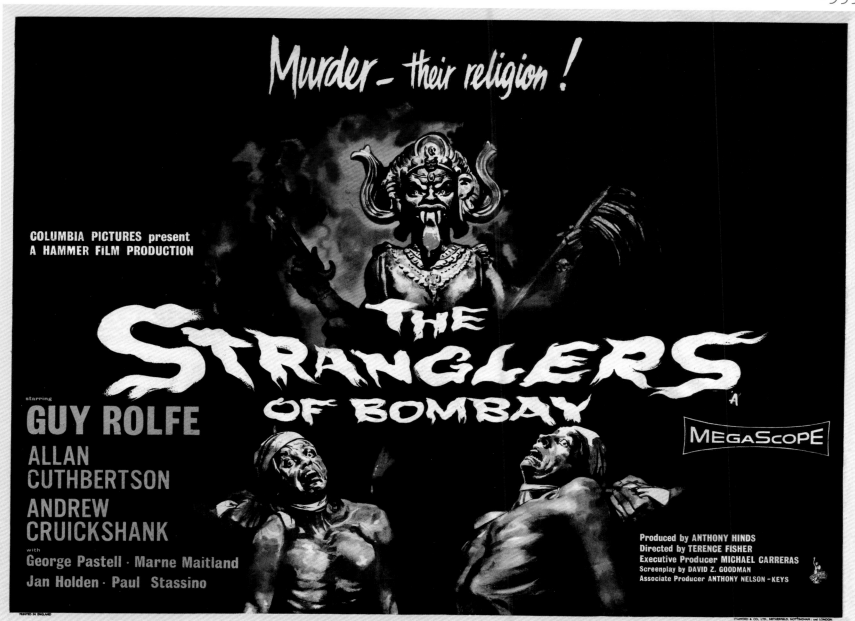

✝ **The Stranglers of Bombay**
BRITISH 30 x 40 in (76 x 102 cm)

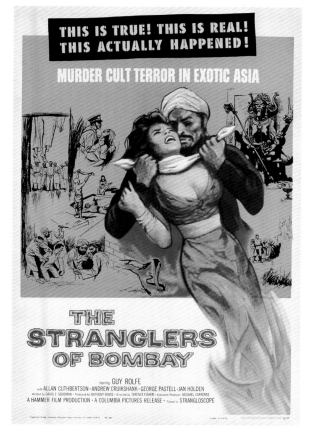

The Stranglers of Bombay ✈
US 41 x 27 in (104 x 69 cm)

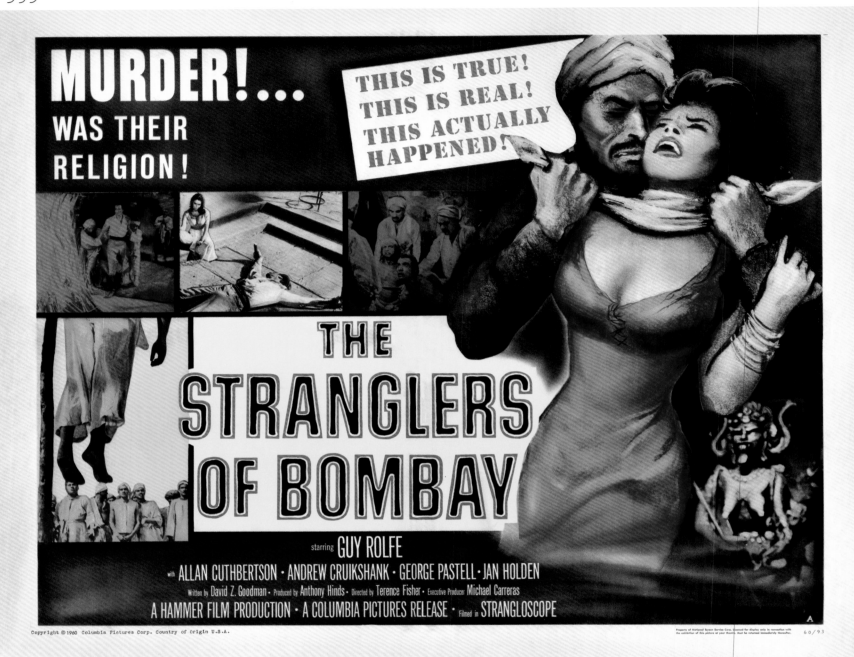

✝ **The Stranglers of Bombay**
US 22 x 28 in (56 x 71 cm)

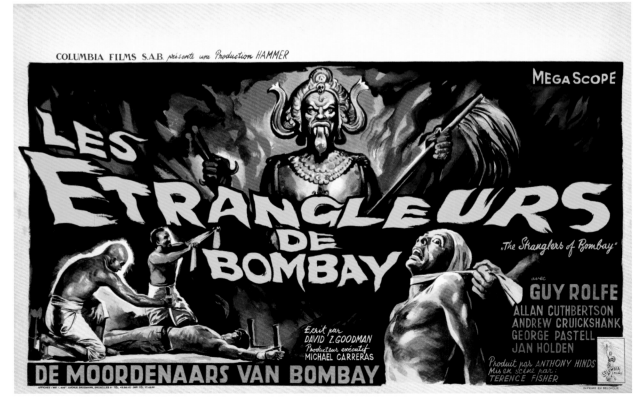

✣ **The Stranglers of Bombay**
BELGIAN 14 x 20 in (36 x 51 cm)

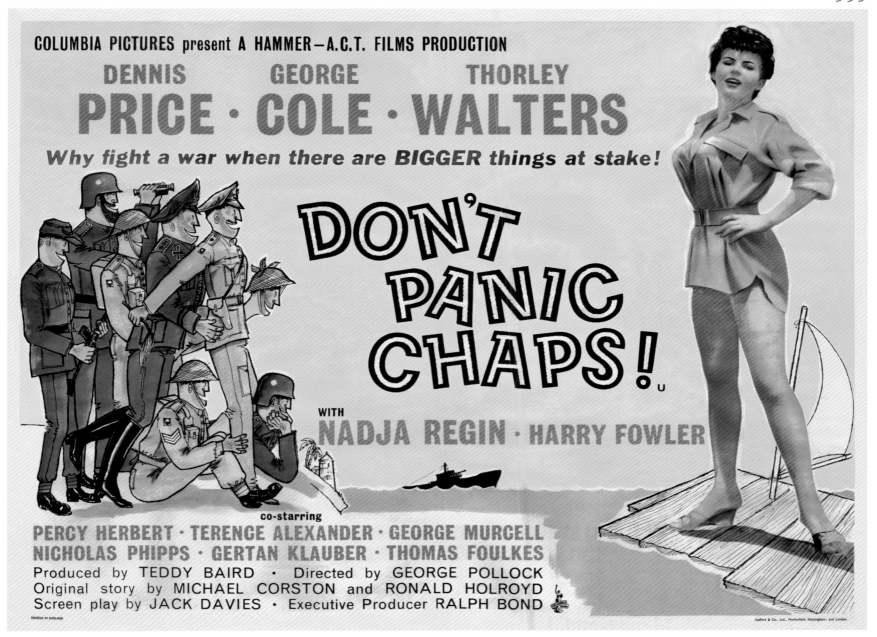

† **Don't Panic Chaps**
Bʀɪᴛɪsʜ 30 x 40 in (76 x 102 cm)

Don't Panic Chaps ⇥
US 41 x 27 in (104 x 69 cm)

1960-1969

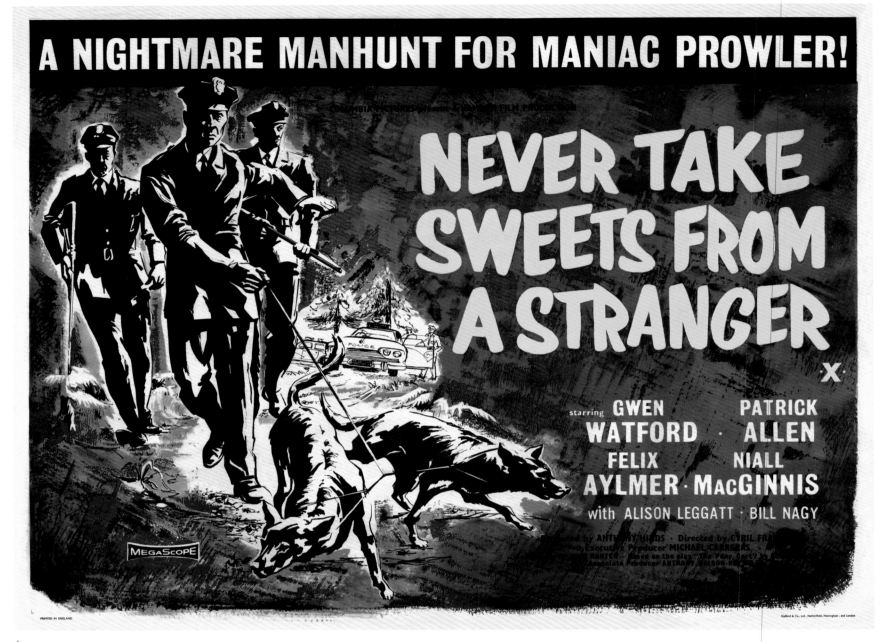

✝ **Never Take Sweets From a Stranger**
BRITISH 30 x 40 in (76 x 102 cm)

Never Take Sweets From a Stranger ⇥
BELGIAN 15 x 20 in (38 x 50 cm)

The British posters for this film were relatively subdued compared to their European counterparts, which made it clear that the difficult subject matter was child abuse.

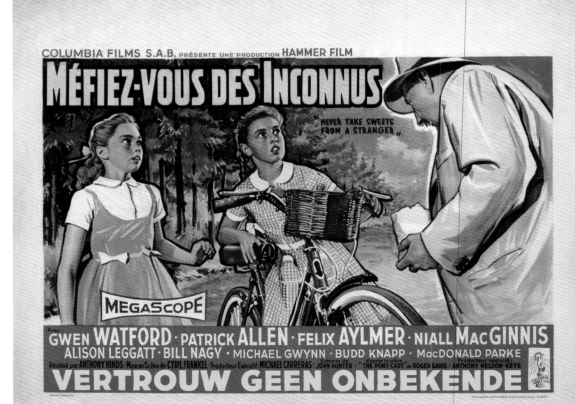

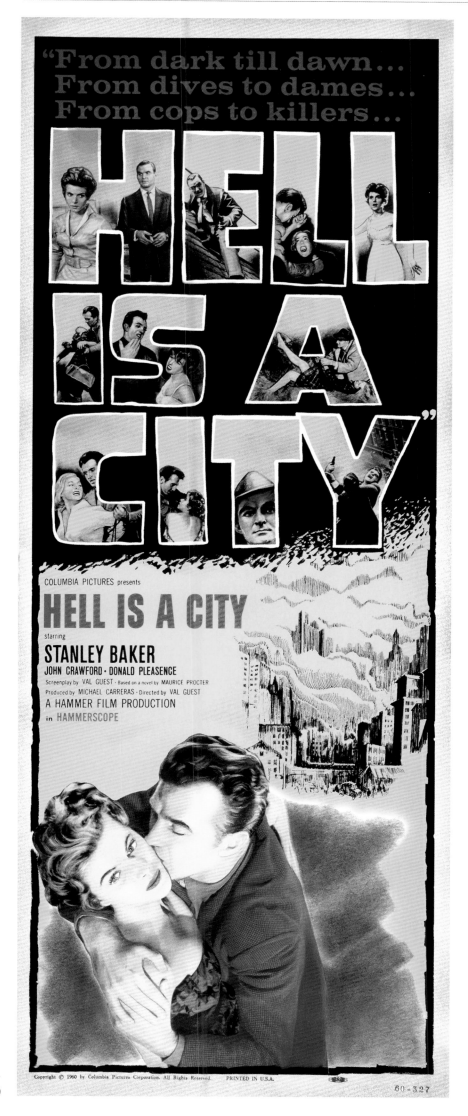

Hell is a City ✈
US 36 x 14 in (91 x 36 cm)

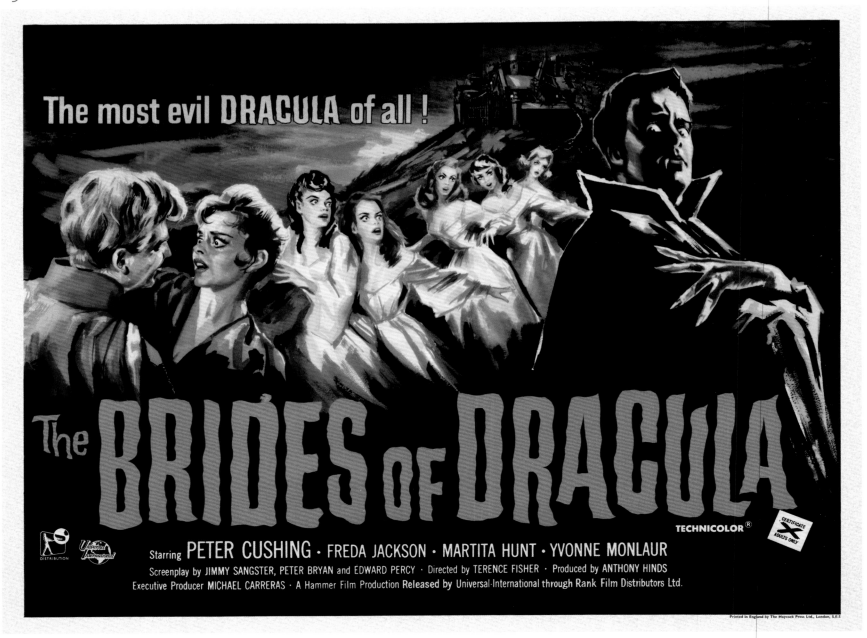

✝ **The Brides of Dracula**
BRITISH 30 x 40 in (76 x 102 cm)

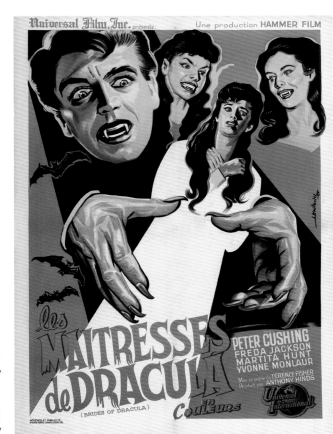

The Brides of Dracula ⚜
FRENCH 32 x 24 in (80 x 60 cm)
Illustration by Joseph Koutachy

The Brides of Dracula ⚜
FRENCH 32 x 24 in (80 x 60 cm)
Illustration by Joseph Koutachy

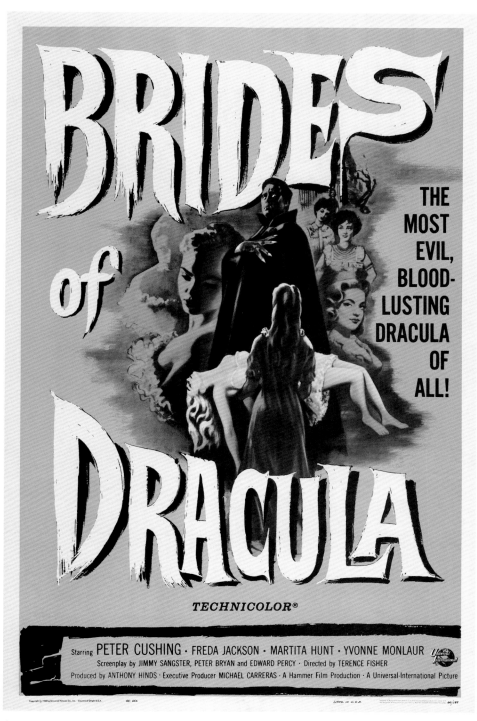

✠ The Brides of Dracula
US 41 x 27 in (104 x 69 cm)

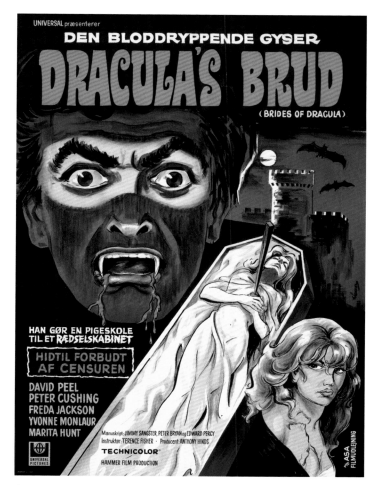

✠ The Brides of Dracula
DANISH 33 x 25 in (83 x 64 cm)

This poster belonged to the film's co-star David Peel, who kept it in his collection because Denmark was the only territory to give him top billing over Peter Cushing.

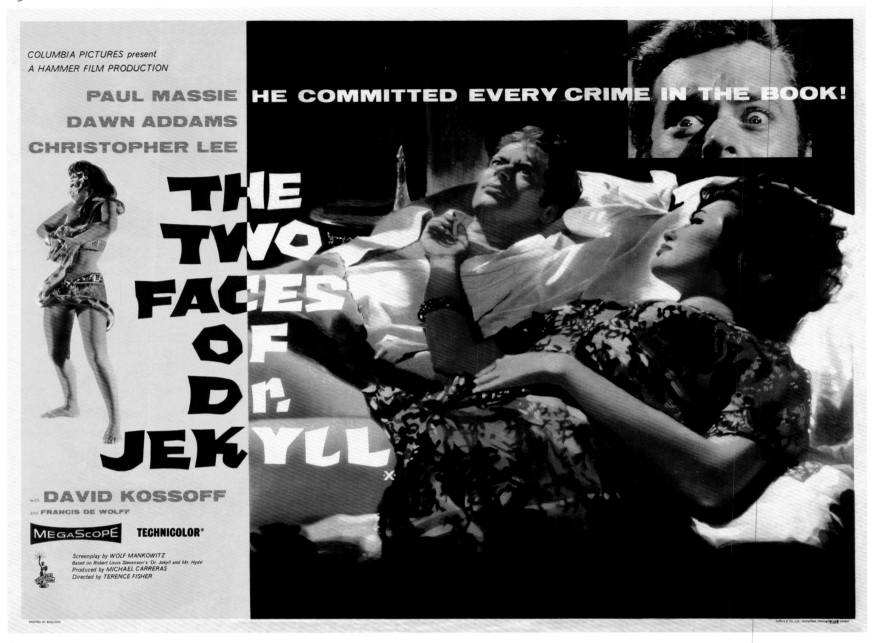

COLUMBIA PICTURES present
A HAMMER FILM PRODUCTION

PAUL MASSIE
DAWN ADDAMS
CHRISTOPHER LEE

HE COMMITTED EVERY CRIME IN THE BOOK!

THE TWO FACES OF Dr. JEKYLL

with DAVID KOSSOFF
and FRANCIS DE WOLFF

MegaScope TECHNICOLOR®

Screenplay by WOLF MANKOWITZ
Based on Robert Louis Stevenson's 'Dr. Jekyll and Mr. Hyde'
Produced by MICHAEL CARRERAS
Directed by TERENCE FISHER

PRINTED IN ENGLAND

☦ The Two Faces of Dr Jekyll
BRITISH 30 x 40 in (76 x 102 cm)

Hammer had originally intended Laurence Harvey
to star in this film. The Quad Crown seems
to have been influenced by the marketing of
Harvey's *Room at the Top* and other kitchen sink
dramas of the era. Something of a departure from
Hammer's usual style, this poster nevertheless
confirms that the film received its 'X' certificate
for its sexual content as much as its horror.

The Two Faces of Dr Jekyll ☦
US 41 x 27 in (104 x 69 cm)

The Two Faces of Dr Jekyll contravened America's
Motion Picture Production Code, effectively
making it impossible for Columbia to distribute
the film in that territory. The film was retitled
Jekyll's Inferno and licensed to independent
distributor American International Pictures.
After receiving a 'morally objectionable' verdict
from the Catholic Legion of Decency, *Jekyll's
Inferno* was cut down from 88 minutes to 80
and eventually released under the title *House of
Fright*. Unfortunately the *Jekyll's Inferno* posters
had already been printed, so *House of Fright*
stickers were issued to cover up the old title.

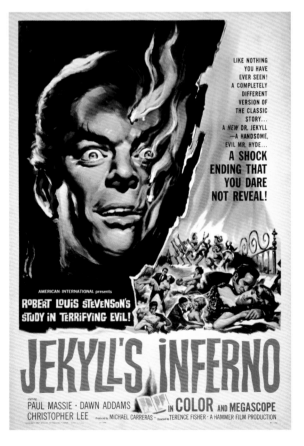

LIKE NOTHING
YOU HAVE
EVER SEEN!
A COMPLETELY
DIFFERENT
VERSION OF
THE CLASSIC
STORY...
A NEW DR. JEKYLL
—A HANDSOME,
EVIL MR. HYDE...
A SHOCK
ENDING THAT
YOU DARE
NOT REVEAL!

AMERICAN INTERNATIONAL presents
ROBERT LOUIS STEVENSON'S
STUDY IN TERRIFYING EVIL!

JEKYLL'S INFERNO

PAUL MASSIE · DAWN ADDAMS IN COLOR AND MEGASCOPE
CHRISTOPHER LEE Produced by MICHAEL CARRERAS · Directed by TERENCE FISHER · A HAMMER FILM PRODUCTION

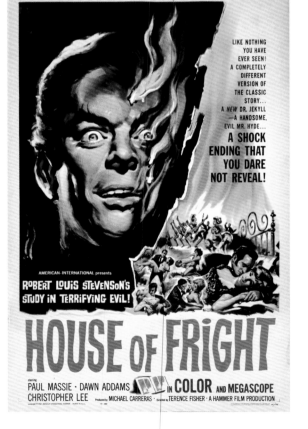

LIKE NOTHING
YOU HAVE
EVER SEEN!
A COMPLETELY
DIFFERENT
VERSION OF
THE CLASSIC
STORY...
A NEW DR. JEKYLL
—A HANDSOME,
EVIL MR. HYDE...
A SHOCK
ENDING THAT
YOU DARE
NOT REVEAL!

AMERICAN INTERNATIONAL presents
ROBERT LOUIS STEVENSON'S
STUDY IN TERRIFYING EVIL!

HOUSE OF FRIGHT

PAUL MASSIE · DAWN ADDAMS IN COLOR AND MEGASCOPE
CHRISTOPHER LEE Produced by MICHAEL CARRERAS · Directed by TERENCE FISHER · A HAMMER FILM PRODUCTION

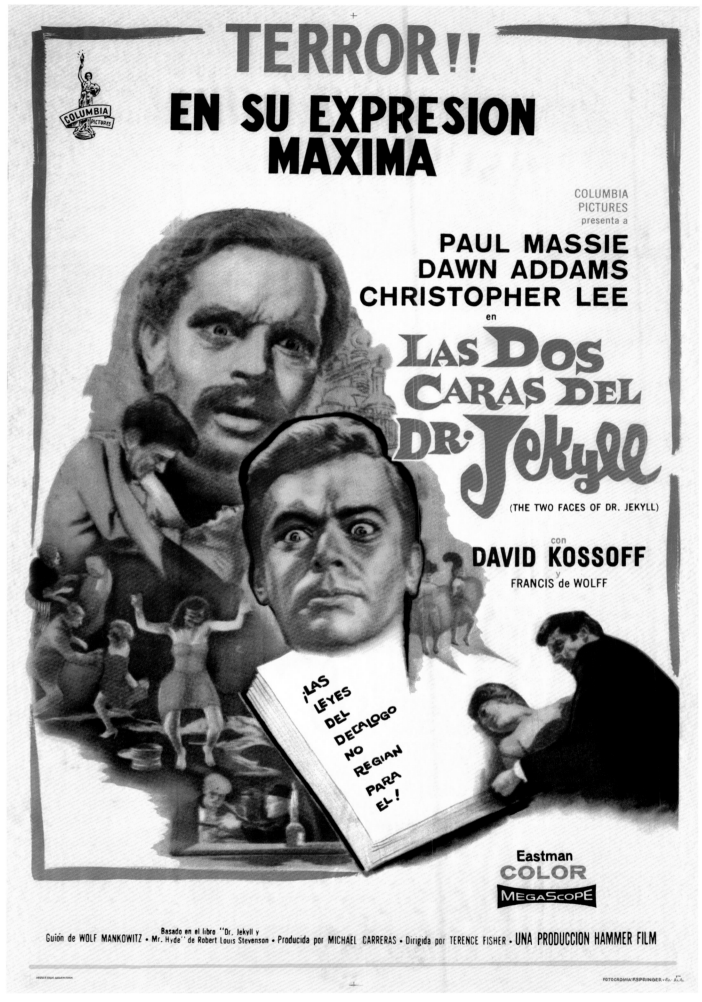

† The Two Faces of Dr Jekyll

SPANISH 39 x 28 in (100 x 70 cm)

Unlike the posters that ultimately appeared in
Britain and the US, this Spanish example conforms
to the key art originally prepared by Columbia.

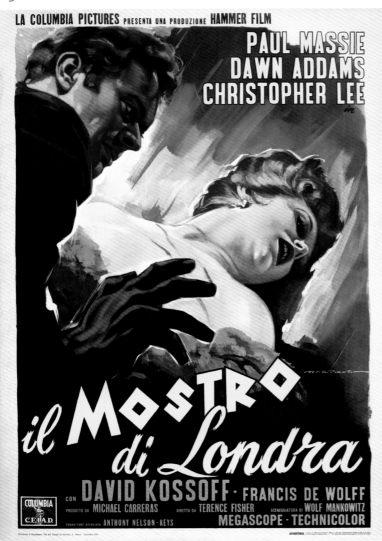

✝ **The Two Faces of Dr Jekyll**
ITALIAN 78 x 55 in (198 x 140 cm)
Illustration by Luigi Martinati

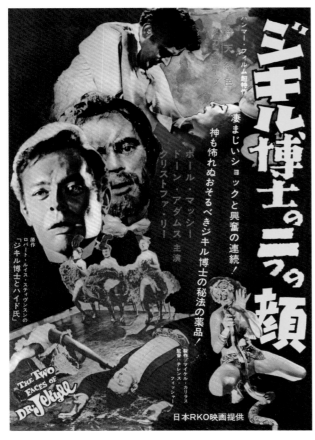

✝ **The Two Faces of Dr Jekyll**
JAPANESE 30 x 20 in (76 x 51 cm)

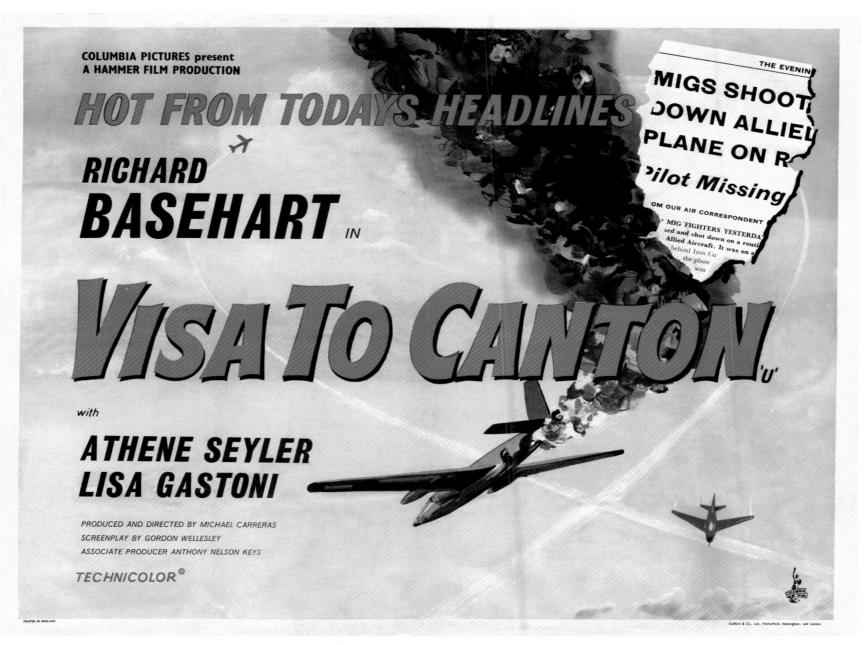

✢ **Visa to Canton**
BRITISH 30 x 40 in (76 x 102 cm)

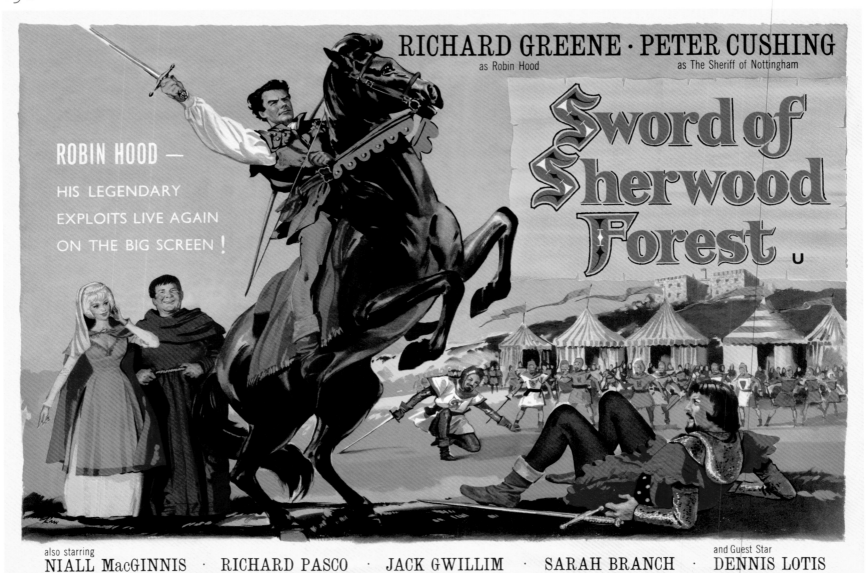

✝ **Sword of Sherwood Forest**
BRITISH 30 x 40 in (76 x 102 cm)

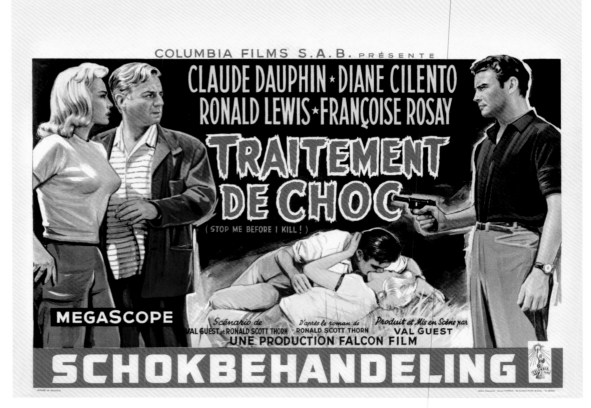

The Full Treatment ⇥
BELGIAN 15 x 20 in (38 x 50 cm)

The Full Treatment (aka **Stop Me Before I Kill!**) ⇥ ⇥
US 41 x 27 in (104 x 69 cm)

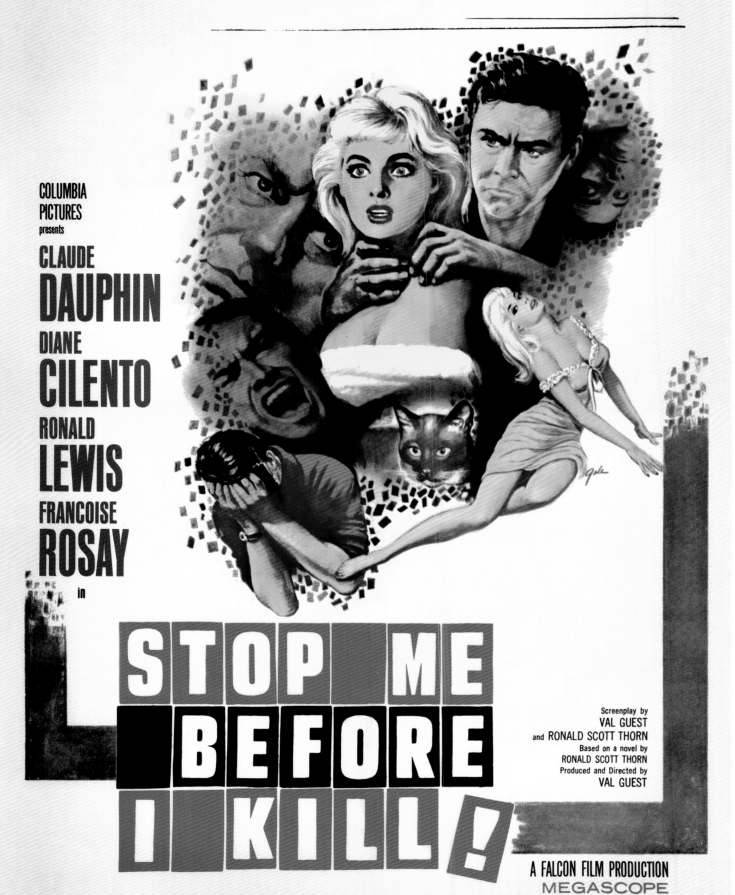

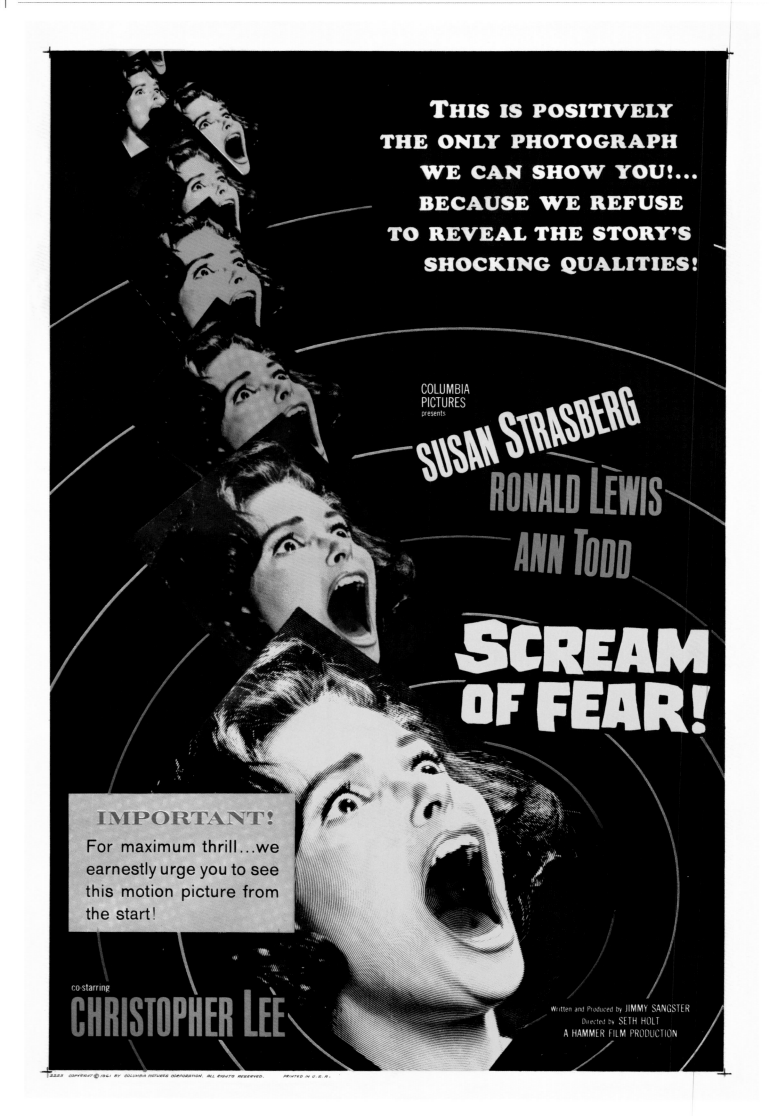

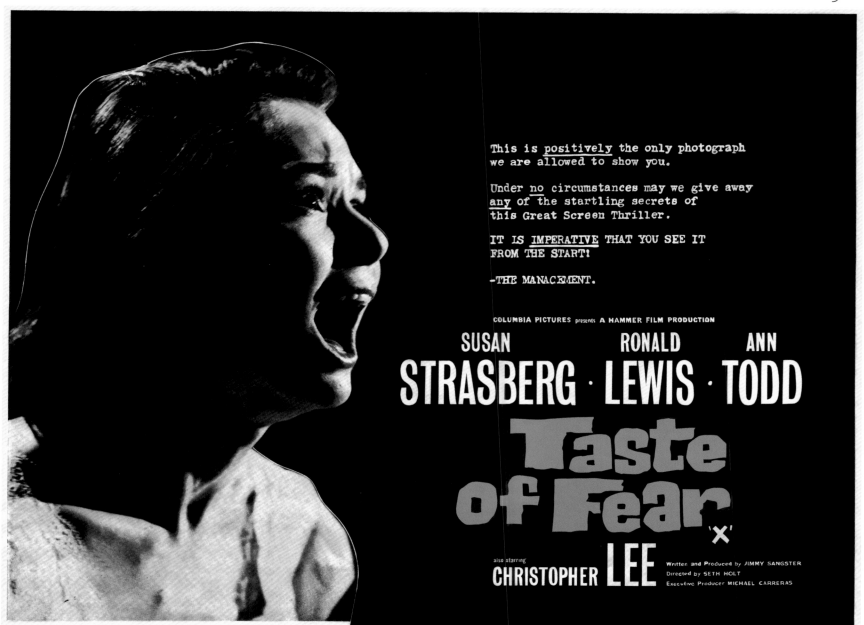

This is positively the only photograph we are allowed to show you.

Under no circumstances may we give away any of the startling secrets of this Great Screen Thriller.

IT IS IMPERATIVE THAT YOU SEE IT FROM THE START!

—THE MANAGEMENT.

COLUMBIA PICTURES presents A HAMMER FILM PRODUCTION

SUSAN **STRASBERG** · RONALD **LEWIS** · ANN **TODD**

Taste of Fear 'X'

also starring CHRISTOPHER **LEE**

Written and Produced by JIMMY SANGSTER
Directed by SETH HOLT
Executive Producer MICHAEL CARRERAS

✠ **Taste of Fear**
BRITISH 30 x 40 in (76 x 102 cm)

✦ **Taste of Fear** (aka **Scream of Fear**)
US 41 x 27 in (104 x 69 cm)

This outstanding one-sheet was commended as the best of 1961 by the Motion Picture Association of America.

Taste of Fear ✦
BELGIAN 19 x 14 in (47 x 36 cm)

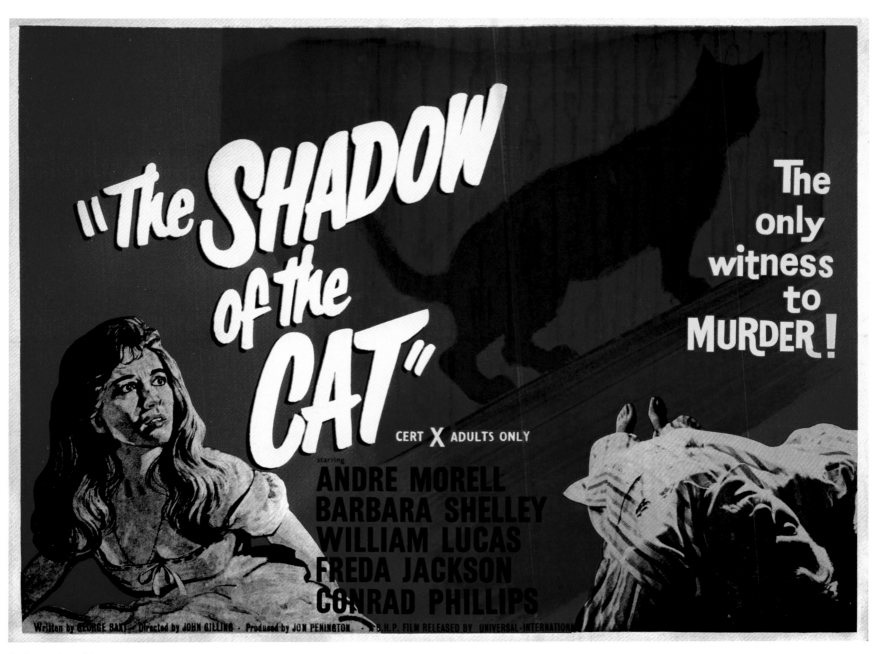

✝ **The Shadow of the Cat**
BRITISH 30 x 40 in (76 x 102 cm)
Illustration by Bill Wiggins

⇤ **A Weekend With Lulu**
US 41 x 27 in (104 x 69 cm)

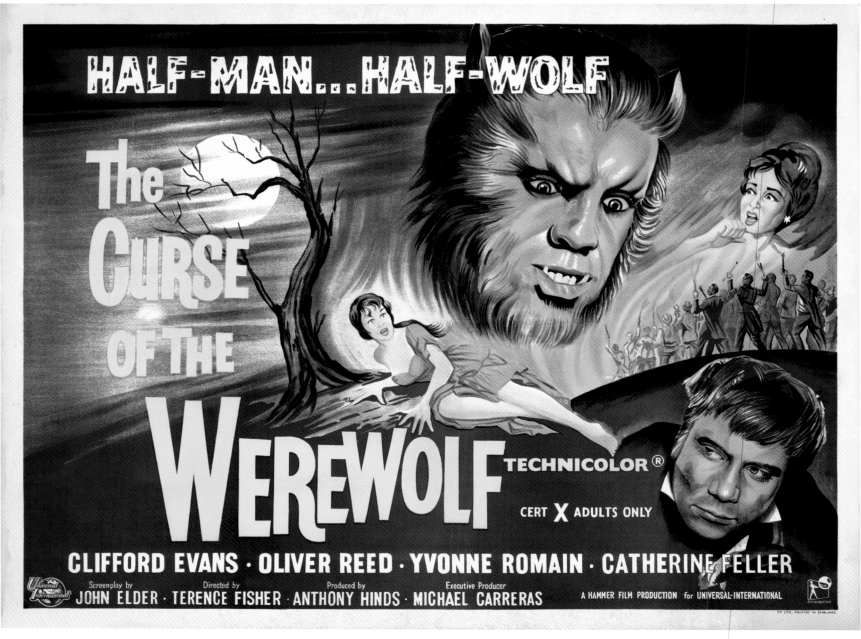

† The Curse of the Werewolf
BRITISH 30 x 40 in (76 x 102 cm)
Illustration by Bill Wiggins

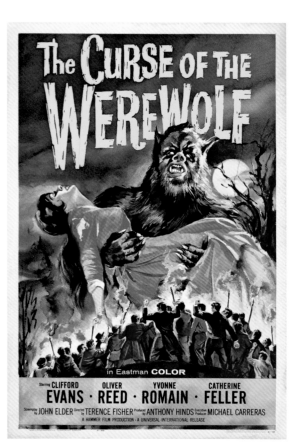

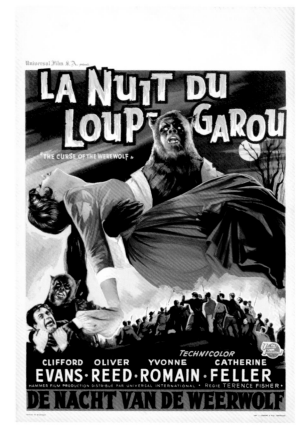

⊕⊕ The Curse of the Werewolf
US 41 x 27 in (104 x 69 cm)

⊕ The Curse of the Werewolf
BELGIAN 21 x 14 in (54 x 36 cm)

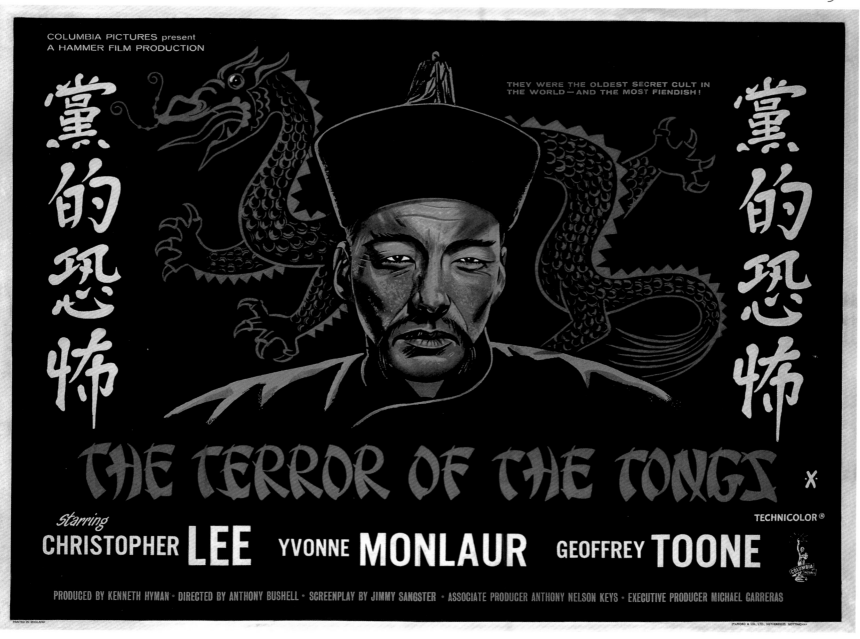

✠ **The Terror of the Tongs**
BRITISH 30 x 40 in (76 x 102 cm)
Illustration by John Stockle

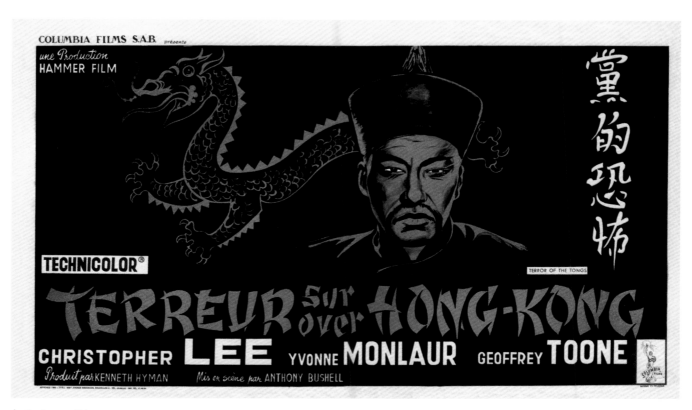

✠ **The Terror of the Tongs**
BELGIAN 14 x 21 in (36 x 54 cm)

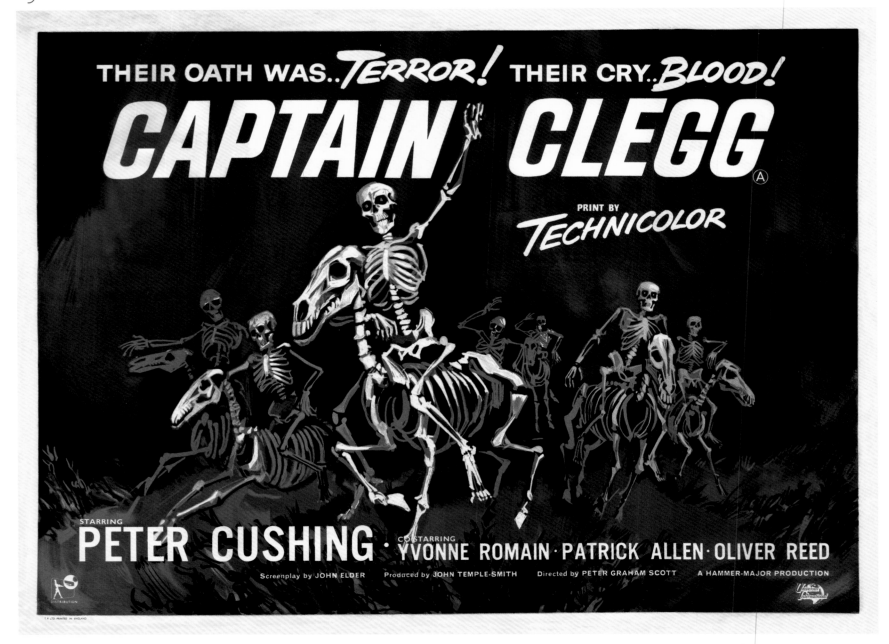

† Captain Clegg
BRITISH 30 x 40 in (76 x 102 cm)
Illustration by Renato Fratini

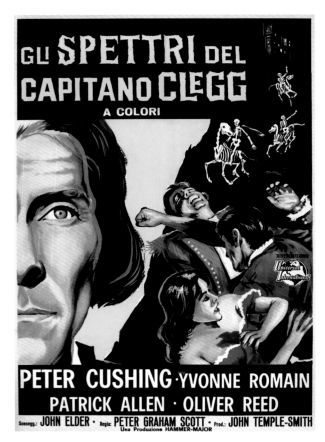

⊕ Captain Clegg
ITALIAN 39 x 28 in (99 x 71 cm)

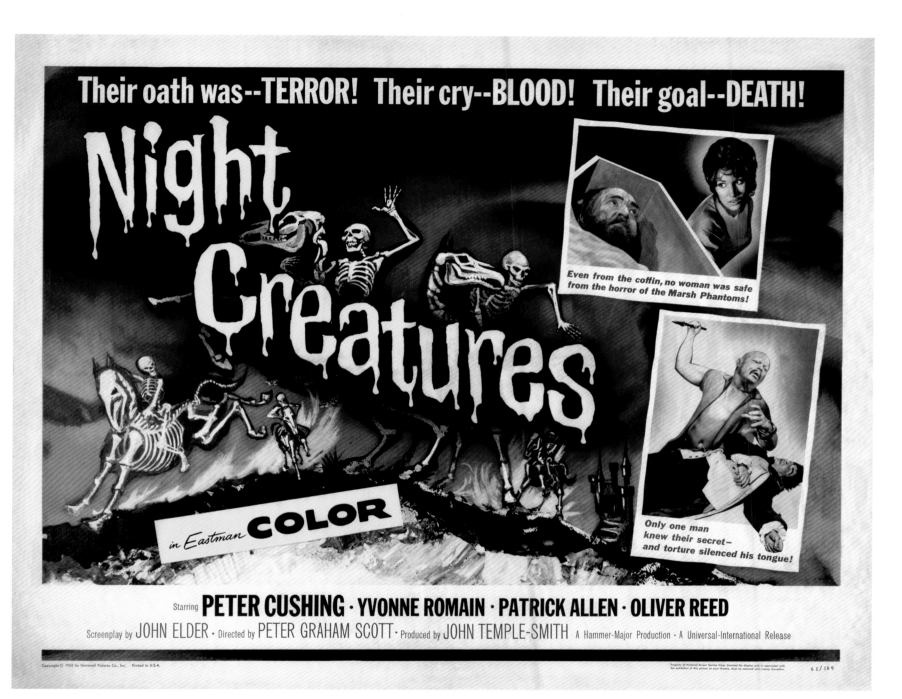

† **Captain Clegg** (aka **Night Creatures**)
US 22 x 28 in (56 x 71 cm)

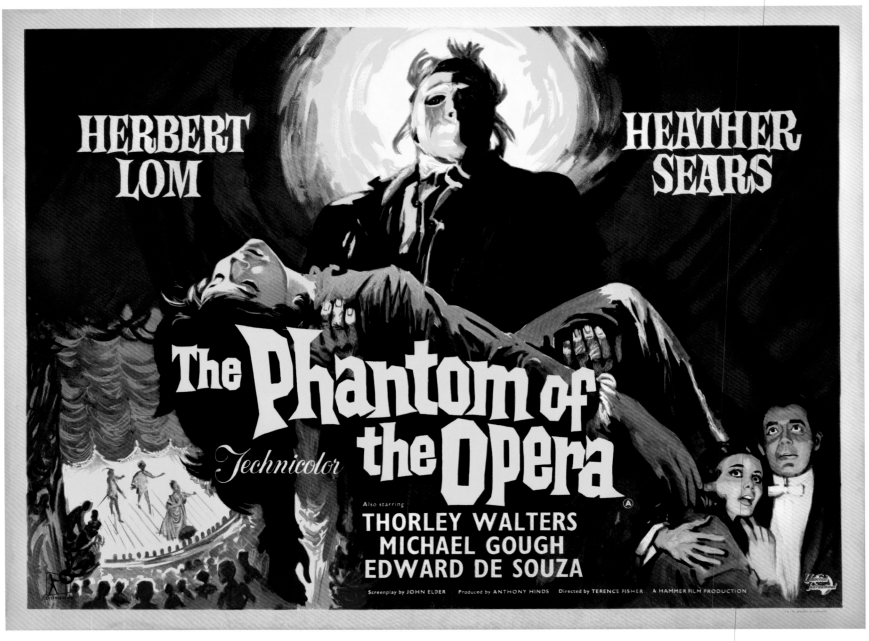

✝ **The Phantom of the Opera**
BRITISH 30 x 40 in (76 x 102 cm)
Illustration by Renato Fratini

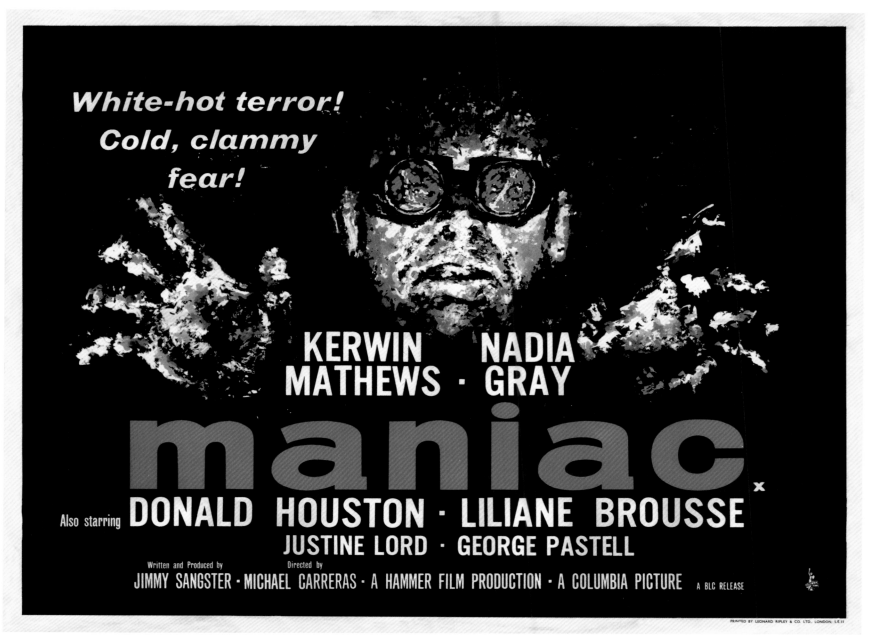

✞ **Maniac**
BRITISH 30 x 40 in (76 x 102 cm)

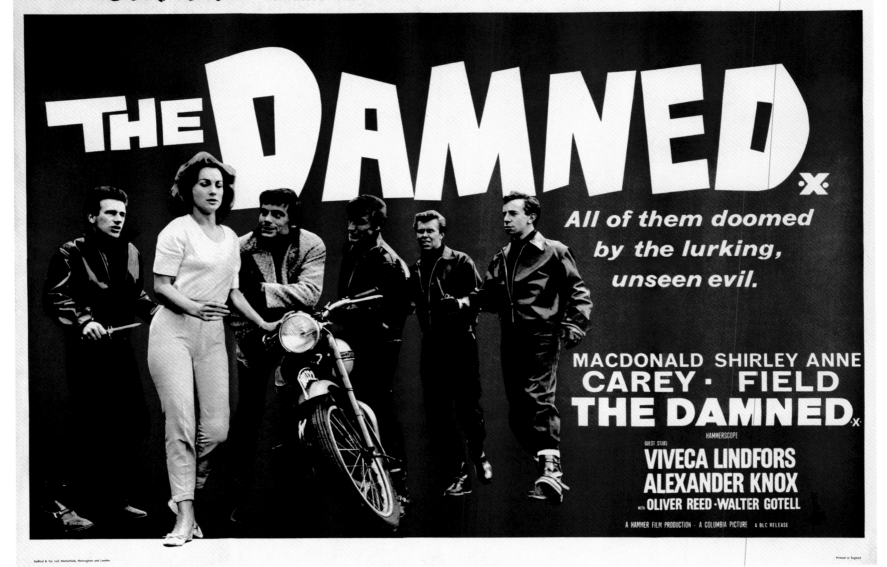

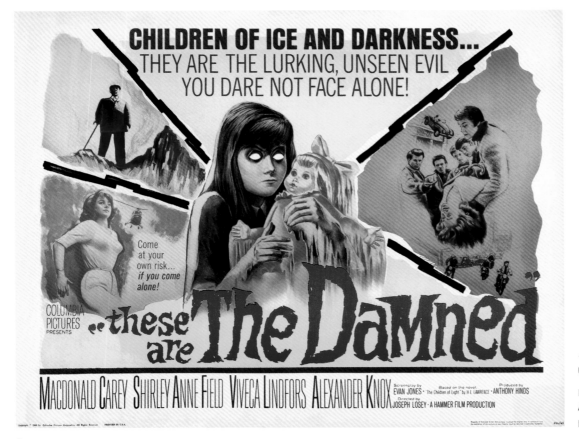

✝ **The Damned**
BRITISH 30 x 40 in (76 x 102 cm)
Design by John Stockle

Frustrated with the quality of the stills he was receiving from Hammer, John Stockle spent a day on location in Weymouth with unit photographer Tom Edwards during the filming of *The Damned*. Stockle selected one of the pictures from that session for use on the Quad Crown poster, even though it bore no resemblance to any of the scenes in the film.

⚜ **The Damned** (aka **These Are The Damned**)
US 22 x 28 in (56 x 71 cm)

In contrast with the British posters, the American marketing campaign for *The Damned* presented the film as a science fiction thriller.

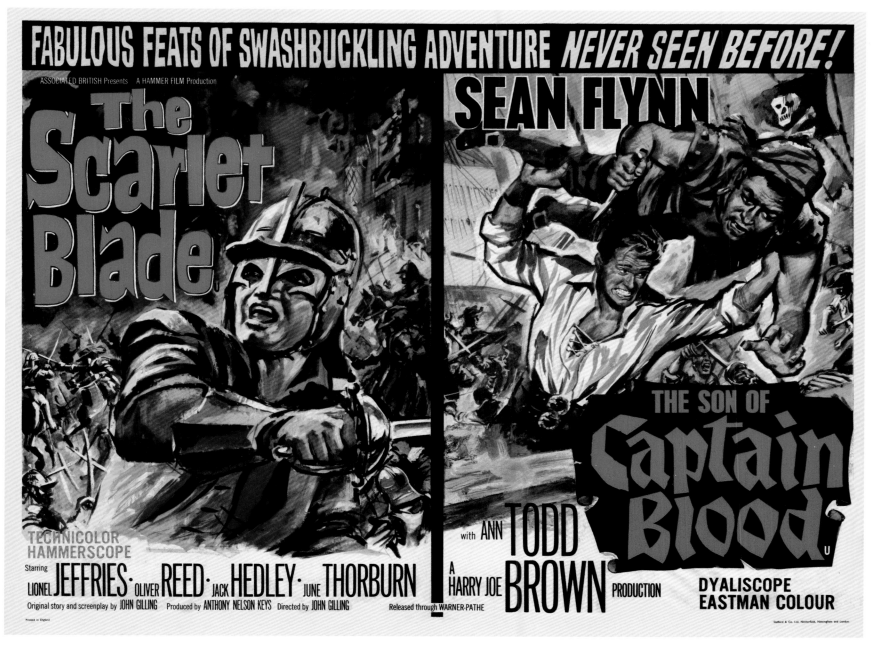

✣ **The Scarlet Blade/The Son of Captain Blood**
BRITISH 30 x 40 in (76 x 102 cm)
Illustration by Tom Chantrell

Sometimes the most colourful British poster art was reserved for double-bills where a Hammer film was paired with another picture handled by the same distributor. In this instance, Hammer's *The Scarlet Blade* sat alongside *The Son of Captain Blood*.

The title lettering on this poster is highlighted in daylight fluorescent DayGlo ink. Either applied during the screen-printing process, or added as a fifth colour in addition to cyan, magenta, yellow and black during lithographic printing, the use of lurid DayGlo became commonplace on Hammer's posters during the 1960s.

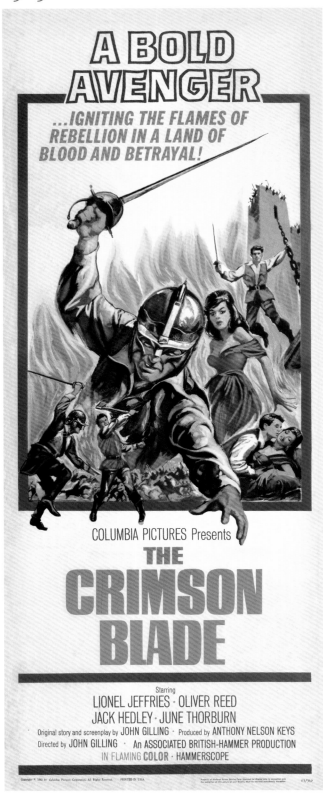

† **The Scarlet Blade** (aka **The Crimson Blade**)
US 36 x 14 in (91 x 36 cm)

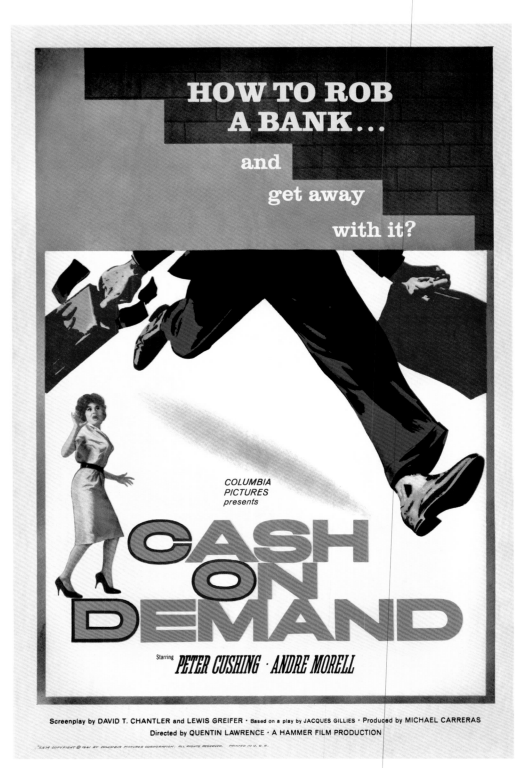

† **Cash On Demand**
US 41 x 27 in (104 x 69 cm)

Paranoiac ⊹†
US 41 x 27 in (104 x 69 cm)

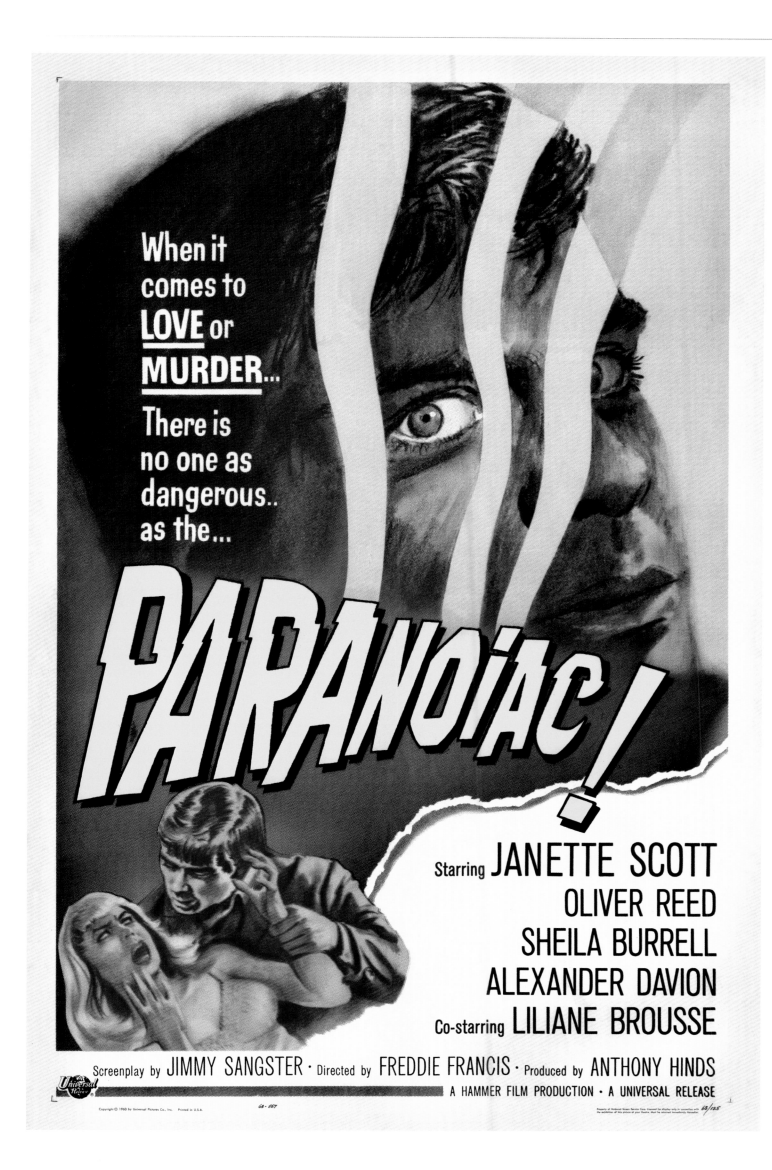

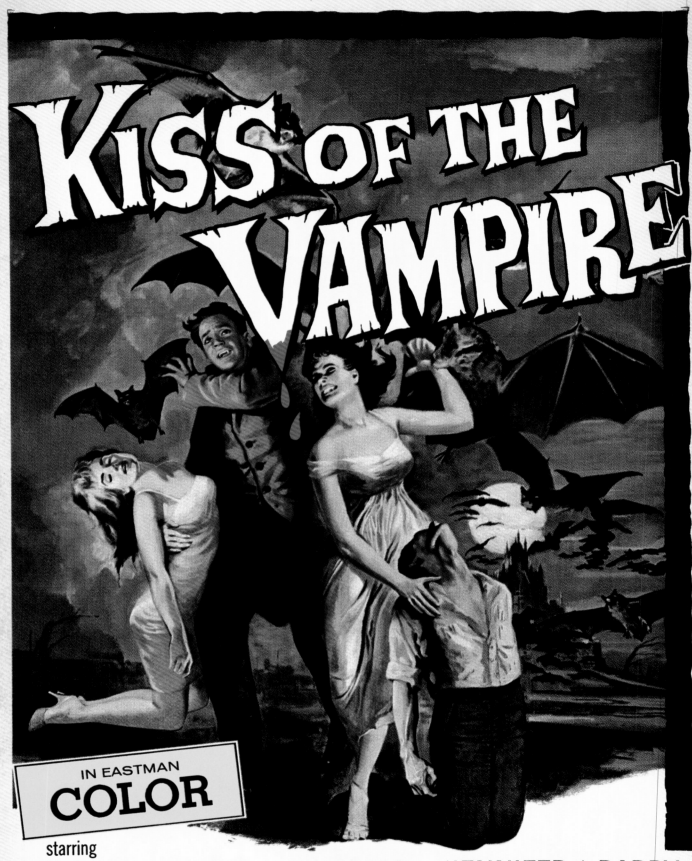

KISS OF THE VAMPIRE

IN EASTMAN COLOR

starring
CLIFFORD / NOEL / EDWARD / JENNIFER / BARRY
EVANS / WILLMAN / DE SOUZA / DANIEL / WARREN

Screenplay by JOHN ELDER · Directed by DON SHARP
Produced by ANTHONY HINDS · A Hammer Film Production

A Universal Release

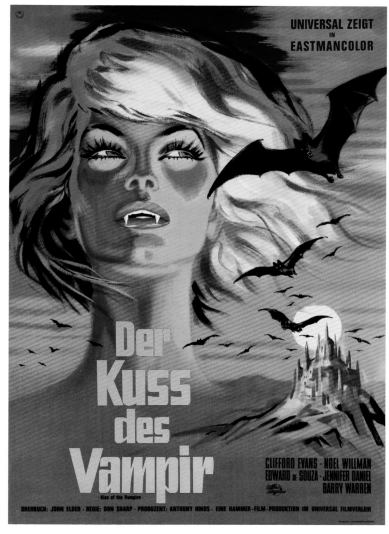

✝ **The Kiss of the Vampire**
GERMAN 34 x 22 in (85 x 56 cm)

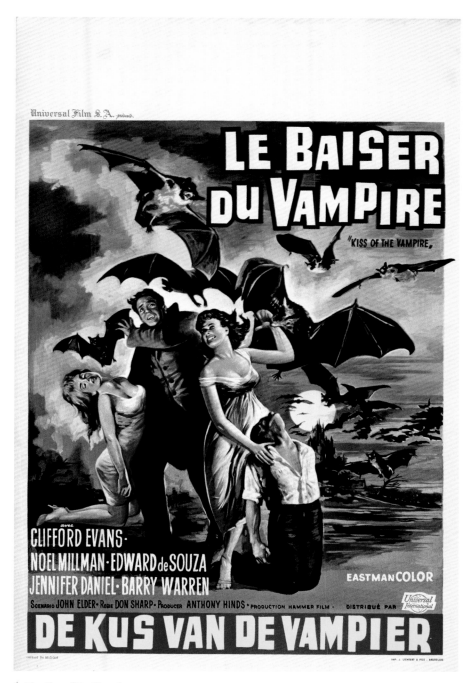

✝ **The Kiss of the Vampire**
BELGIAN 21 x 14 in (54 x 36 cm)

⚜ **The Kiss of the Vampire**
US 41 x 27 in (104 x 69 cm)
Illustration by Joe Smith

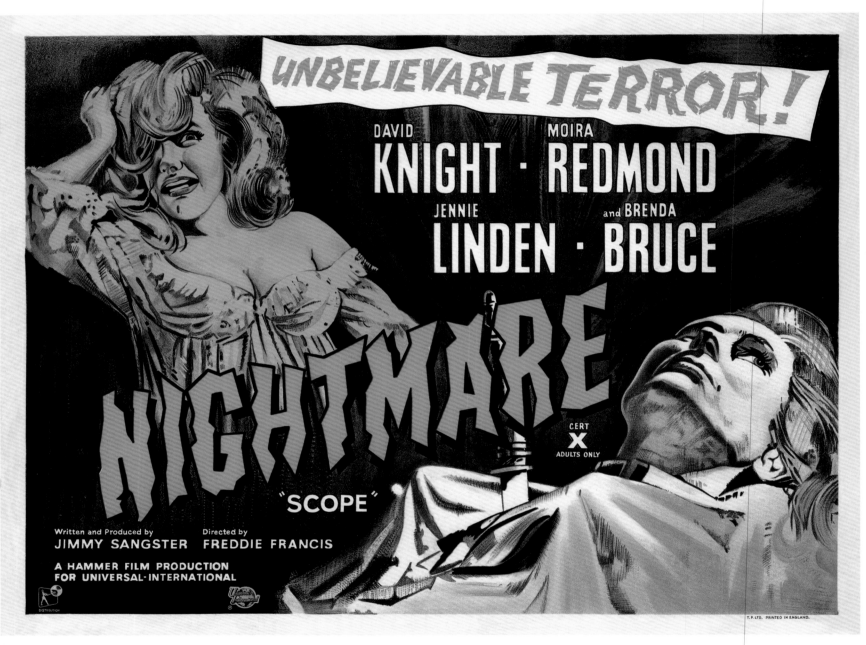

✝ **Nightmare**
BRITISH 30 x 40 in (76 x 102 cm)

Nightmare ↦
US 41 x 27 in (104 x 69 cm)

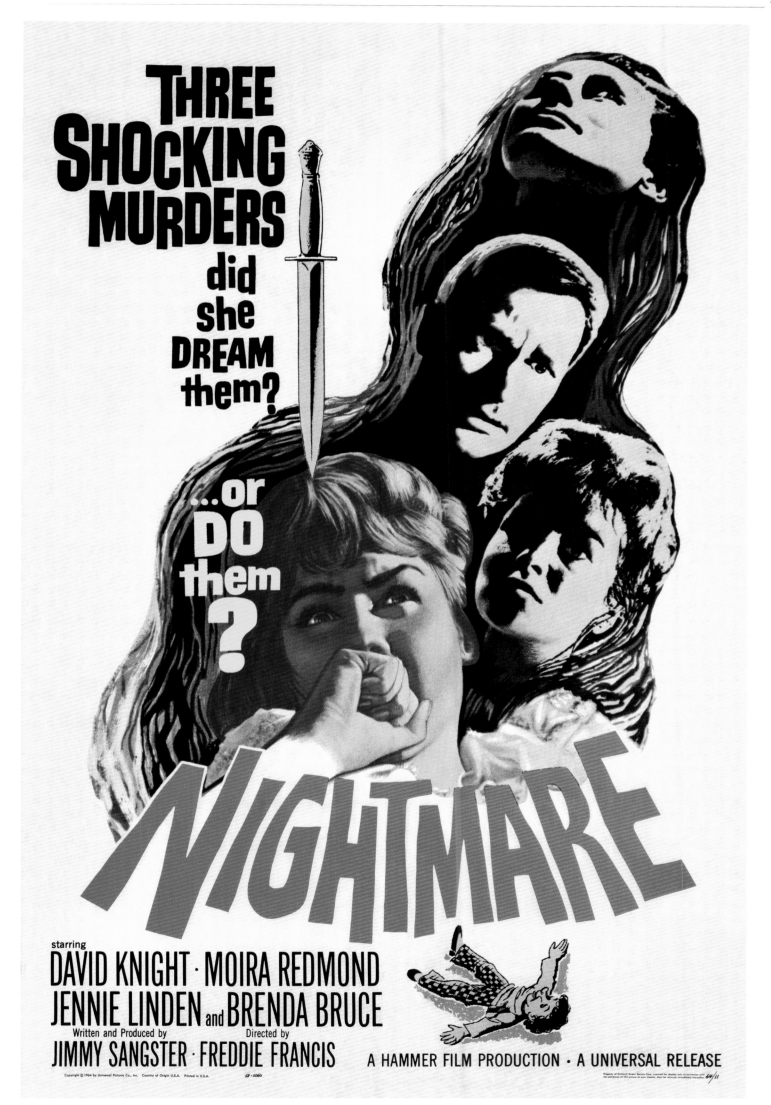

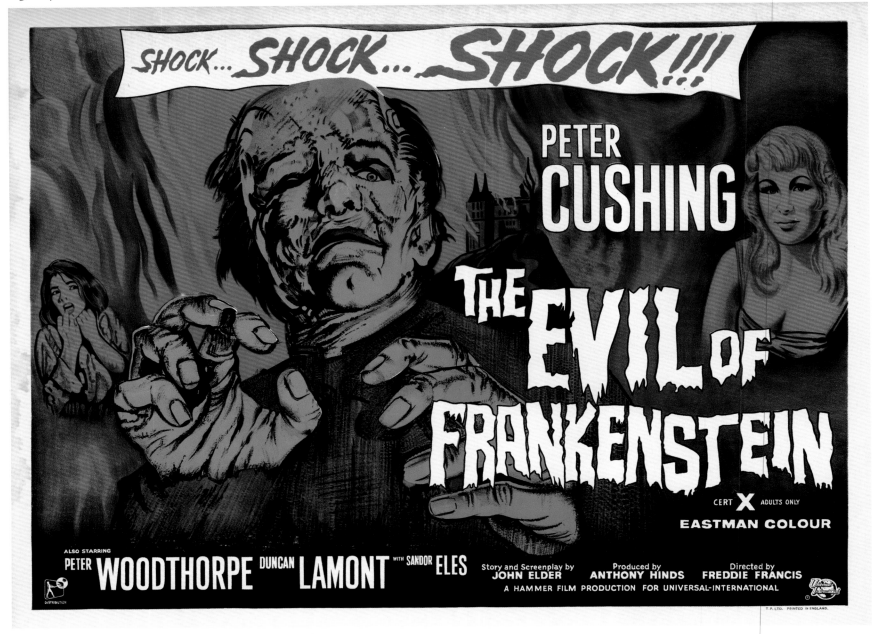

✟ **The Evil of Frankenstein**
BRITISH 30 x 40 in (76 x 102 cm)

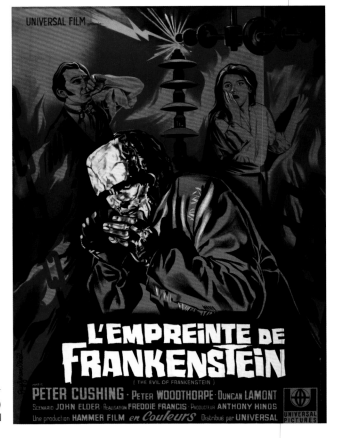

The Evil of Frankenstein ✈
FRENCH 63 x 47 in (160 x 120 cm)
Illustration by Guy Gerard Noel

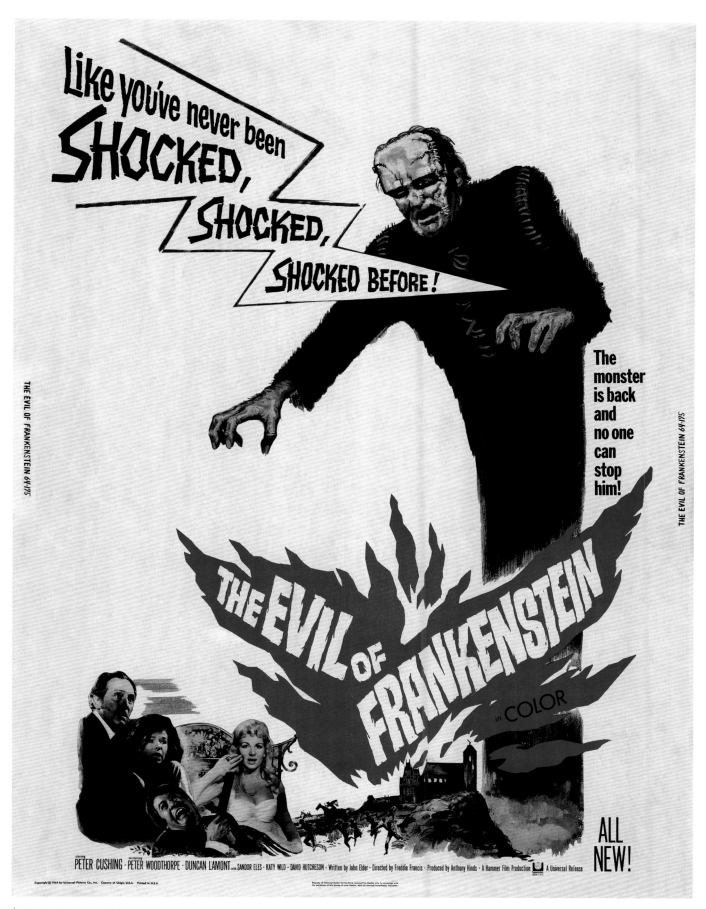

✝ **The Evil of Frankenstein**
US 41 x 27 in (104 x 69 cm)

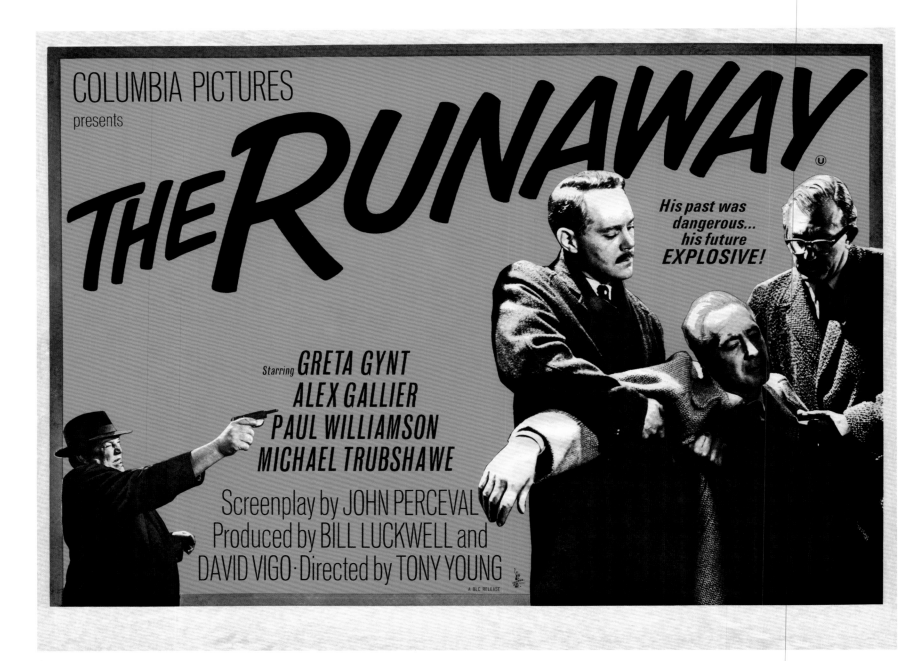

✝ **The Runaway**
BRITISH 30 x 40 in (76 x 102 cm)

There are more examples of DayGlo
colouring on this spread. The first is a
poster for one of several co-productions
on which Hammer did not receive a credit.

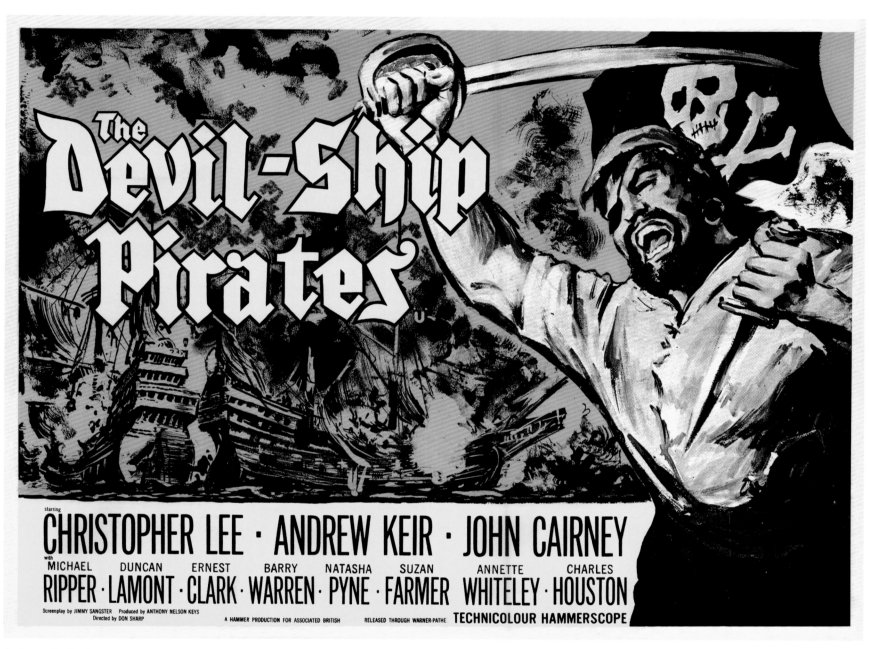

✝ **The Devil-Ship Pirates**
BRITISH 30 x 40 in (76 x 102 cm)
Illustration by Tom Chantrell

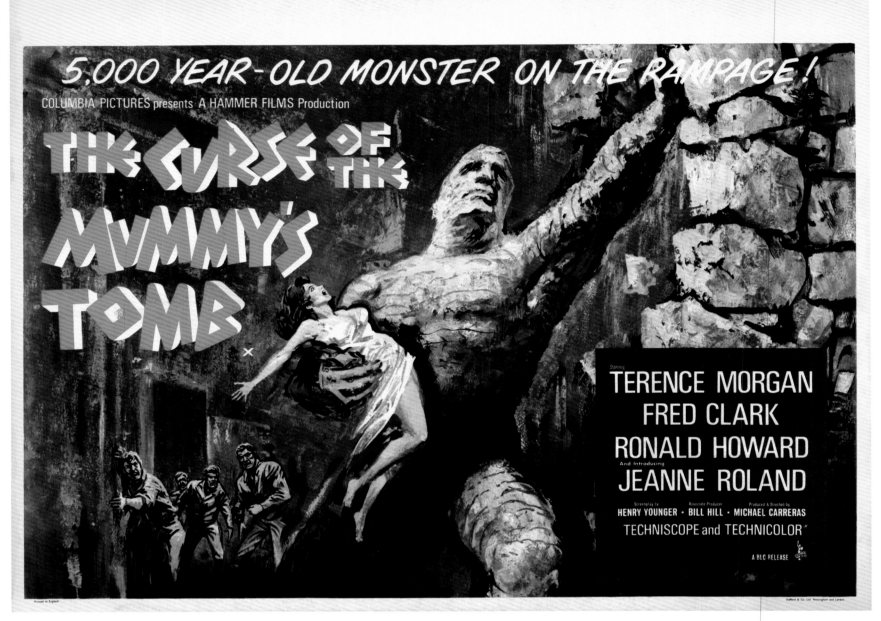

The Curse of the Mummy's Tomb
BRITISH 30 x 40 in (76 x 102 cm)

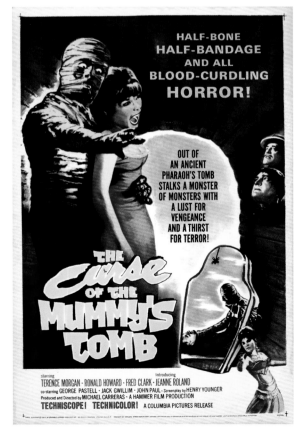

The Curse of the Mummy's Tomb
US 41 x 27 in (104 x 69 cm)

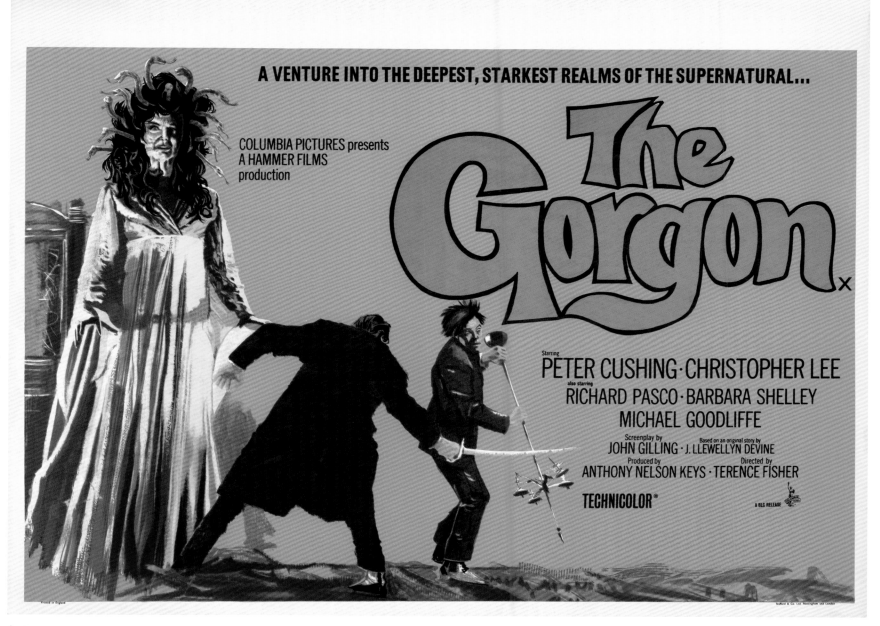

✠ The Gorgon
BRITISH 30 x 40 in (76 x 102 cm)

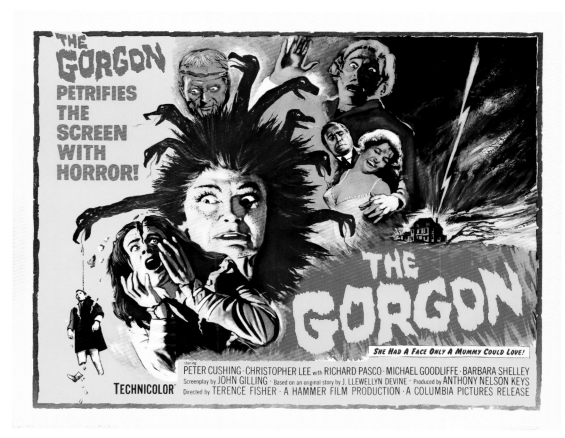

The Gorgon ✈
US 22 x 28 in (56 x 71 cm)

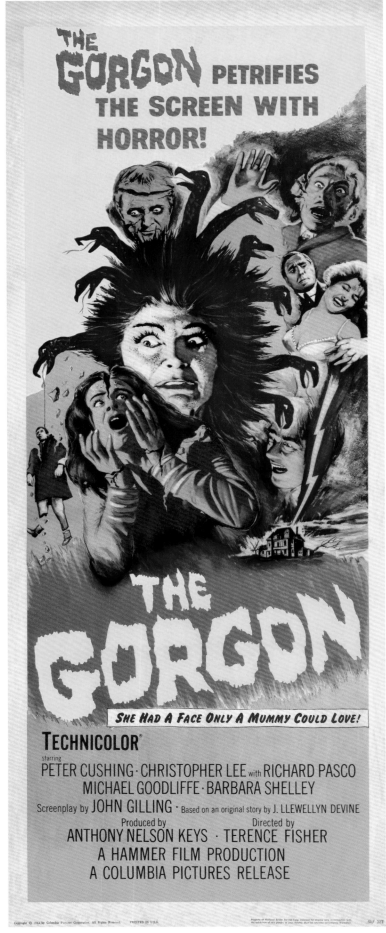

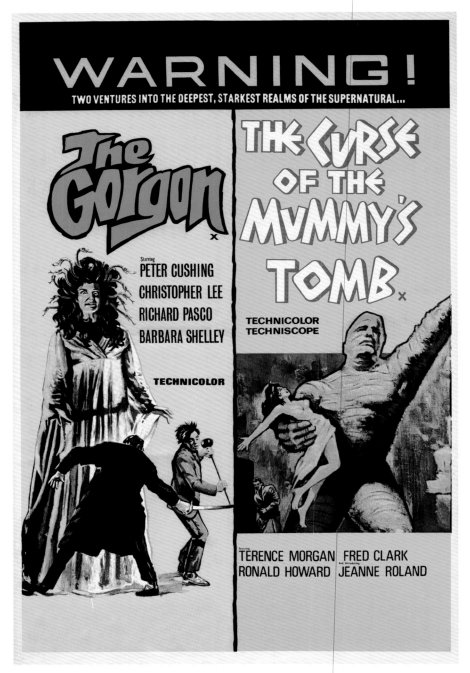

✝ **The Gorgon**
US 36 x 14 in (91 x 36 cm)

✝ **The Gorgon/The Curse of the Mummy's Tomb**
BRITISH 30 x 20 in (76 x 51 cm)

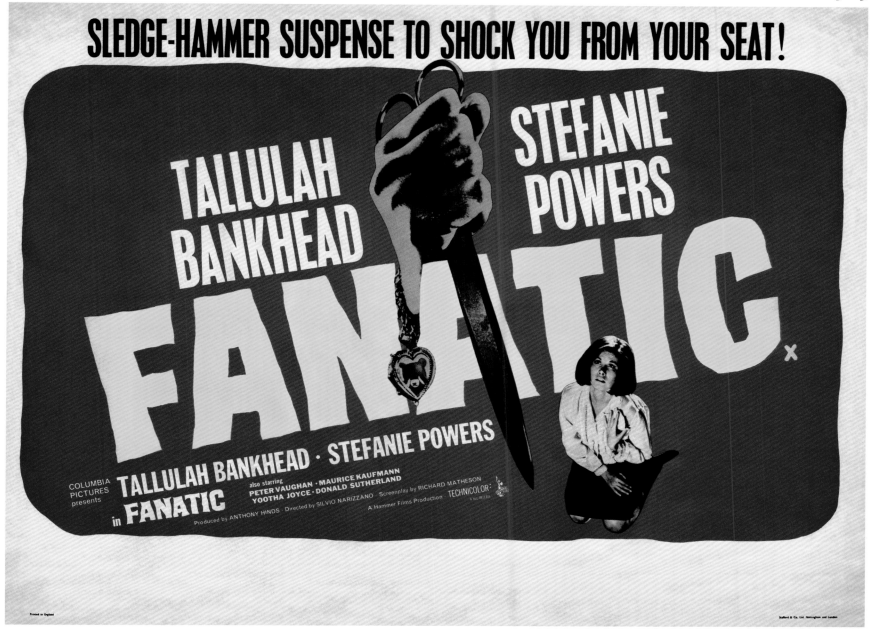

† Fanatic
BRITISH 30 x 40 in (76 x 102 cm)

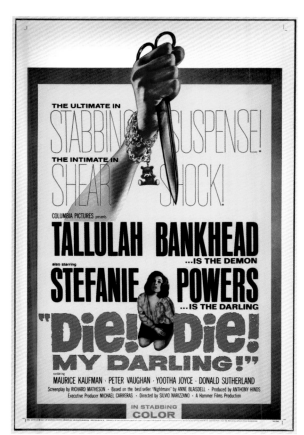

Fanatic (aka **Die! Die! My Darling!**) ⇥
US 41 x 27 in (104 x 69 cm)

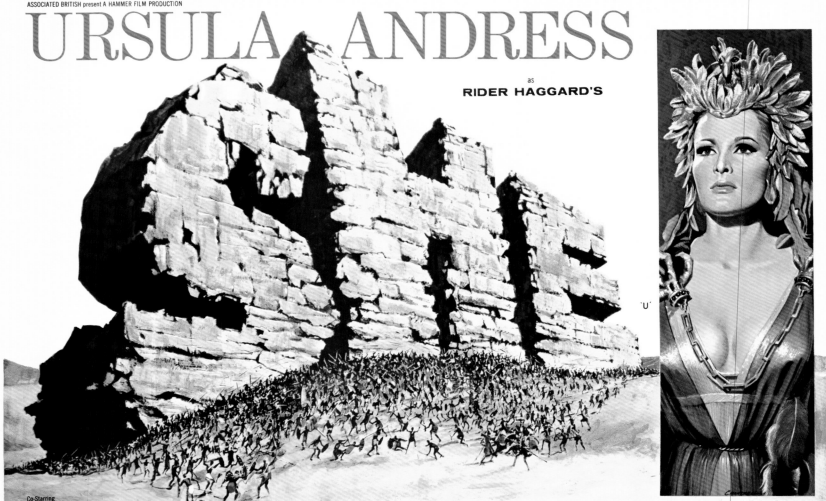

⚔ She
BRITISH 30 x 40 in (76 x 102 cm)
Illustration by Tom Chantrell

This collectable poster owes an obvious debt to the then-recent marketing campaign for *Zulu*. The brazen tagline is one of the most memorable to grace any Hammer poster.

She ➤⚔
US 41 x 27 in (104 x 69 cm)

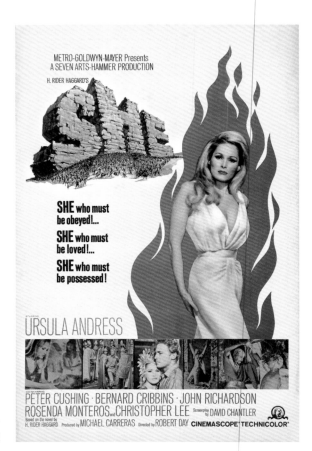

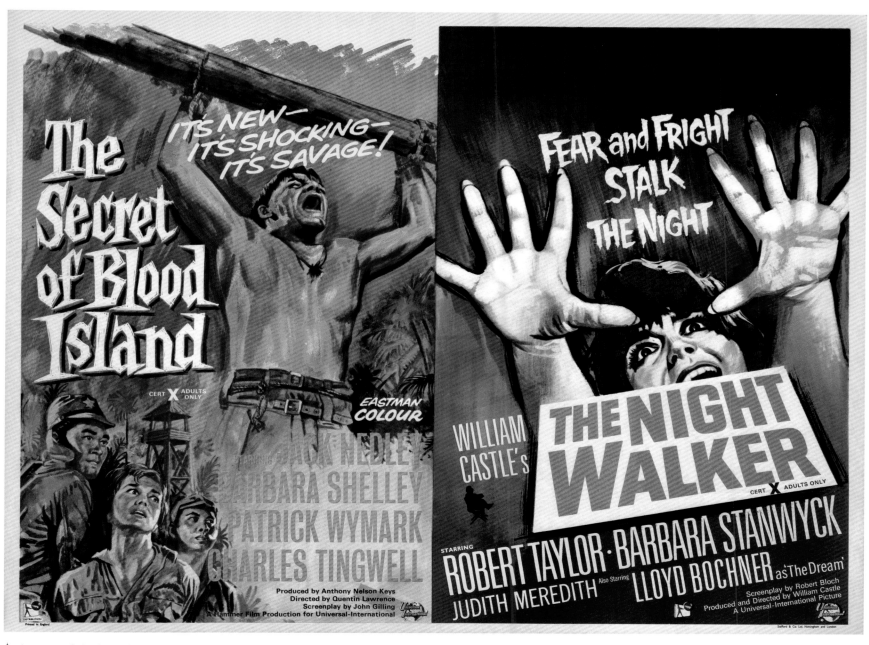

✝ **The Secret of Blood Island/The Night Walker**
BRITISH 30 x 40 in (76 x 102 cm)

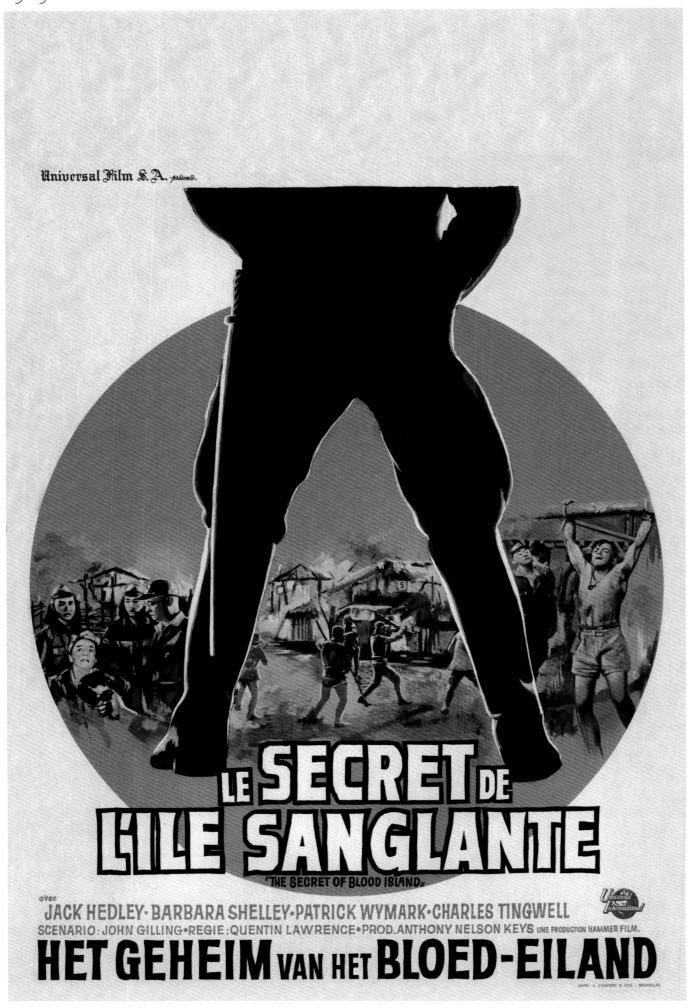

† The Secret of Blood Island
BELGIAN 21 x 14 in (53 x 35 cm)

Hysteria ⇥
US 41 x 27 in (104 x 69 cm)

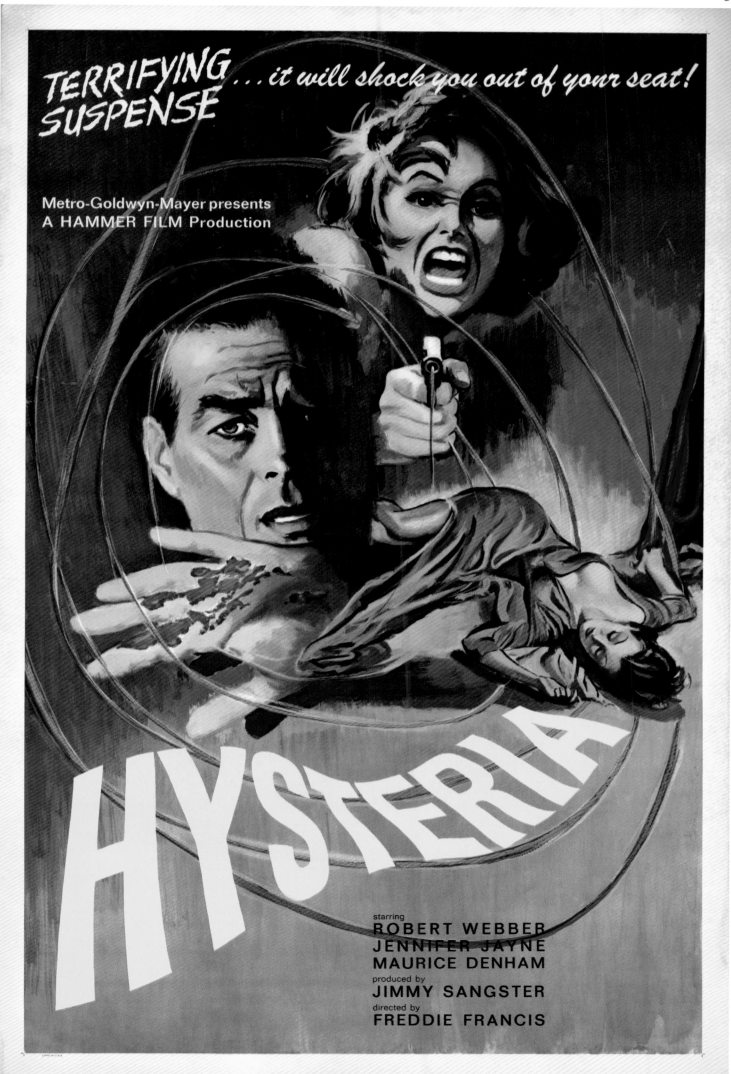

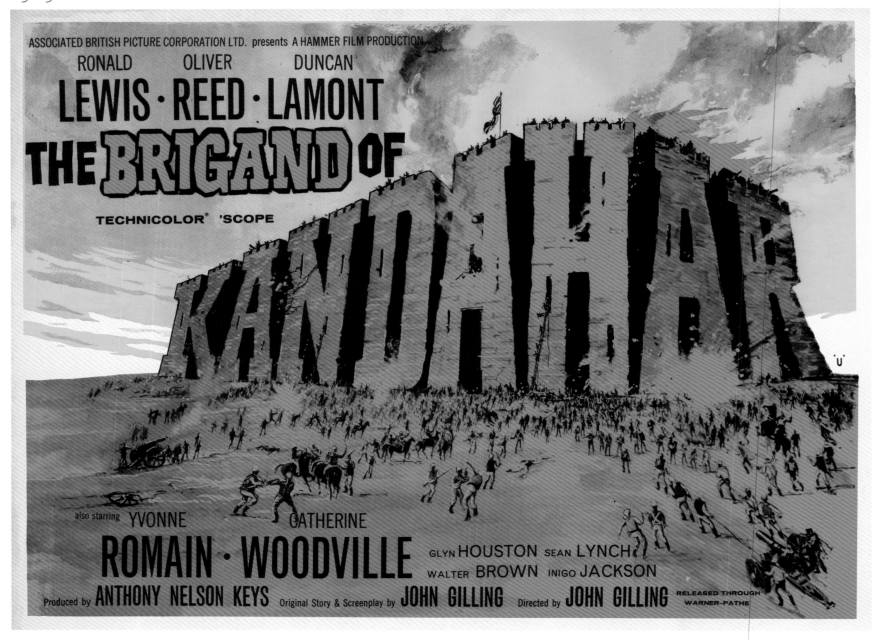

The Brigand of Kandahar
BRITISH 30 x 40 in (76 x 102 cm)
Illustration by Tom Chantrell

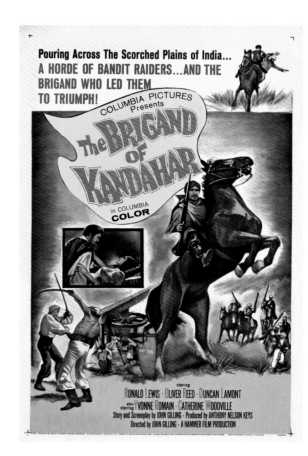

The Brigand of Kandahar
US 41 x 27 in (104 x 69 cm)

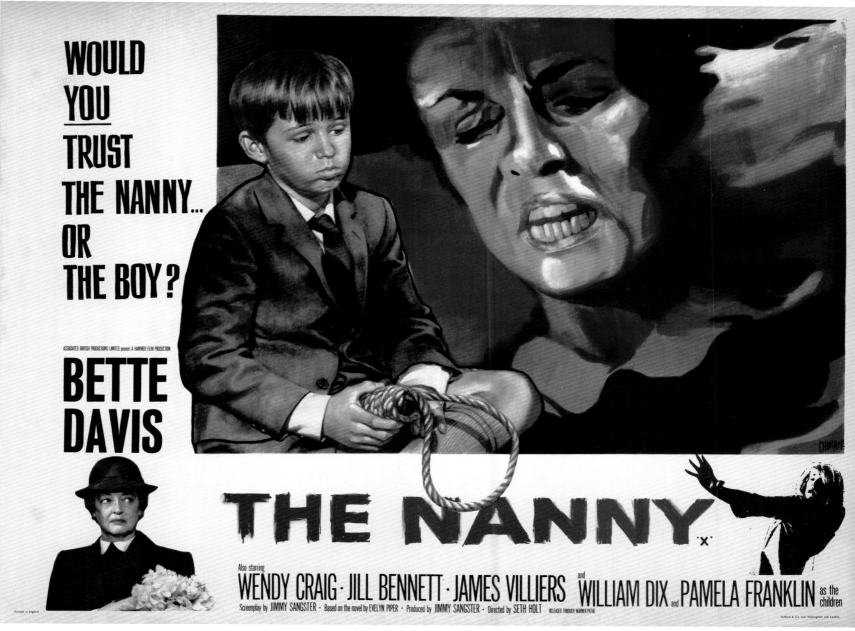

† The Nanny
BRITISH 30 x 40 in (76 x 102 cm)
Illustration by Tom Chantrell

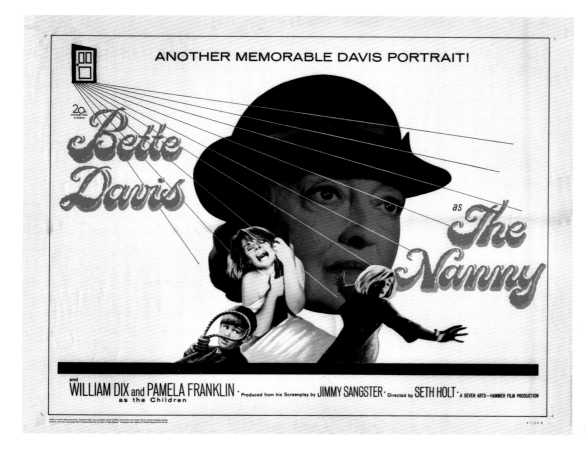

☩ The Nanny
US 22 x 28 in (56 x 71 cm)

ANOTHER MEMORABLE DAVIS PORTRAIT!

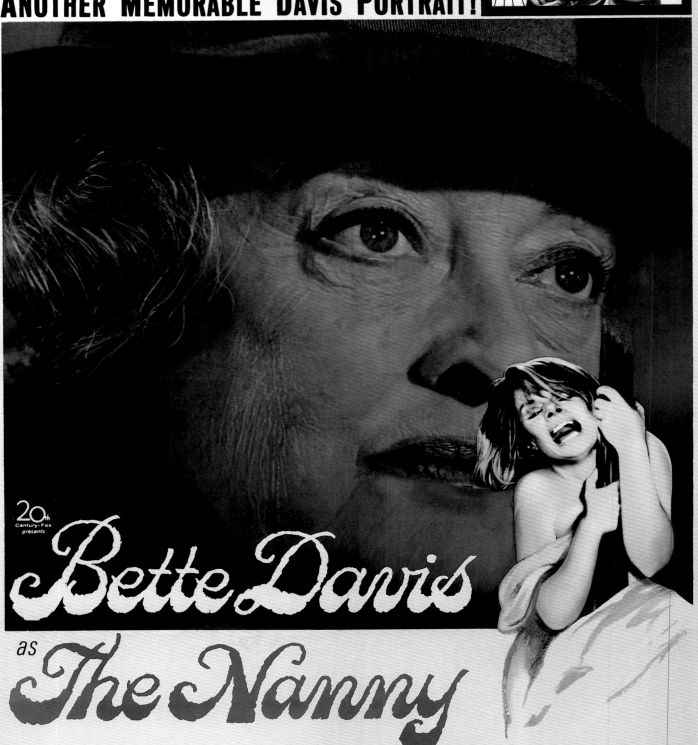

20th
Century-Fox
presents

Bette Davis

as *The Nanny*

and WILLIAM DIX and PAMELA FRANKLIN Produced from his Screenplay by Directed by A SEVEN ARTS—HAMMER
as the Children. JIMMY SANGSTER · SETH HOLT · FILM PRODUCTION

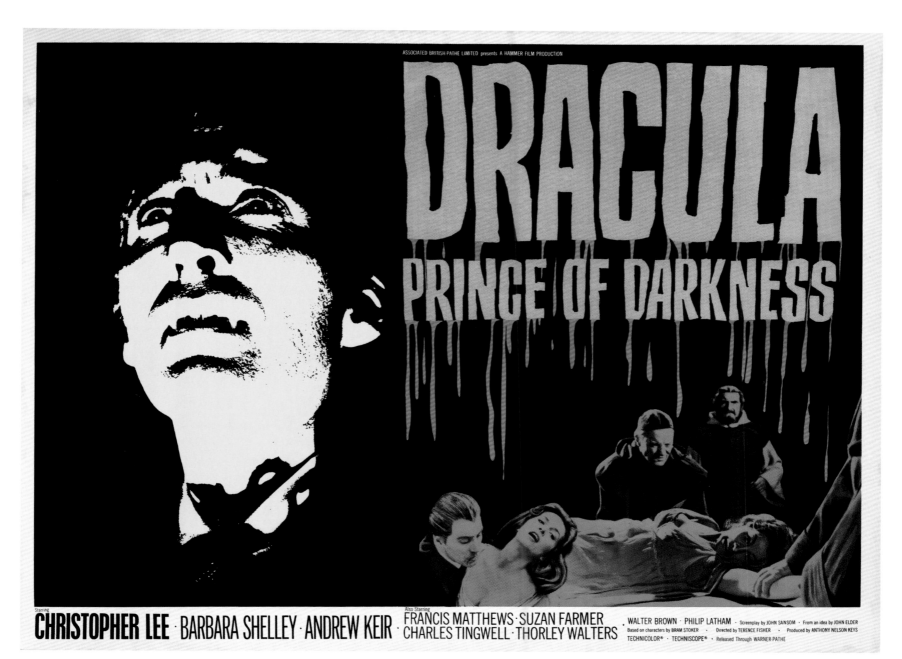

✝ **Dracula Prince of Darkness**
BRITISH 30 x 40 in (76 x 102 cm)
Illustration by Tom Chantrell

This striking Quad Crown was produced for
the UK and Commonwealth territories, so did
not feature any details of British certification.

⚜ **The Nanny**
US 41 x 27 in (104 x 69 cm)

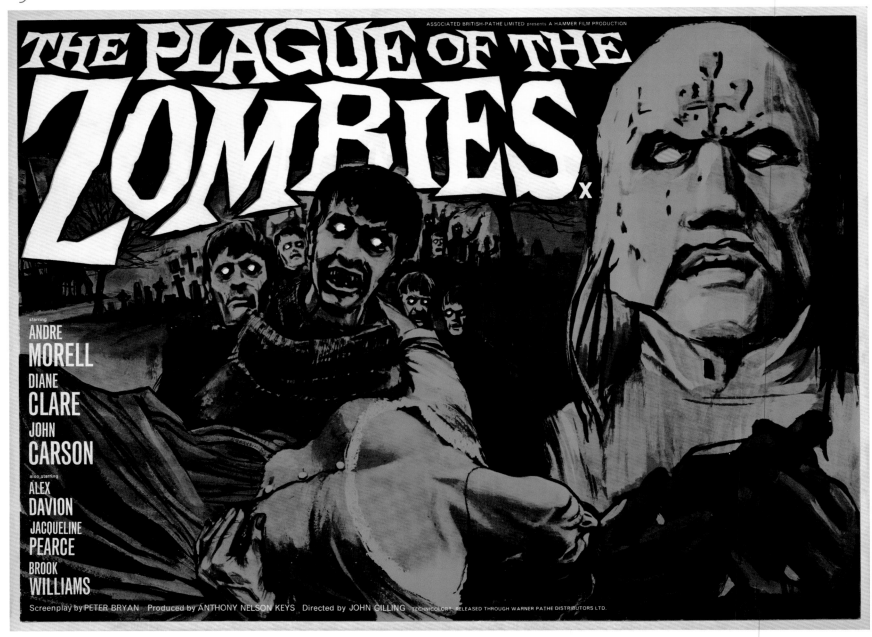

✝ **The Plague of the Zombies**
BRITISH 30 x 40 in (76 x 102 cm)
Illustration by Tom Chantrell

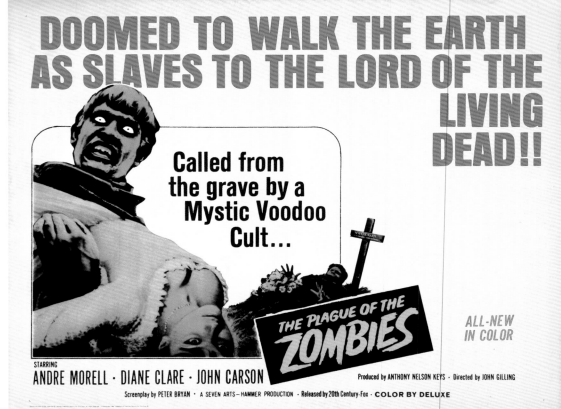

The Plague of the Zombies ✝
US 22 x 28 in (56 x 71 cm)

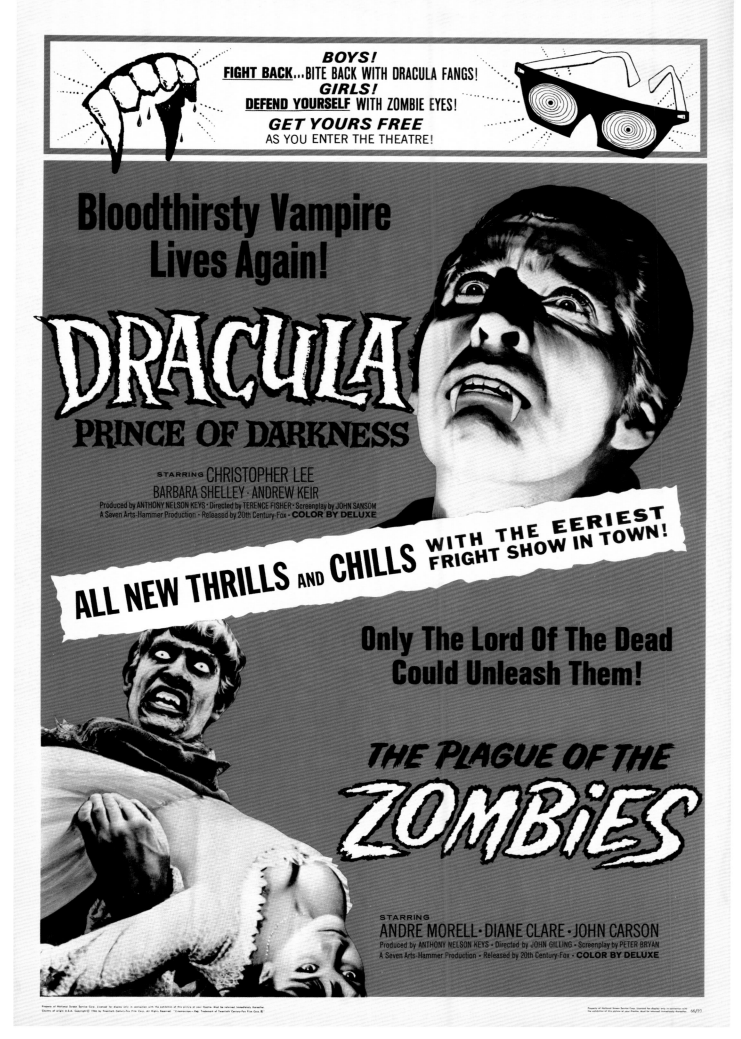

66/73

† **Dracula Prince of Darkness / The Plague of the Zombies**
US 41 x 27 in (104 x 69 cm)

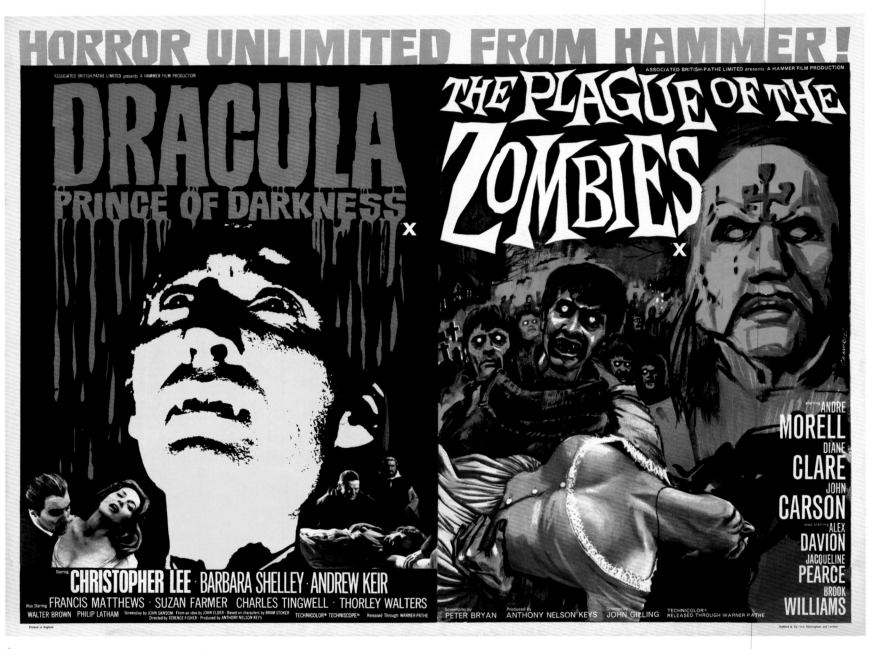

✝ **Dracula Prince of Darkness/The Plague of the Zombies**
BRITISH 30 x 40 in (76 x 102 cm)
Illustration by Tom Chantrell

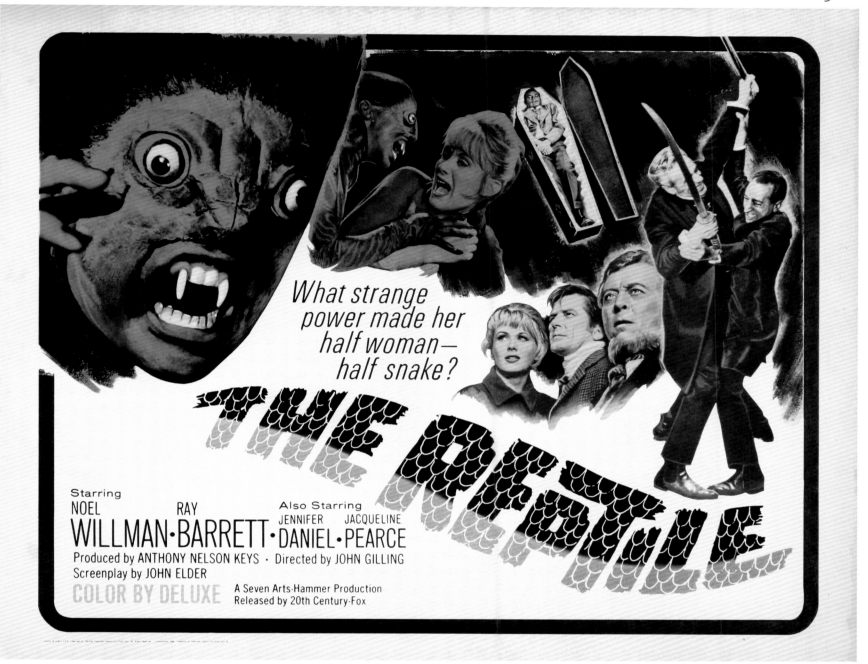

✝ **The Reptile**
US 22 x 28 in (56 x 71 cm)

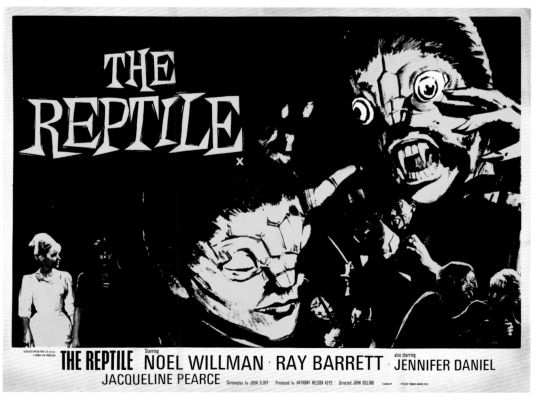

The Reptile ✦
BRITISH 30 x 40 in (76 x 102 cm)
Illustration by Tom Chantrell

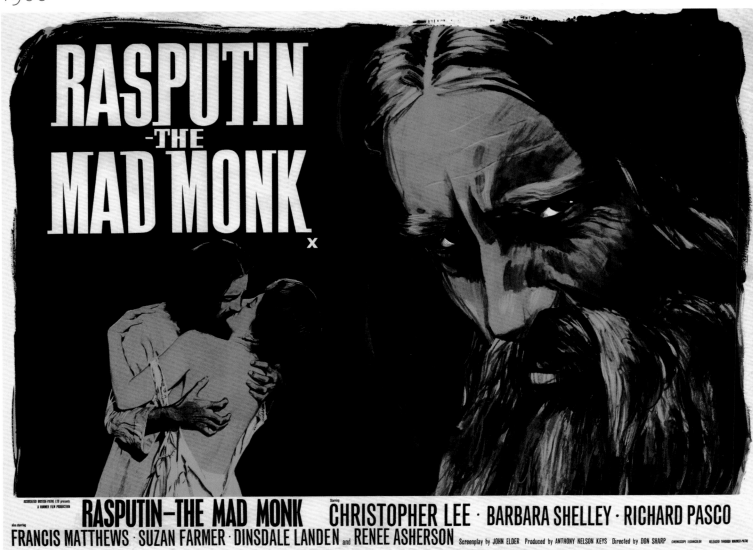

✝ **Rasputin the Mad Monk**
BRITISH 30 x 40 in (76 x 102 cm)
Illustration by Tom Chantrell

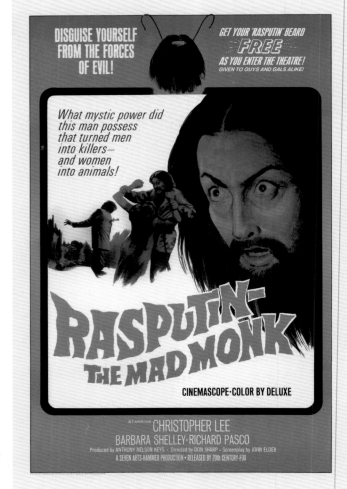

Rasputin the Mad Monk ✈
US 41 x 27 in (104 x 69 cm)

Rasputin the Mad Monk/The Reptile ✈ ✈
BRITISH 60 x 40 in (152 x 102 cm)

This rare double-bill features elements of
Tom Chantrell's art for the above two films,
and was produced for display in subways.

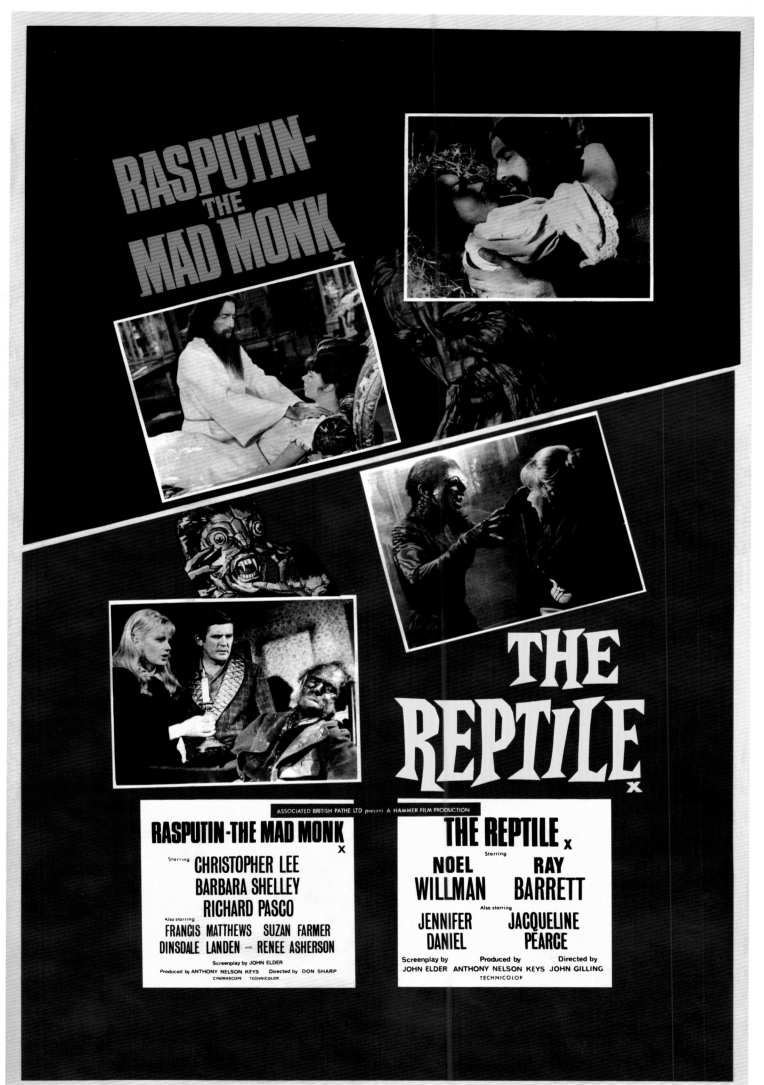

ASSOCIATED BRITISH PATHE LTD present A HAMMER FILM PRODUCTION

RASPUTIN-THE MAD MONK x

Starring **CHRISTOPHER LEE**
BARBARA SHELLEY
RICHARD PASCO

Also starring
FRANCIS MATTHEWS **SUZAN FARMER**
DINSDALE LANDEN AND **RENEE ASHERSON**

Screenplay by JOHN ELDER
Produced by ANTHONY NELSON KEYS Directed by DON SHARP
CINEMASCOPE TECHNICOLOR

THE REPTILE x

Starring
NOEL WILLMAN **RAY BARRETT**

Also starring
JENNIFER DANIEL **JACQUELINE PEARCE**

Screenplay by Produced by Directed by
JOHN ELDER ANTHONY NELSON KEYS JOHN GILLING
TECHNICOLOR

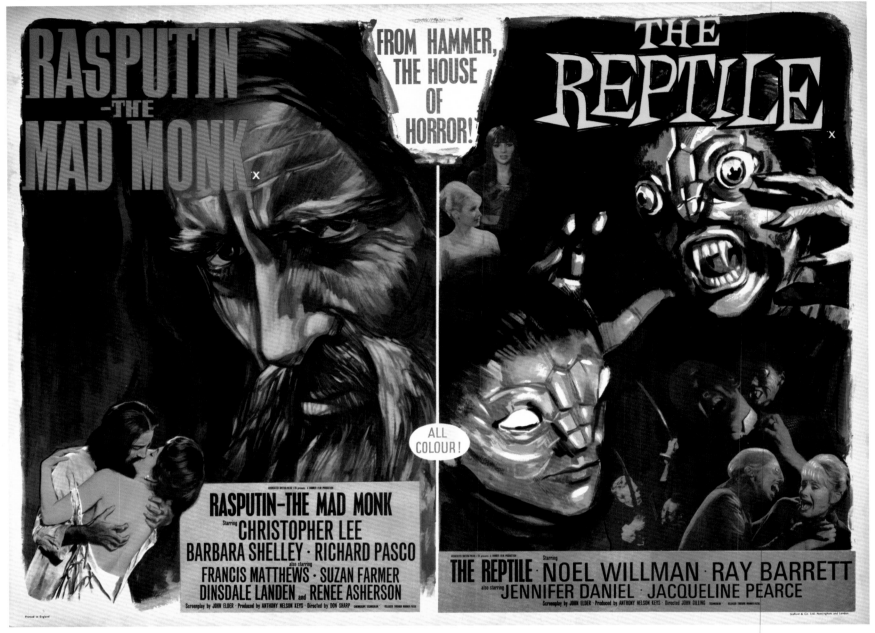

✝ **Rasputin the Mad Monk/The Reptile**
BRITISH 30 x 40 in (76 x 102 cm)
Illustration by Tom Chantrell

This poster promoted a double-bill that opened on 6 March 1966, and was the first time Hammer laid claim to the brand 'The House of Horror'.

Rasputin the Mad Monk/The Reptile ✝
BRITISH 30 x 40 in (76 x 102 cm)
Illustration by Tom Chantrell

In 1964 Hammer struck a long-term deal with ABPC (the Associated British Picture Corporation) for British and Commonwealth theatrical distribution. Films were screened by the distributor's ABC (Associated British Cinemas) chain, and numerous poster designs were specially adapted to accommodate the ABC banner.

Rasputin the Mad Monk/The Reptile ✝ ✝
US 41 x 27 in (104 x 69 cm)

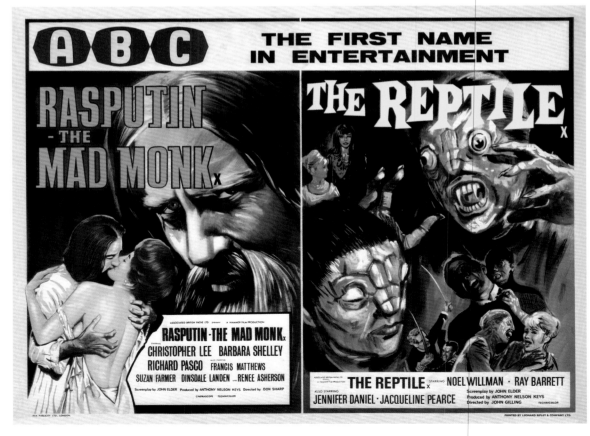

DISGUISE YOURSELF FROM THE FORCES OF EVIL!

GET YOUR "RASPUTIN" BEARD FREE AS YOU ENTER THE THEATRE!

GIVEN TO GUYS AND GALS ALIKE!

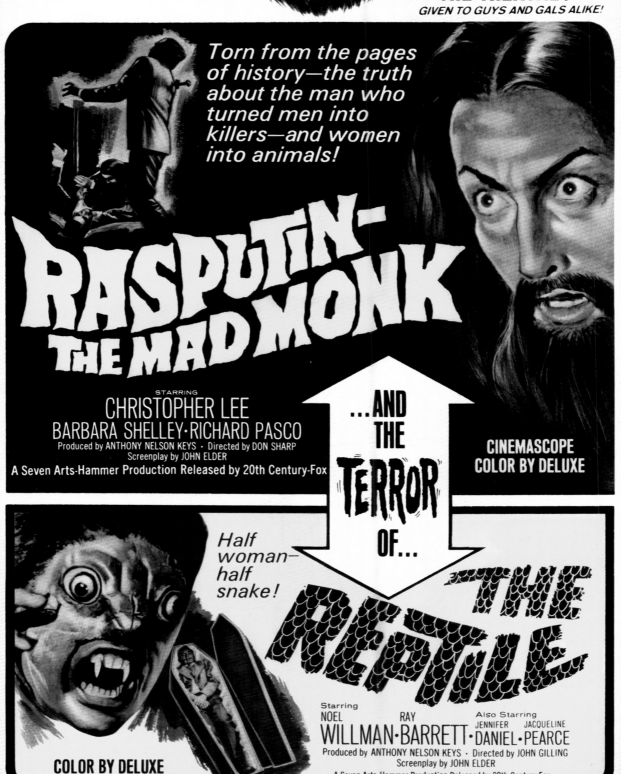

Torn from the pages of history—the truth about the man who turned men into killers—and women into animals!

RASPUTIN - THE MAD MONK

STARRING
CHRISTOPHER LEE
BARBARA SHELLEY · RICHARD PASCO
Produced by ANTHONY NELSON KEYS · Directed by DON SHARP
Screenplay by JOHN ELDER
A Seven Arts-Hammer Production Released by 20th Century-Fox

...AND THE "TERROR" OF...

CINEMASCOPE
COLOR BY DELUXE

Half woman— half snake!

THE REPTILE

COLOR BY DELUXE

Starring
NOEL **WILLMAN** · RAY **BARRETT**

Also Starring
JENNIFER **DANIEL** · JACQUELINE **PEARCE**

Produced by ANTHONY NELSON KEYS · Directed by JOHN GILLING
Screenplay by JOHN ELDER
A Seven Arts-Hammer Production Released by 20th Century-Fox

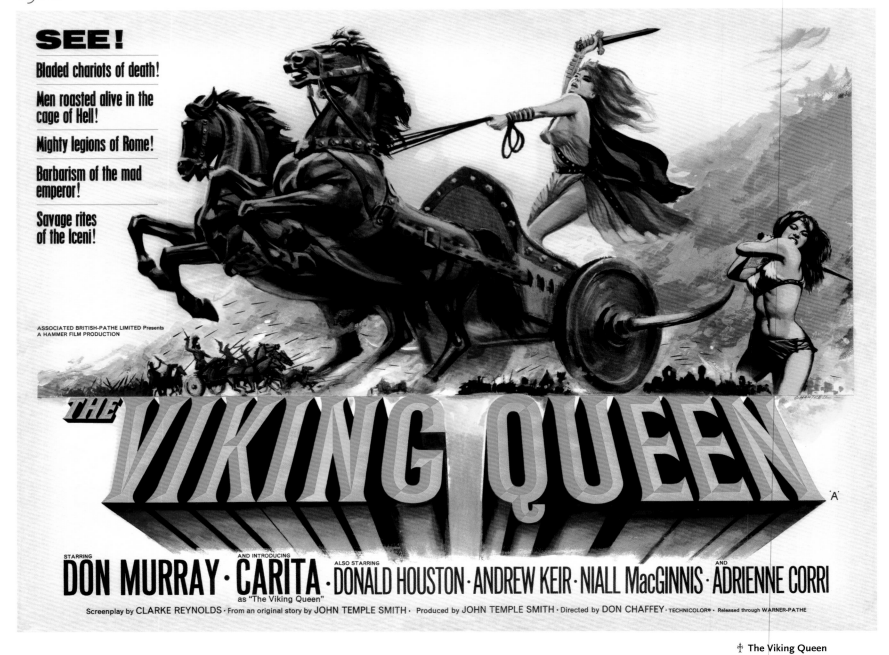

SEE!

Bladed chariots of death!

Men roasted alive in the cage of Hell!

Mighty legions of Rome!

Barbarism of the mad emperor!

Savage rites of the Iceni!

ASSOCIATED BRITISH-PATHE LIMITED Presents
A HAMMER FILM PRODUCTION

THE VIKING QUEEN

STARRING
DON MURRAY · **CARITA** · ALSO STARRING **DONALD HOUSTON** · **ANDREW KEIR** · **NIALL MacGINNIS** AND **ADRIENNE CORRI**
AND INTRODUCING
as "The Viking Queen"

Screenplay by CLARKE REYNOLDS · From an original story by JOHN TEMPLE SMITH · Produced by JOHN TEMPLE SMITH · Directed by DON CHAFFEY · TECHNICOLOR® · Released through WARNER-PATHE

✝ **The Viking Queen**
BRITISH 30 x 40 in (76 x 102 cm)
Illustration by Tom Chantrell

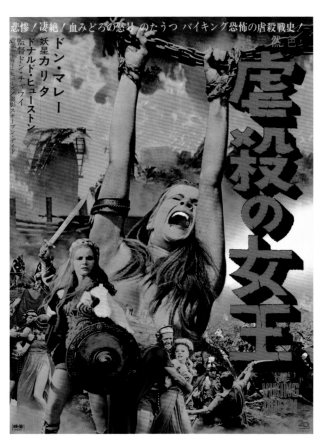

✤ **The Viking Queen**
JAPANESE 30 x 20 in (76 x 51 cm)

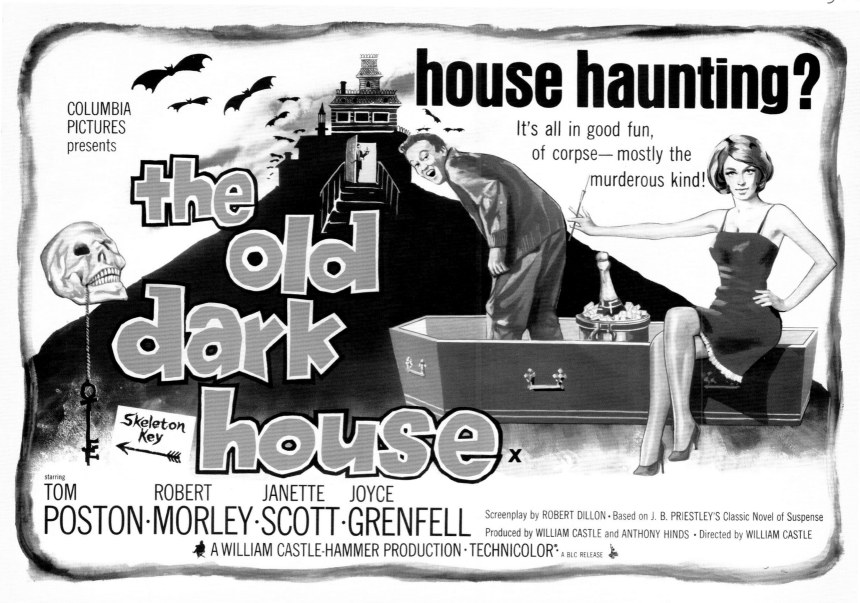

✝ **The Old Dark House**
BRITISH 30 x 40 in (76 x 102 cm)

The chequered distribution history of this film is reflected in the different posters on this page. Produced in the summer of 1962, *The Old Dark House* was a comedy horror that the British Board of Film Censors struggled to categorise to Hammer's satisfaction. This Quad Crown was designed to promote an 83-minute 'X' certificate version of the film that was unsuccessfully offered to exhibitors in 1963.

Big Deal at Dodge City/The Old Dark House ✈
BRITISH 30 x 40 in (76 x 102 cm)
Illustration by Tom Chantrell

ABC finally granted *The Old Dark House* a general release as a support feature in September 1966. This version of the film was cut down to 76 minutes and carried an 'A' certificate.

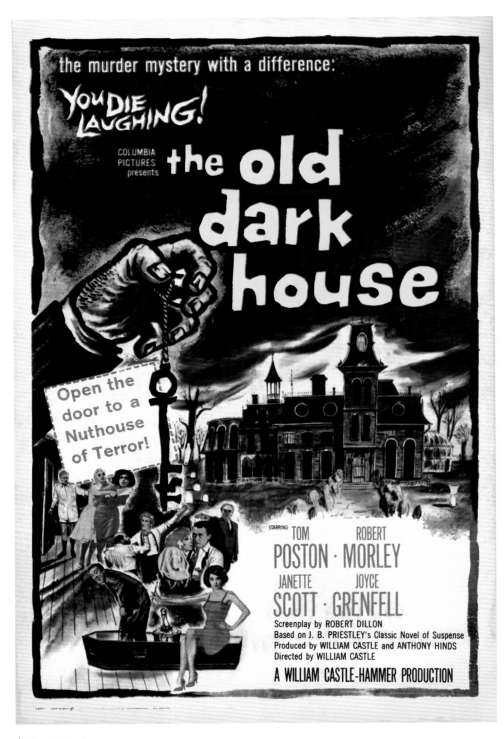

✝ **The Old Dark House**
US 41 x 27 in (104 x 69 cm)

✝ **The Old Dark House**
BELGIAN 21 x 14 in (54 x 36 cm)

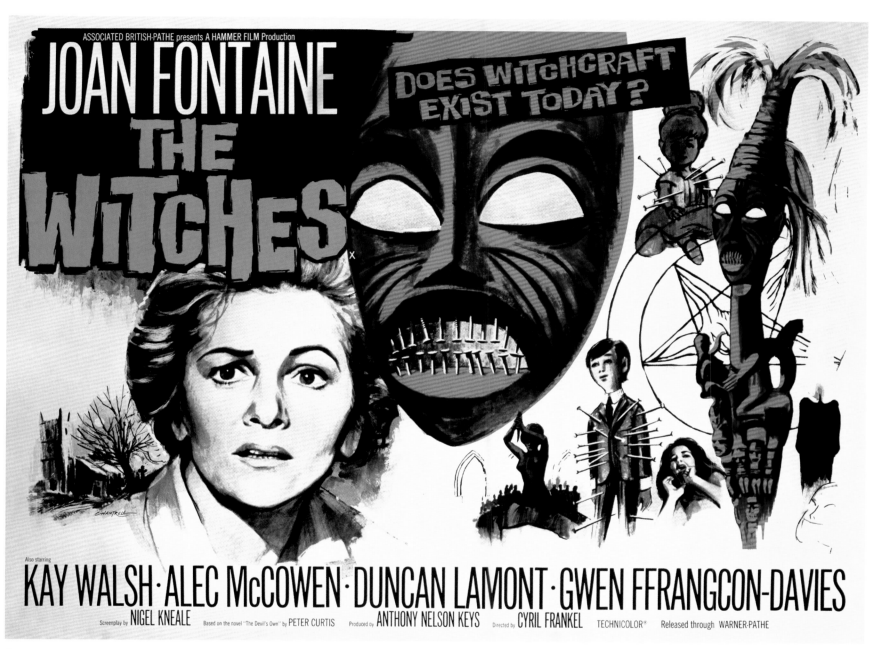

✝ **The Witches**
BRITISH 30 x 40 in (76 x 102 cm)
Illustration by Tom Chantrell

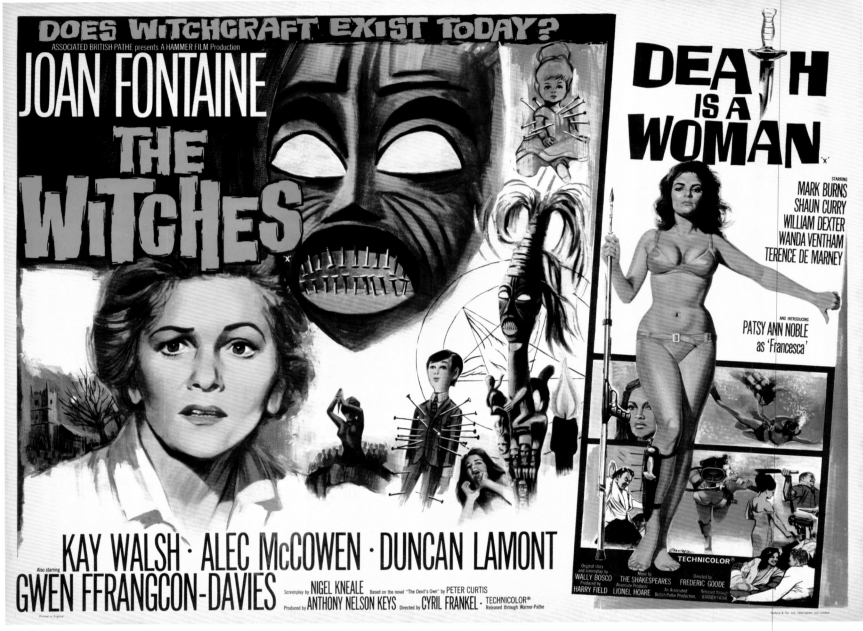

✝ The Witches/Death is a Woman
BRITISH 30 x 40 in (76 x 102 cm)
Illustration by Tom Chantrell

The Witches (aka The Devil's Own) ⤵
US 41 x 27 in (104 x 69 cm)

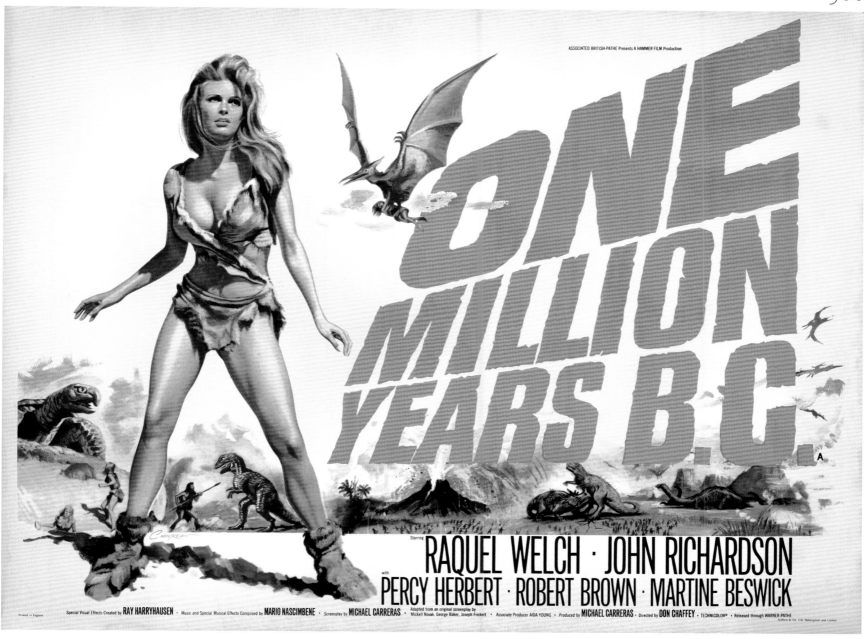

⚓ One Million Years B.C.
BRITISH 30 x 40 in (76 x 102 cm)
Illustration by Tom Chantrell

The most iconic of all Hammer posters was based on an impromptu still of Raquel Welch taken by unit photographer Pierre Luigi. Tom Chantrell's design and illustration formed the centrepiece for arguably the most successful marketing campaign in the company's history.

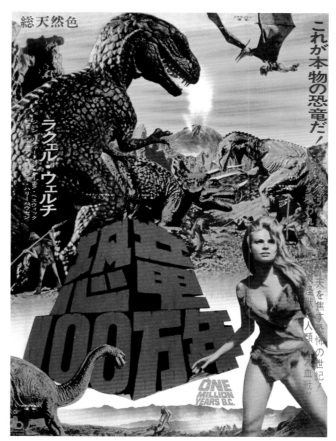

One Million Years B.C. ⚓
JAPANESE 30 x 20 in (76 x 51 cm)

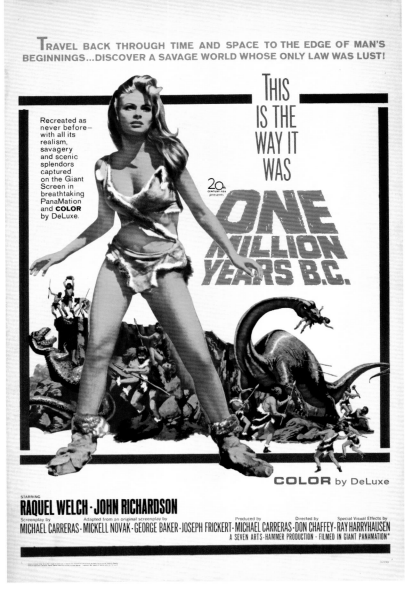

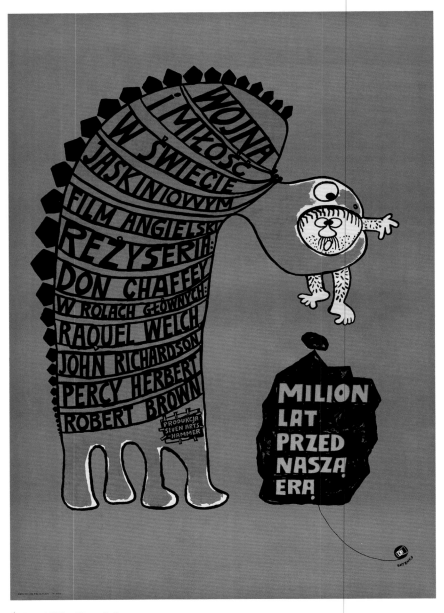

✝ **One Million Years B.C.**
US 41 x 27 in (104 x 69 cm)

✝ **One Million Years B.C.**
POLISH 33 x 23 in (84 x 58 cm)
Illustration by Bohdan Butenko

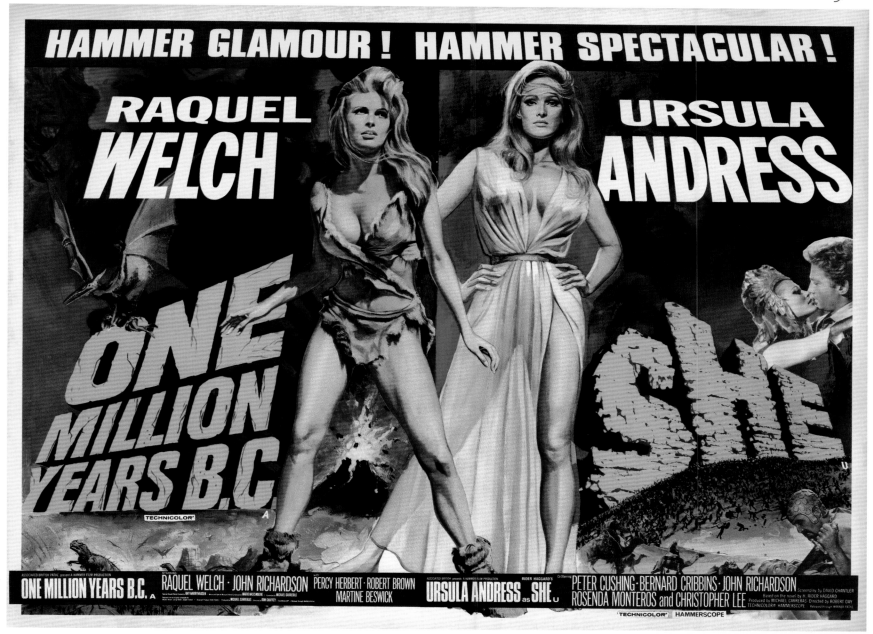

⚜ One Million Years B.C./She
BRITISH 30 x 40 in (76 x 102 cm)
Illustration by Tom Chantrell

These films were rereleased as a highly successful double-bill in August 1969. Tom Chantrell's illustration incorporated a new version of his famous Raquel Welch artwork and prominent Hammer branding.

Additional copies of this Quad Crown were printed by Hammer for distribution to fans. These were rolled, and not machine-folded like posters issued to cinemas. As a consequence fine examples can still be found at a relatively low price.

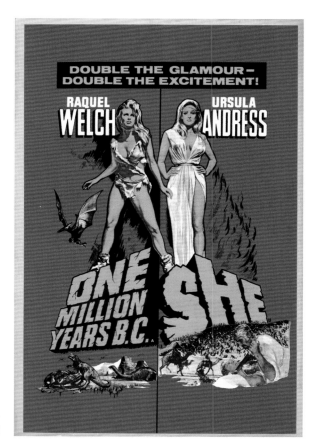

One Million Years B.C./She ⚜
BRITISH 30 x 20 in (76 x 51 cm)

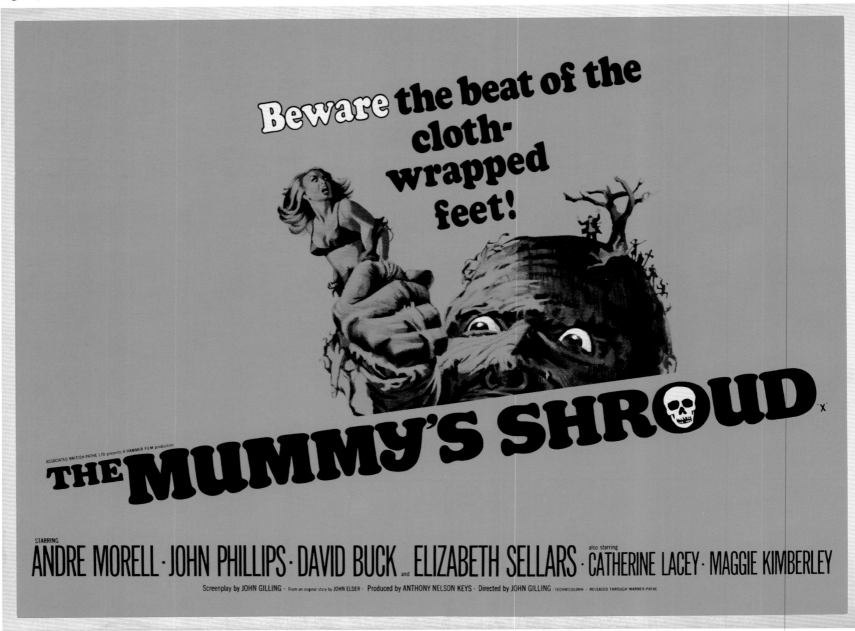

✝ **The Mummy's Shroud**
BRITISH 30 x 40 in (76 x 102 cm)
Illustration by Tom Chantrell

The Mummy's Shroud ✈
FRENCH 63 x 47 in (160 x 120 cm)
Illustration by Boris Grinsson

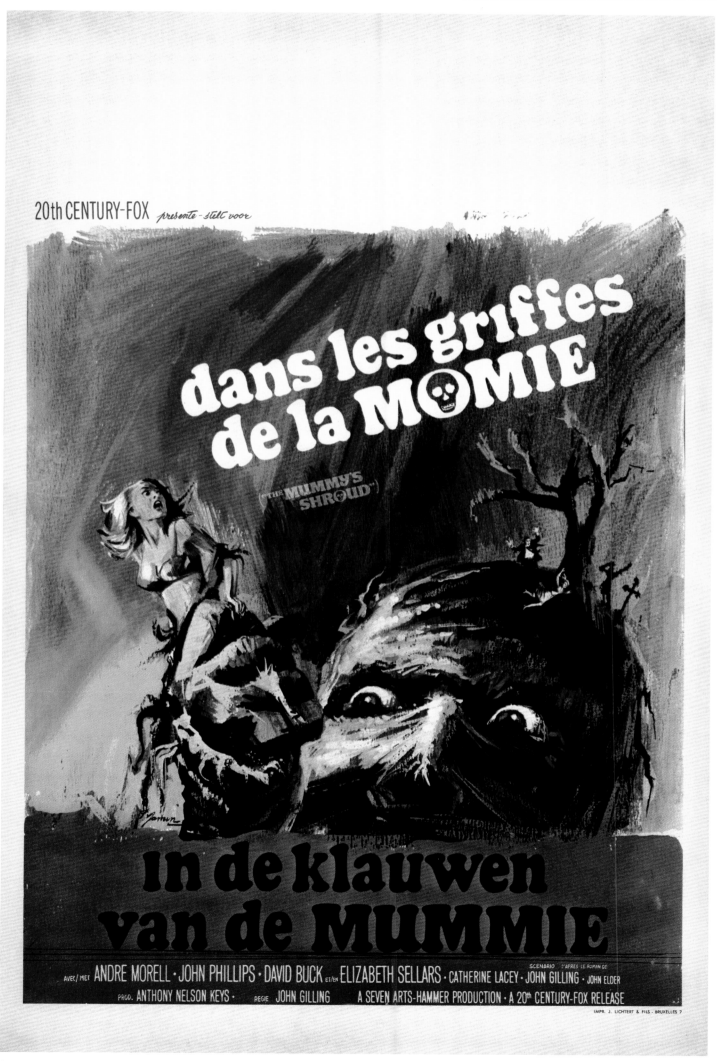

✝ **The Mummy's Shroud**
BELGIAN 21 x 14 in (53 x 35 cm)

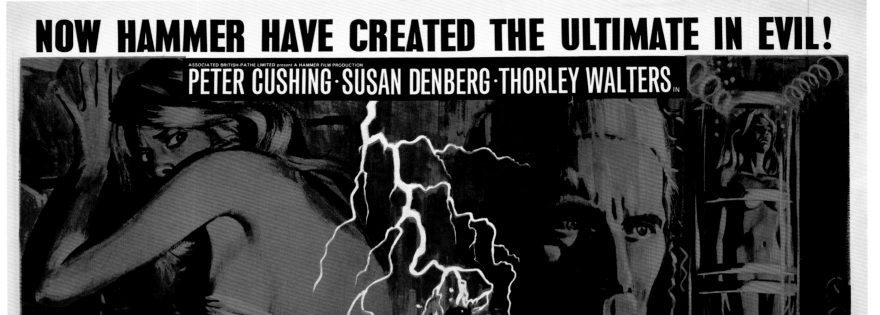

NOW HAMMER HAVE CREATED THE ULTIMATE IN EVIL!

ASSOCIATED BRITISH-PATHE LIMITED present A HAMMER FILM PRODUCTION
PETER CUSHING · SUSAN DENBERG · THORLEY WALTERS in

FRANKENSTEIN CREATED WOMAN

Original Screenplay by JOHN ELDER · Produced by ANTHONY NELSON KEYS · Directed by TERENCE FISHER TECHNICOLOR· RELEASED THROUGH WARNER-PATHE

☦ **Frankenstein Created Woman**
BRITISH 30 x 40 in (76 x 102 cm)
Illustration by Tom Chantrell

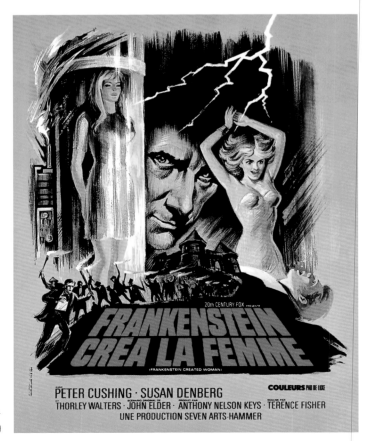

Frankenstein Created Woman ☦
FRENCH 32 x 24 in (80 x 60 cm)

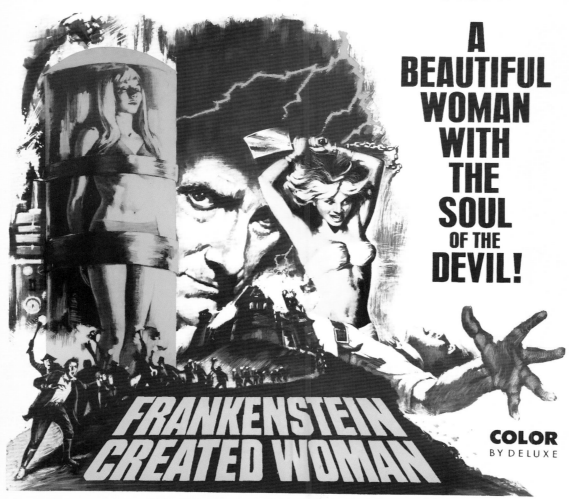

† **Frankenstein Created Woman**
US 41 x 27 in (104 x 69 cm)

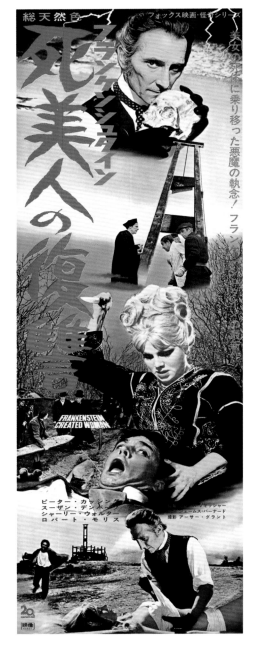

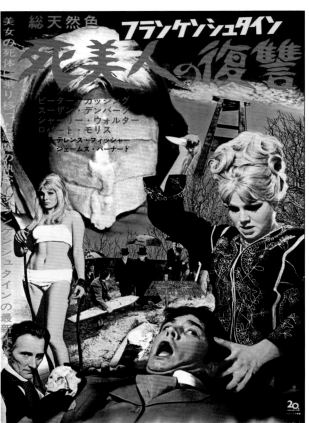

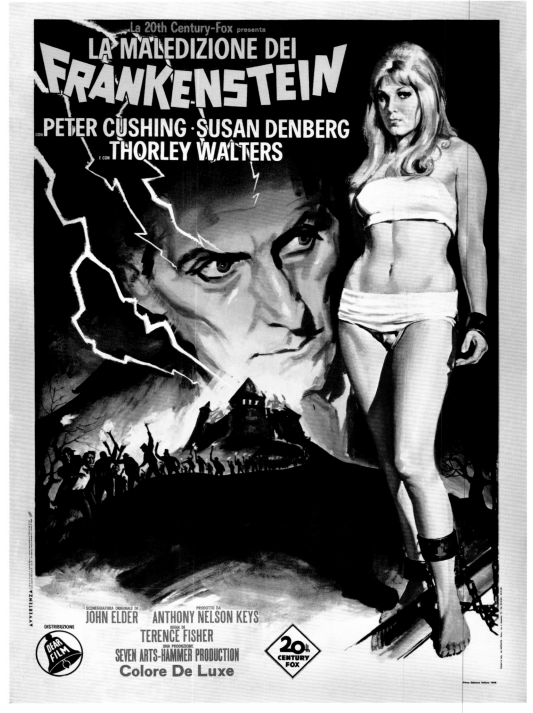

✝ **Frankenstein Created Woman**
ITALIAN 39 x 28 in (99 x 71 cm)

☆ **Frankenstein Created Woman**
JAPANESE 30 x 10 in (76 x 25 cm)

✈ **Frankenstein Created Woman**
JAPANESE 30 x 20 in (76 x 51 cm)

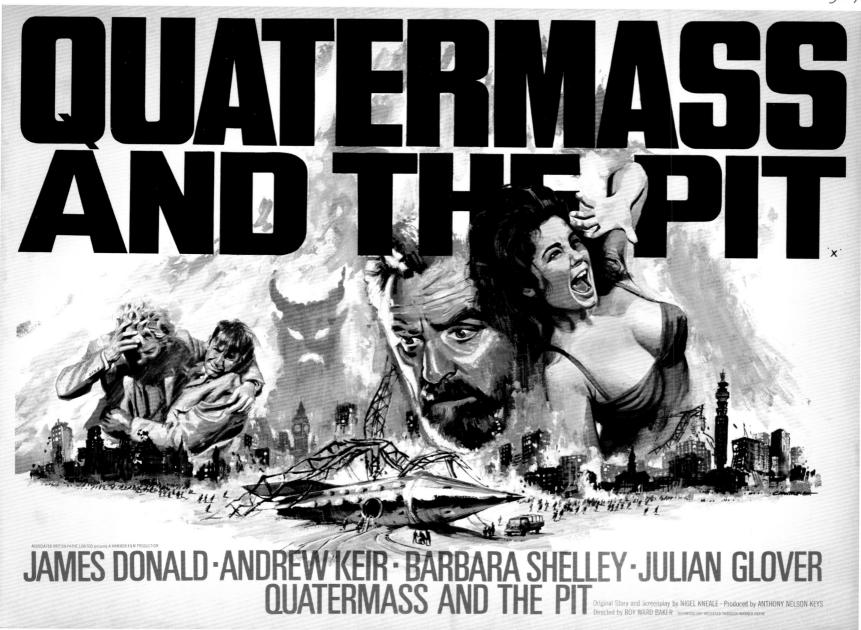

✝ **Quatermass and the Pit**
BRITISH 30 x 40 in (76 x 102 cm)
Illustration by Tom Chantrell

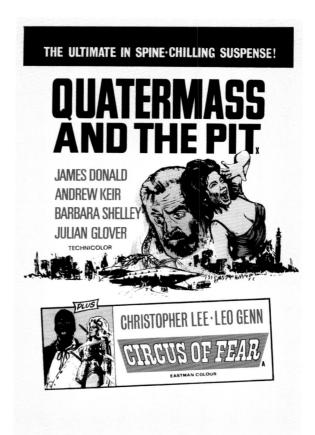

Quatermass and the Pit/Circus of Fear ⇥
BRITISH 30 x 20 in (76 x 51 cm)

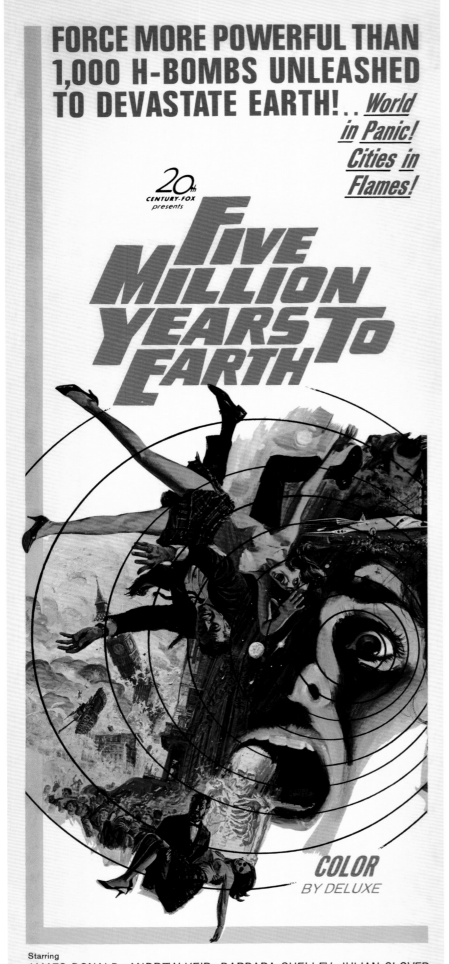

◄┼ Quatermass and the Pit
(aka **Five Million Years to Earth**)
US 36 x 14 in (91 x 36 cm)
Illustration by Grey Morrow

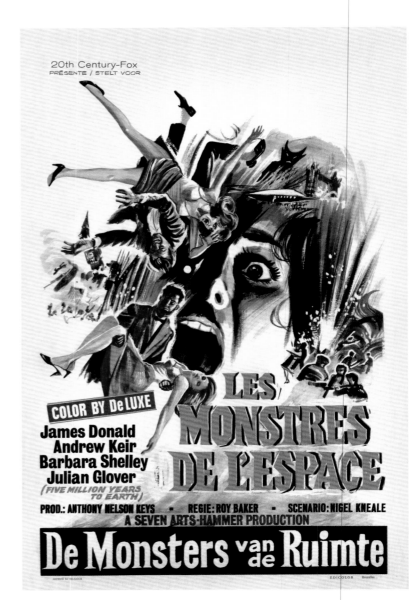

✝ **Quatermass and the Pit**
Belgian 33 x 24 in (84 x 61 cm)

Quatermass and the Pit (aka **Five Million Years to Earth**) ┼►
US 41 x 27 in (104 x 69 cm)
Illustration by Grey Morrow

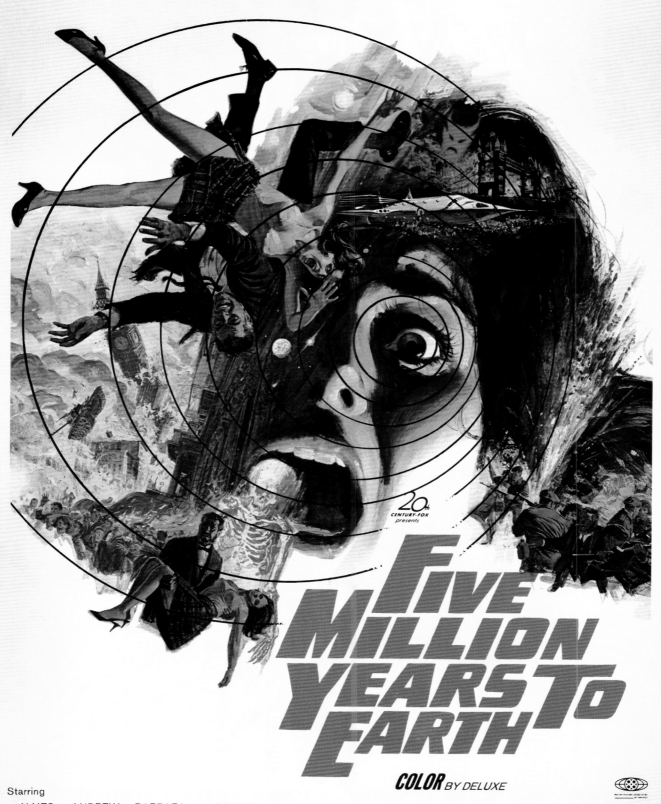

FORCE MORE POWERFUL THAN 1,000 H-BOMBS UNLEASHED TO DEVASTATE EARTH! WORLD IN PANIC! CITIES IN FLAMES!

20th
CENTURY-FOX
presents

FIVE MILLION YEARS TO EARTH

COLOR BY DELUXE

Starring
JAMES · ANDREW · BARBARA · JULIAN
DONALD · KEIR · SHELLEY · GLOVER

Produced by
ANTHONY NELSON KEYS

Directed by
ROY BAKER

Screenplay by
NIGEL KNEALE

A SEVEN ARTS-
HAMMER PRODUCTION

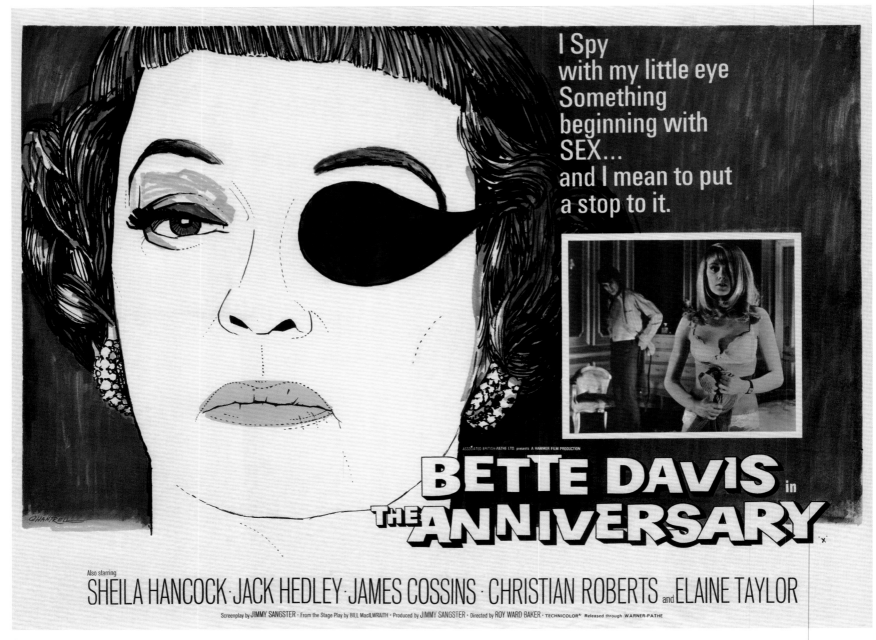

† **The Anniversary**
BRITISH 30 x 40 in (76 x 102 cm)
Illustration by Tom Chantrell

The Anniversary ⇥
US 41 x 27 in (104 x 69 cm)

20th Century-Fox presents

BETTE DAVIS IN THE ANNIVERSARY

Bette Davis adds another portrait in evil as the most merciless mother of them all

...and remember, Mum's the word for depravity!

SUGGESTED FOR MATURE AUDIENCES

Also Starring SHEILA HANCOCK · JACK HEDLEY · CHRISTIAN ROBERTS · JAMES COSSINS · ELAINE TAYLOR

Produced by JIMMY SANGSTER · Directed by ROY BAKER · Screenplay by JIMMY SANGSTER · Color by DeLuxe · A Seven Arts-Hammer Production

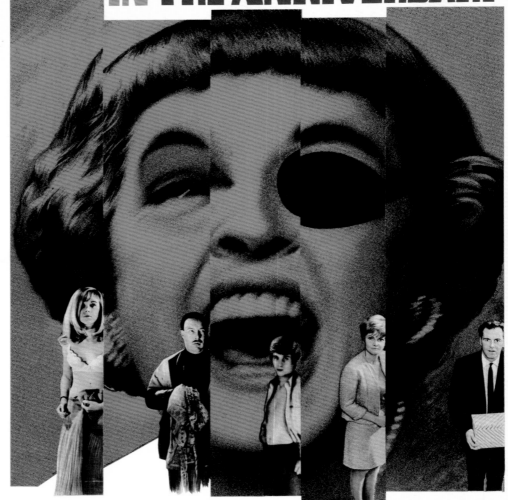

✝ The Anniversary
US 22 x 28 in (56 x 71 cm)

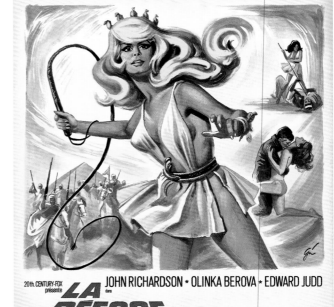

The Vengeance of She ✈
BELGIAN 21 x 14 in (54 x 36 cm)

The Vengeance of She ✈ ✈
US 41 x 27 in (104 x 69 cm)

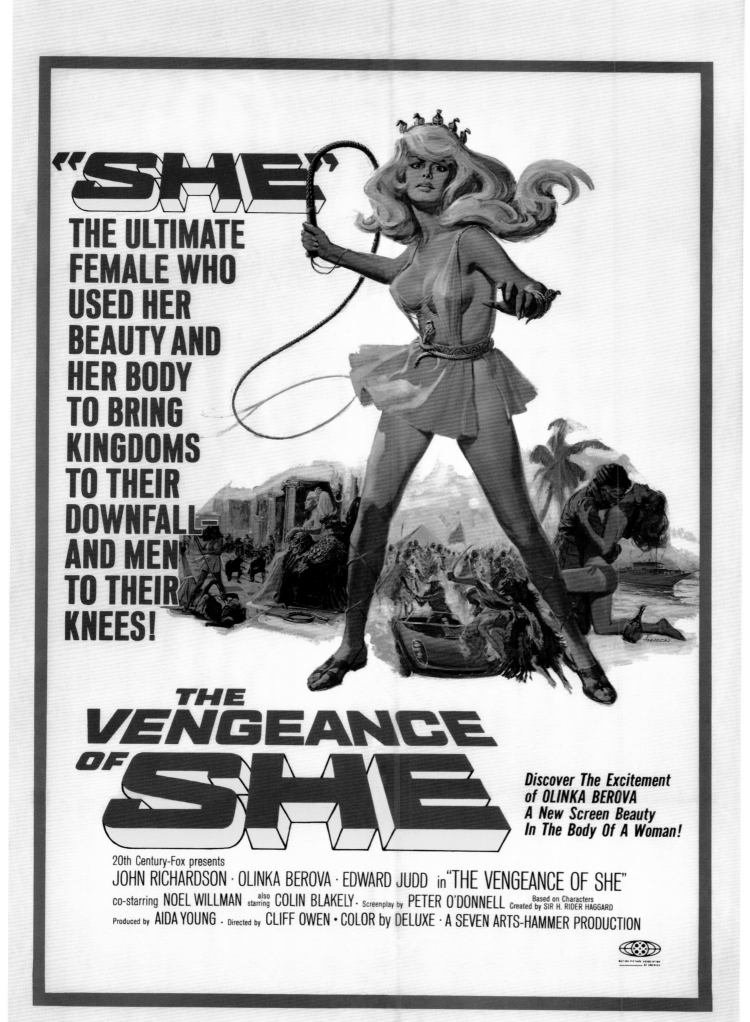

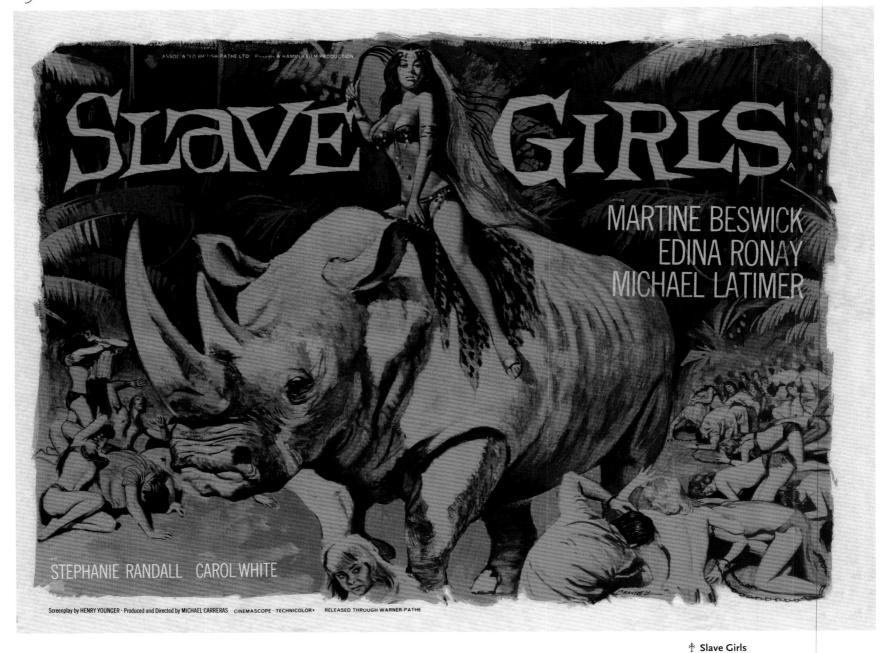

✝ **Slave Girls**
BRITISH 30 x 40 in (76 x 102 cm)
Illustration by Tom Chantrell

Although Chantrell submitted a full-colour version of this design to Hammer, the standalone Quad Crown was issued in this screen-printed DayGlo version.

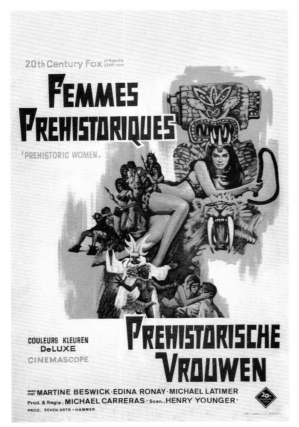

⚔ **Slave Girls**
BELGIAN 33 x 24 in (84 x 61 cm)

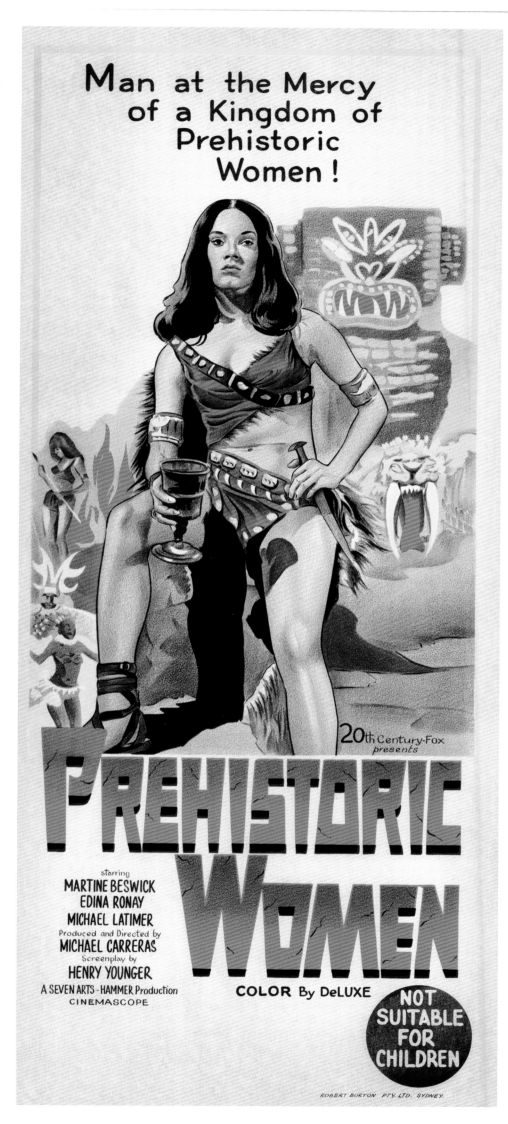

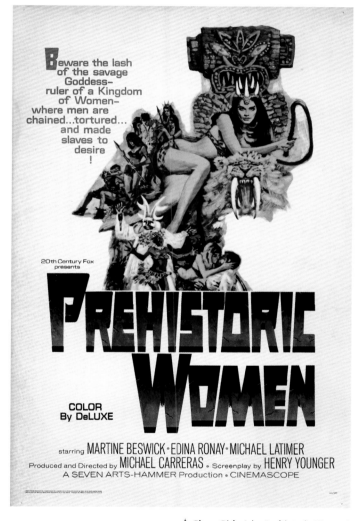

☥ Slave Girls (aka Prehistoric Women)
US 41 x 27 in (104 x 69 cm)

☥ Slave Girls (aka Prehistoric Women)
AUSTRALIAN 30 x 13 in (76 x 33 cm)

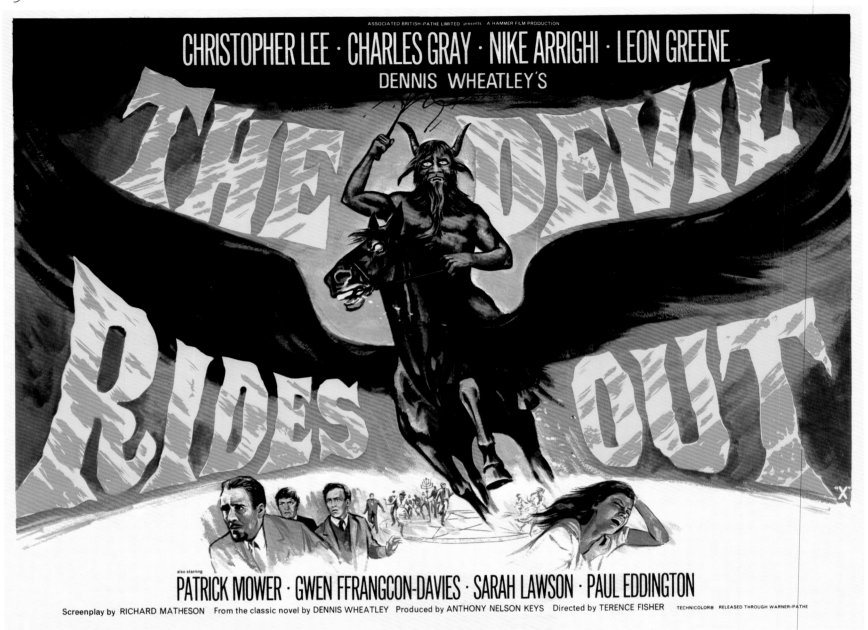

† **The Devil Rides Out**
BRITISH 30 x 40 in (76 x 102 cm)
Illustration by Tom Chantrell

The Devil Rides Out (aka **The Devil's Bride**) ⊁
US 41 x 27 in (104 x 69 cm)

The Devil Rides Out ⊁ ⊁
BRITISH 30 x 20 in (76 x 51 cm)

The Devil Rides Out ⊁ ⊁ ⊁
BELGIAN 22 x 18 in (56 x 45 cm)
Illustration by Paul Jamin

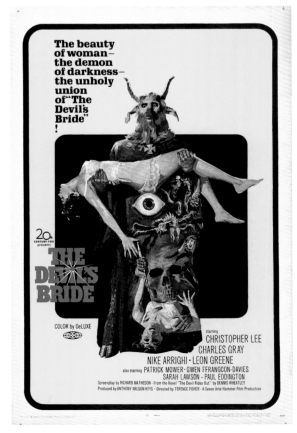

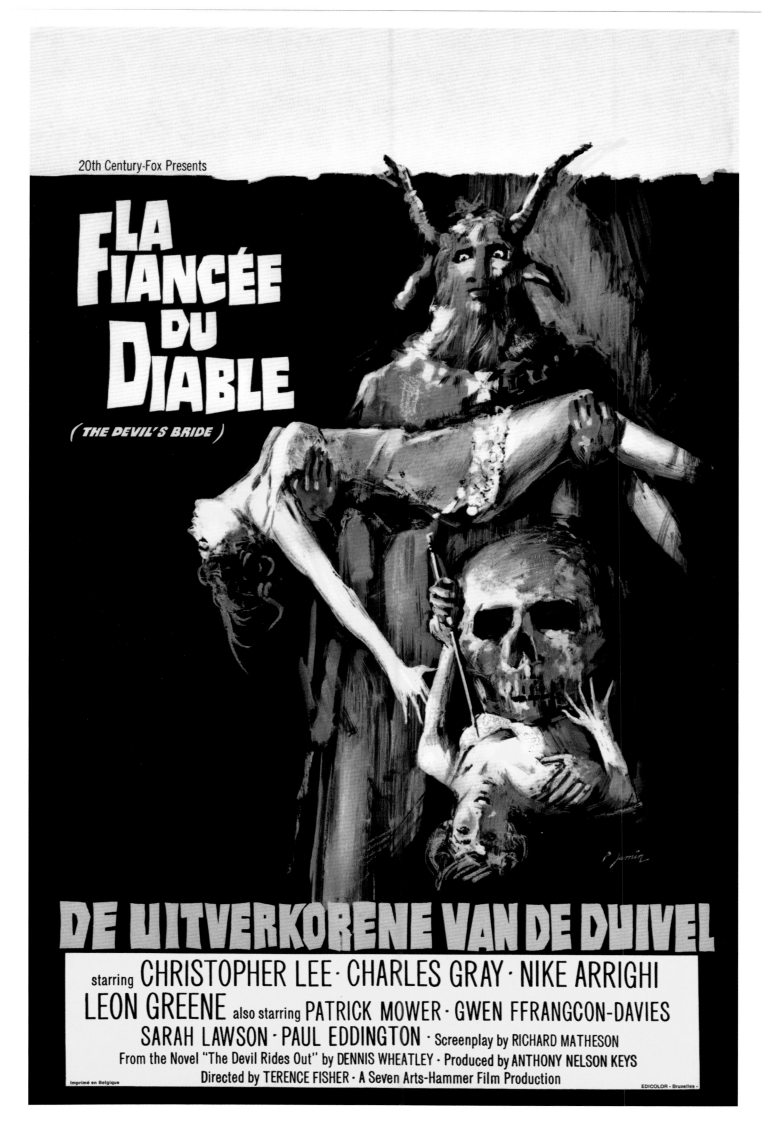

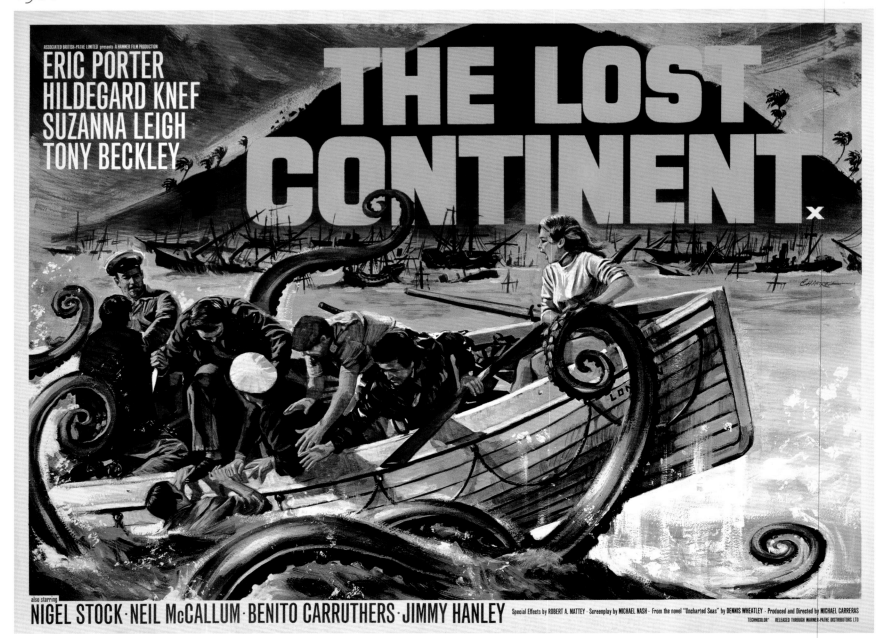

♱ **The Lost Continent**
BRITISH 30 x 40 in (76 x 102 cm)
Illustration by Tom Chantrell

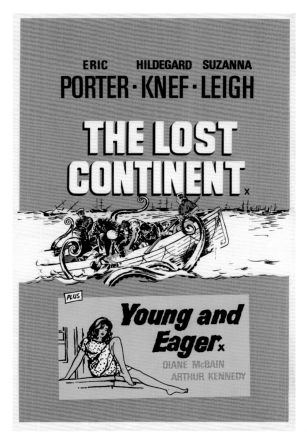

The Lost Continent/Young and Eager ✈
BRITISH 30 x 20 in (76 x 51 cm)

The Lost Continent ✈ ✈
US 41 x 27 in (104 x 69 cm)

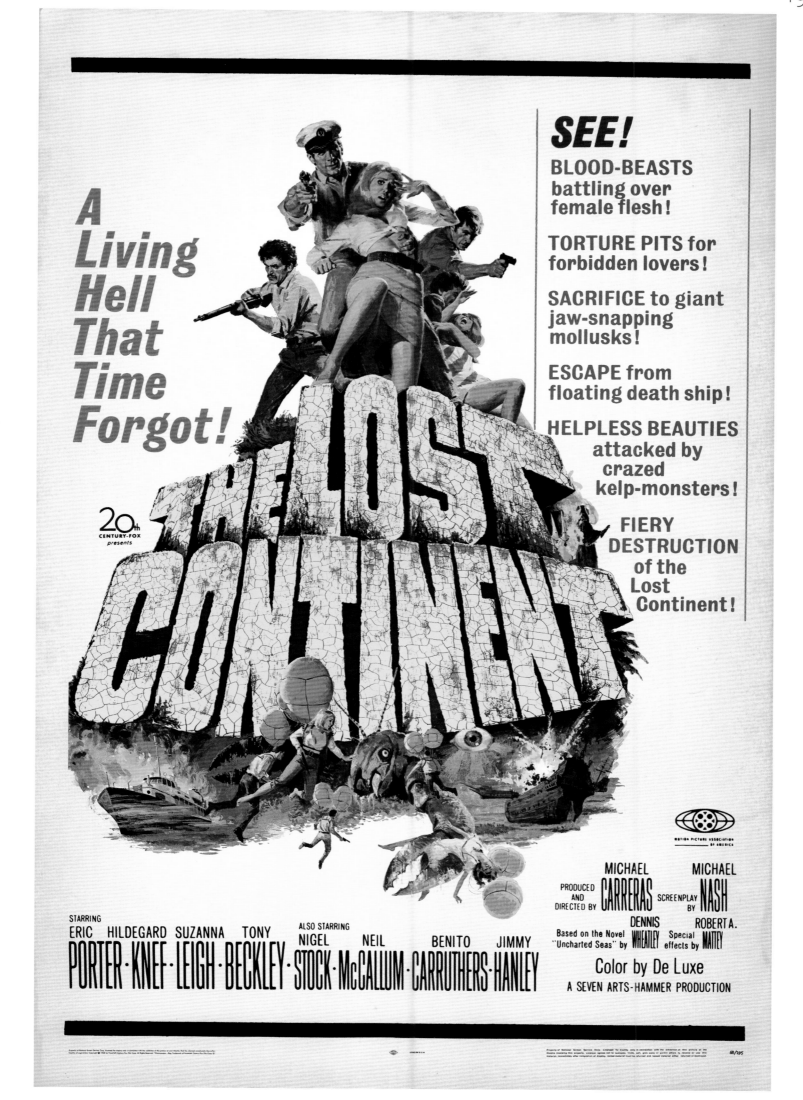

✝ **The Lost Continent**
BRITISH 30 x 20 in (76 x 51 cm)

✝ **The Lost Continent**
BRITISH 30 x 20 in (76 x 51 cm)

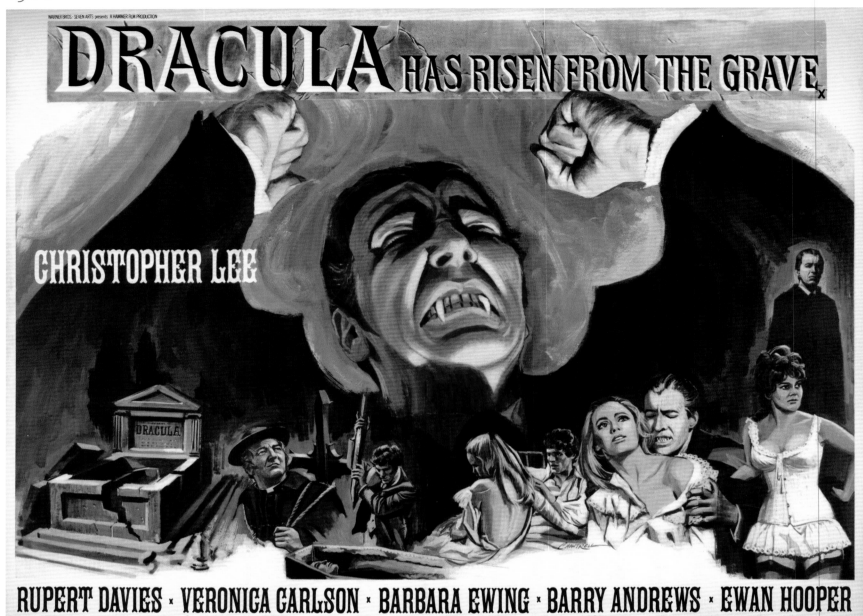

WARNER BROS.-SEVEN ARTS presents A HAMMER FILM PRODUCTION

DRACULA HAS RISEN FROM THE GRAVE

CHRISTOPHER LEE

RUPERT DAVIES × VERONICA CARLSON × BARBARA EWING × BARRY ANDREWS × EWAN HOOPER

Screenplay by JOHN ELDER Based on characters created by BRAM STOKER Produced by AIDA YOUNG Directed by FREDDIE FRANCIS TECHNICOLOR® Released through WARNER-PATHE

✝ **Dracula Has Risen From the Grave**
BRITISH 30 x 40 in (76 x 102 cm)
Illustration by Tom Chantrell

The main image of Dracula on this poster was actually a self-portrait of Chantrell, who posed for a reference photograph when stills of Christopher Lee failed to arrive.

Like *One Million Years B.C./She*, Hammer ordered additional copies of this Quad Crown to give away to fans. These rolled posters are generally available on the collectors' market at a lower price than many other British Hammer posters from this era.

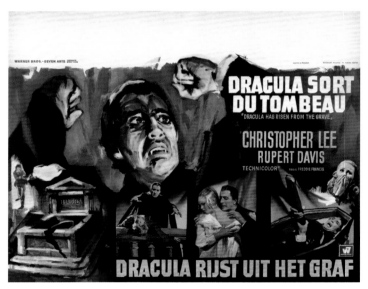

✝ **Dracula Has Risen From the Grave**
BELGIAN 16 x 21 in (42 x 53 cm)
Illustration by Raymond Elseviers

✝ **Dracula Has Risen From the Grave/A Covenant With Death**
BRITISH 30 x 20 in (76 x 51 cm)

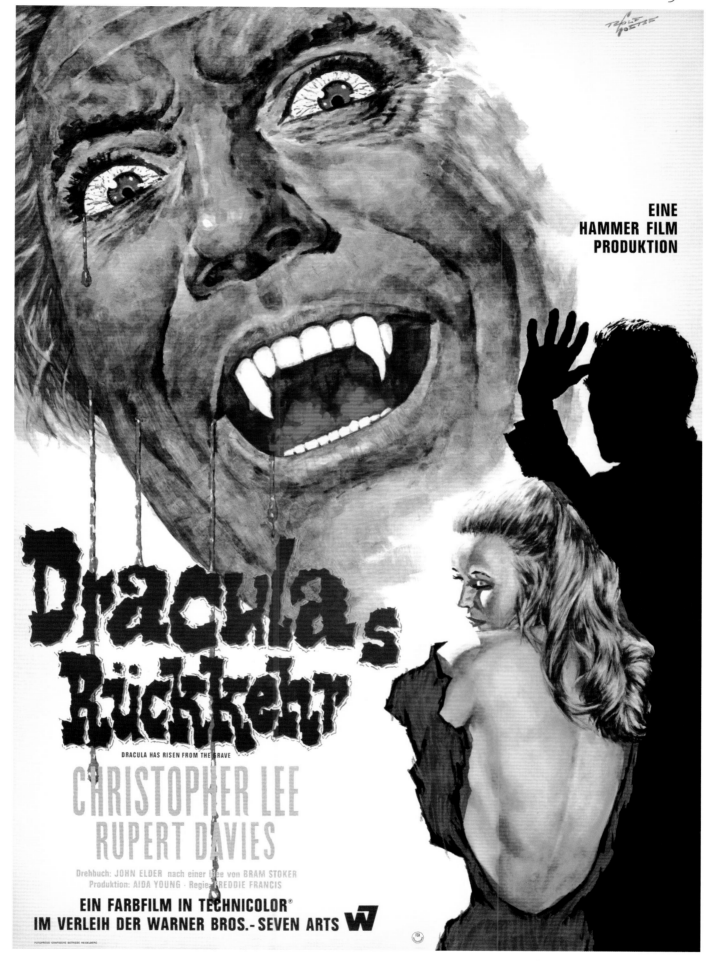

✝ **Dracula Has Risen From the Grave**
GERMAN 34 x 23 in (85 x 60 cm)
Illustration by Rolf Goetze

"DRACULA HAS RISEN FROM THE GRAVE"
(OBVIOUSLY)

A HAMMER FILM PRODUCTION

starring CHRISTOPHER LEE · RUPERT DAVIES · Produced by AIDA YOUNG · Directed by FREDDIE FRANCIS · Screenplay by JOHN ELDER

Based on the Character Created by Bram Stoker · TECHNICOLOR® FROM WARNER BROS.-SEVEN ARTS

G SUGGESTED FOR GENERAL AUDIENCES

69/83

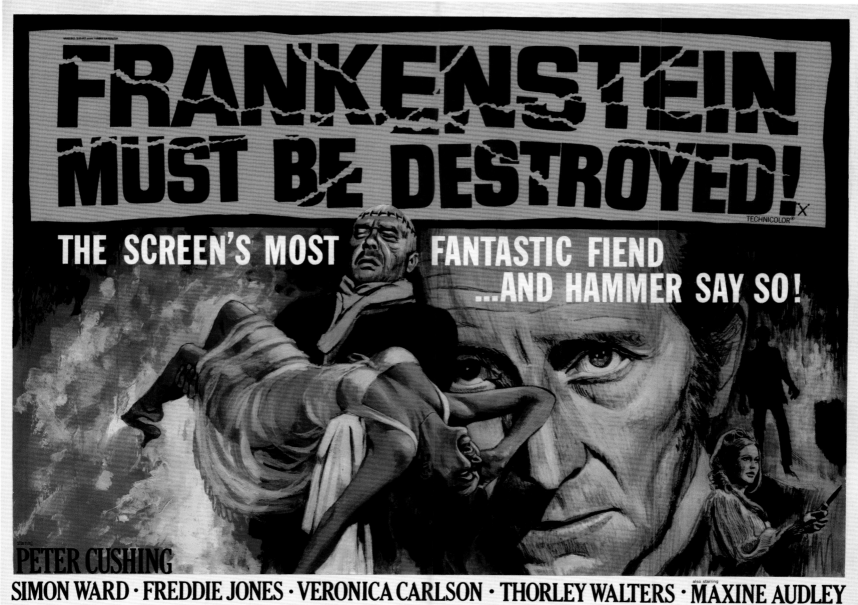

✝ **Frankenstein Must Be Destroyed**
British 30 x 40 in (76 x 102 cm)
Illustration by Tom Chantrell

This was possibly another instance where necessary reference photographs failed to arrive on time – the main portrait of Peter Cushing is based on a publicity still from *Frankenstein Created Woman*.

✠ **Dracula Has Risen From the Grave**
US 41 x 27 in (104 x 69 cm)

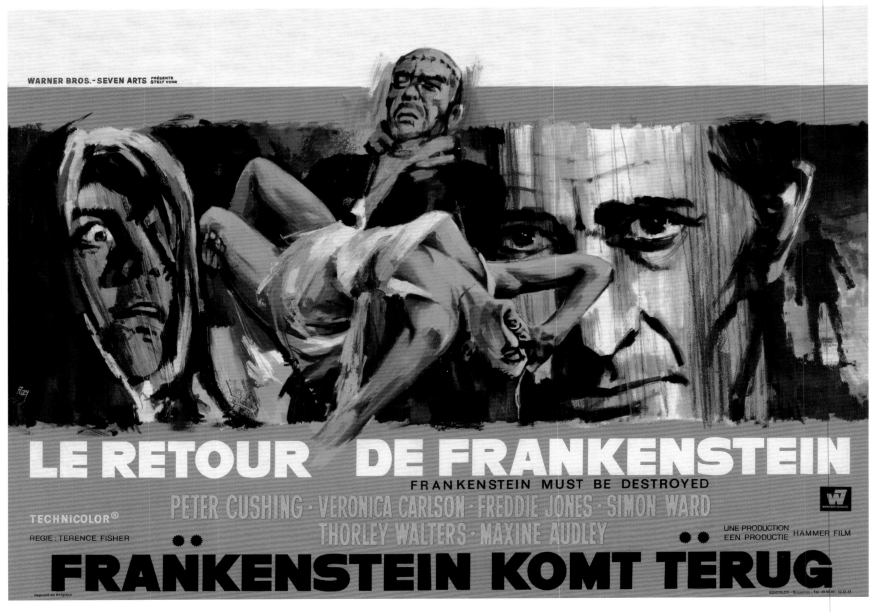

✝ **Frankenstein Must Be Destroyed**
BELGIAN 16 x 21 in (42 x 53 cm)
Illustration by Raymond Elseviers

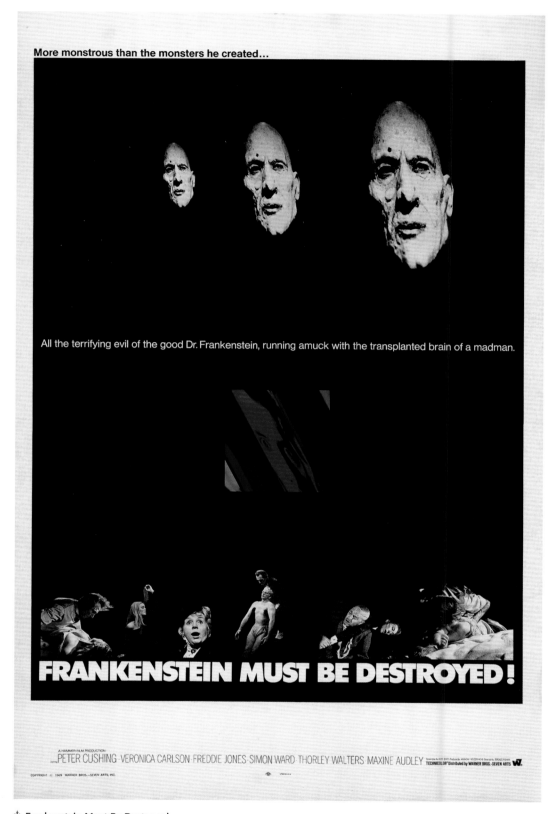

✝ Frankenstein Must Be Destroyed
US 41 x 27 in (104 x 69 cm)

Like *Dracula Has Risen From the Grave* before it, this one-sheet was informed by an understated pop art style far removed from the usual sensational approach. The repeated imagery on this poster, and the distortion of the central image of Peter Cushing, possibly betray the influence of Andy Warhol.

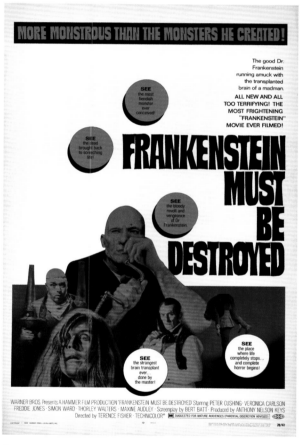

✝ Frankenstein Must Be Destroyed
US 41 x 27 in (104 x 69 cm)

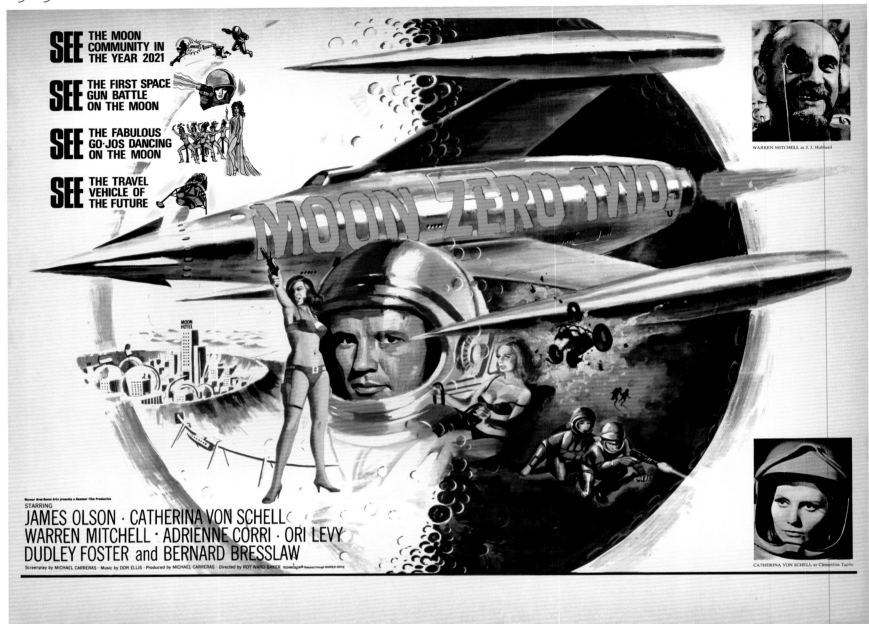

SEE THE MOON COMMUNITY IN THE YEAR 2021

SEE THE FIRST SPACE GUN BATTLE ON THE MOON

SEE THE FABULOUS GO·JOS DANCING ON THE MOON

SEE THE TRAVEL VEHICLE OF THE FUTURE

WARREN MITCHELL as J. J. Hubbard

Warner Bros–Seven Arts presents a Hammer Film Production
STARRING
JAMES OLSON · CATHERINA VON SCHELL
WARREN MITCHELL · ADRIENNE CORRI · ORI LEVY
DUDLEY FOSTER and BERNARD BRESSLAW

Screenplay by MICHAEL CARRERAS · Music by DON ELLIS · Produced by MICHAEL CARRERAS · Directed by ROY WARD BAKER TECHNICOLOR® Released through WARNER-PATHE

CATHERINA VON SCHELL as Clementine Taplin

⚜ **Moon Zero Two**
BRITISH 30 x 40 in (76 x 102 cm)
Illustration by Tom Chantrell

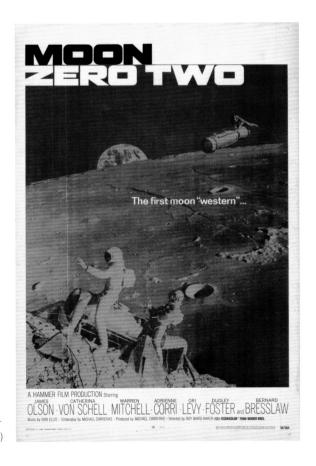

Moon Zero Two ✈
US 41 x 27 in (104 x 69 cm)

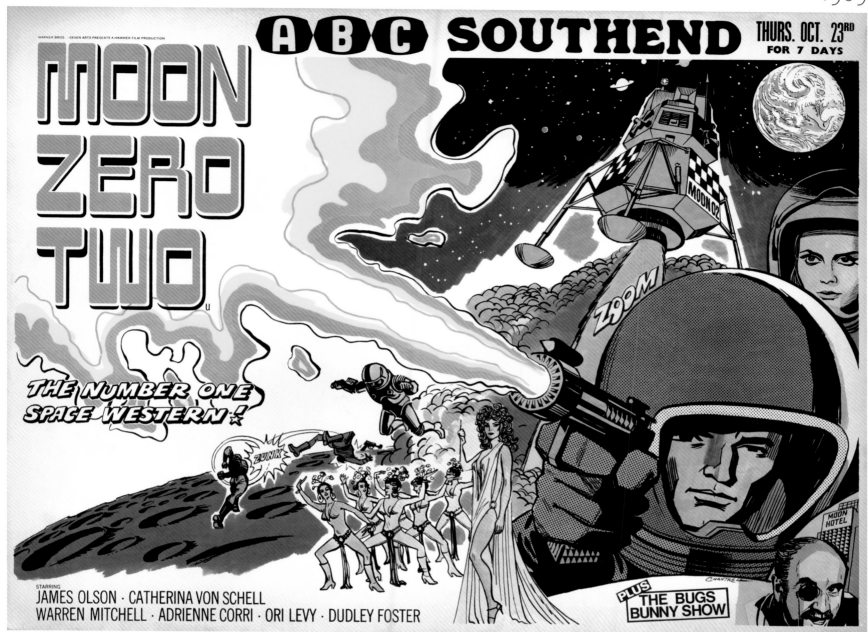

✝ **Moon Zero Two**
BRITISH 30 x 40 in (76 x 102 cm)
Illustration by Tom Chantrell

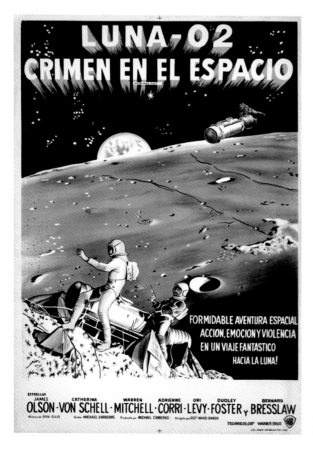

⚞ **Moon Zero Two**
SPANISH 39 x 28 in (100 x 70 cm)

1970-1979

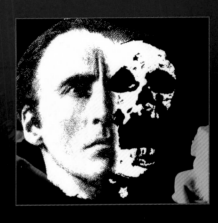

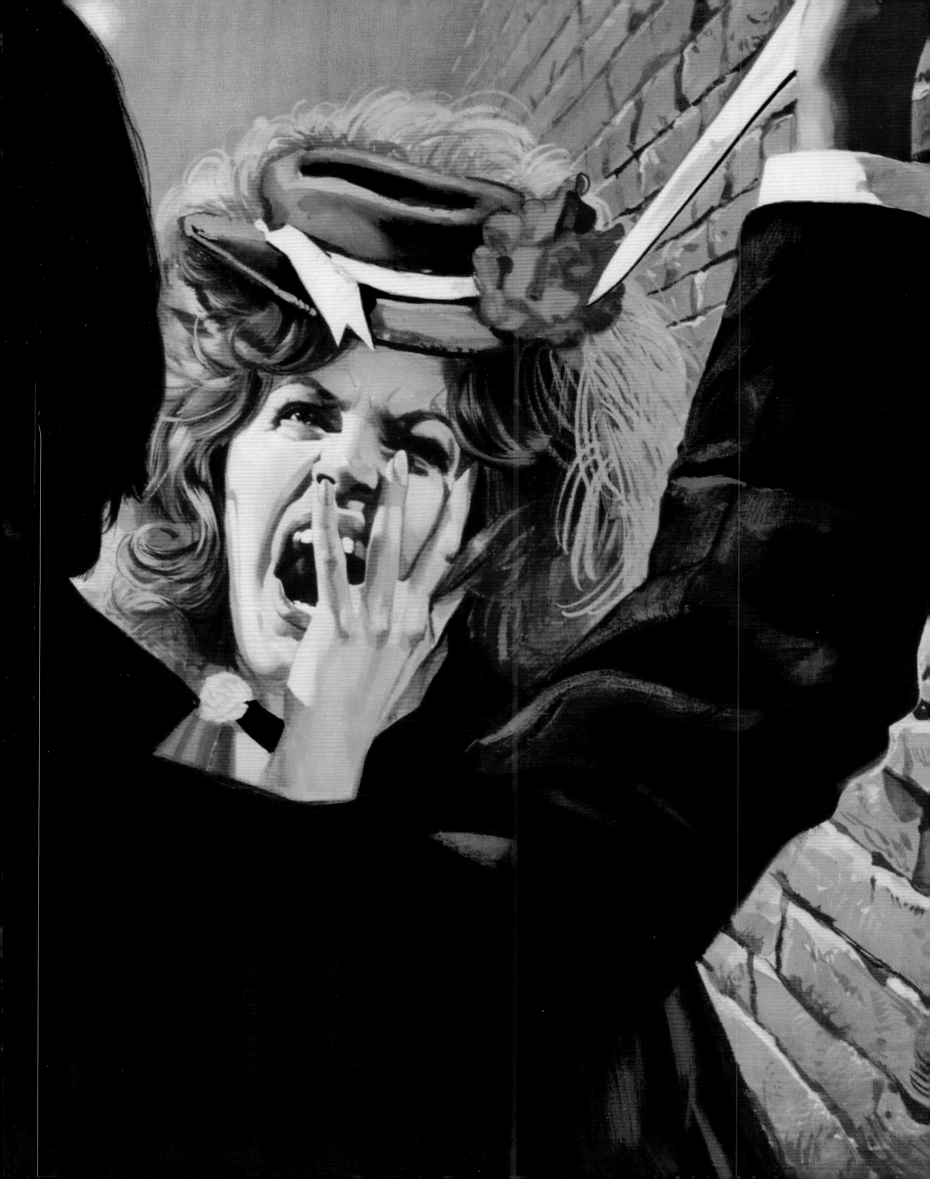

Warner Bros présente une production Hammer Film

le mannequin défiguré

STEFANIE POWERS
JAMES OLSON
MARGARETTA SCOTT
JANE LAPOTAIRE
JOSS ACKLAND
TECHNICOLOR

REGIE: ALAN GIBSON

de verminkte mannequin
(CRESCENDO)

Imprimé en Belgique

A KINNEY COMPANY

EDICOLOR - Bruxelles - Tél. 43.63.49 - 43.87.43

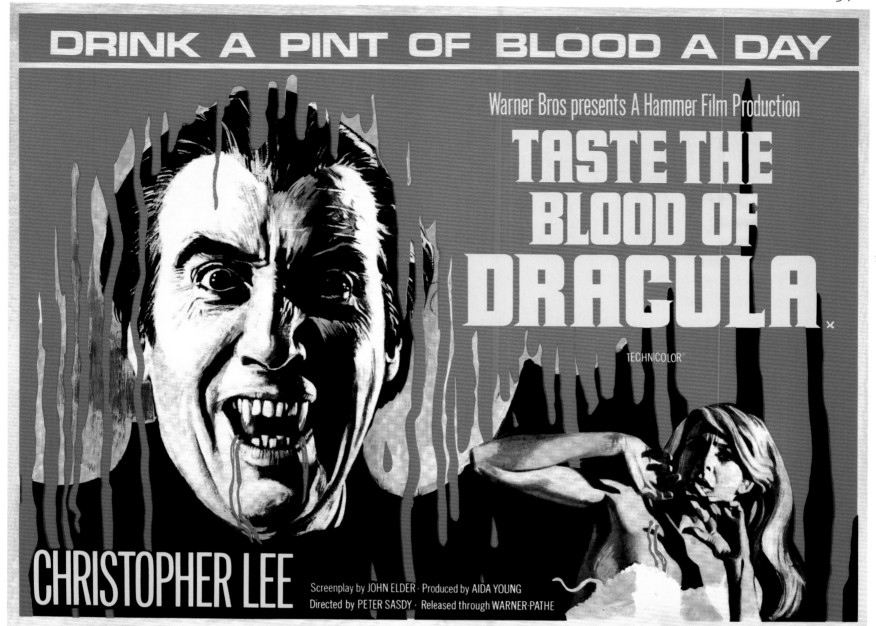

DRINK A PINT OF BLOOD A DAY

Warner Bros presents A Hammer Film Production

TASTE THE BLOOD OF DRACULA

TECHNICOLOR

CHRISTOPHER LEE

Screenplay by JOHN ELDER · Produced by AIDA YOUNG
Directed by PETER SASDY · Released through WARNER·PATHE

✟ **Taste the Blood of Dracula**
BRITISH 30 x 40 in (76 x 102 cm)
Illustration by Tom Chantrell

Chantrell's unbroken run of British posters
came to an end in 1970. His design for *Taste
the Blood of Dracula* featured a tagline that
parodied the Milk Marketing Board slogan
'Drinka pinta milka day'.

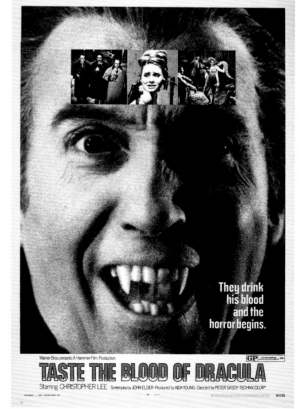

Taste the Blood of Dracula ✈
US 41 x 27 in (104 x 69 cm)

American one-sheets continued to
employ more subtle typography and pop
art imagery. The style of this one-sheet
recalls Alan Aldridge's poster for Andy
Warhol's 1966 film *Chelsea Girls*.

⚜ **Crescendo**
BELGIAN 22 x 14 in (55 x 36 cm)
Illustration by Landi

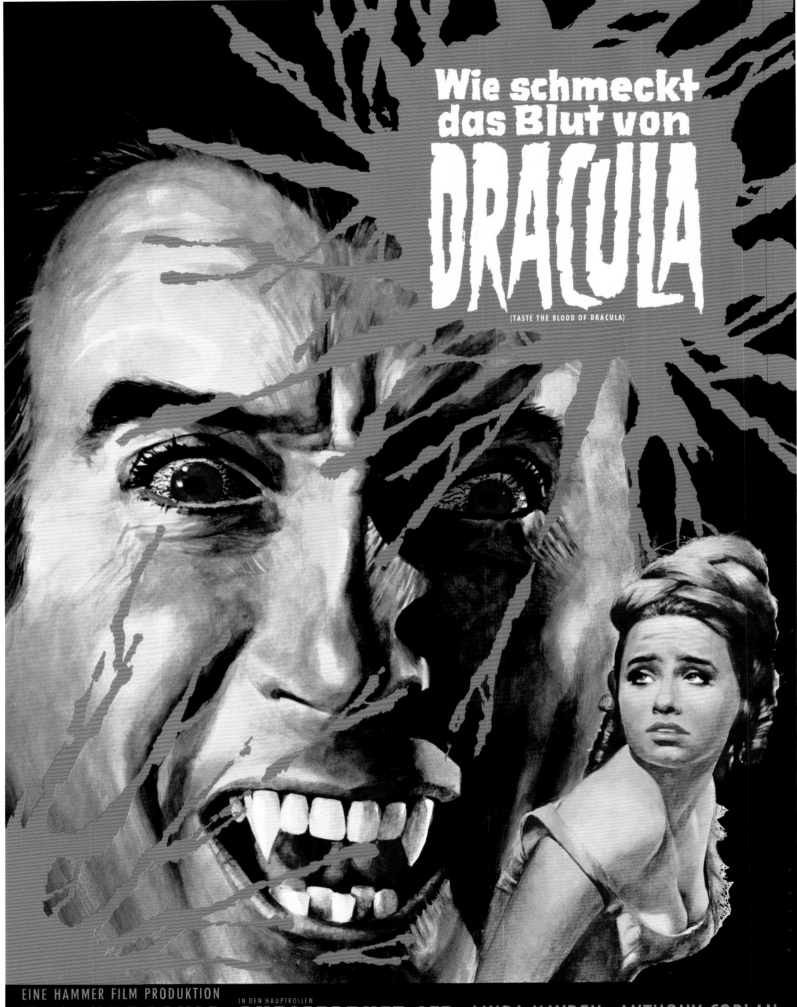

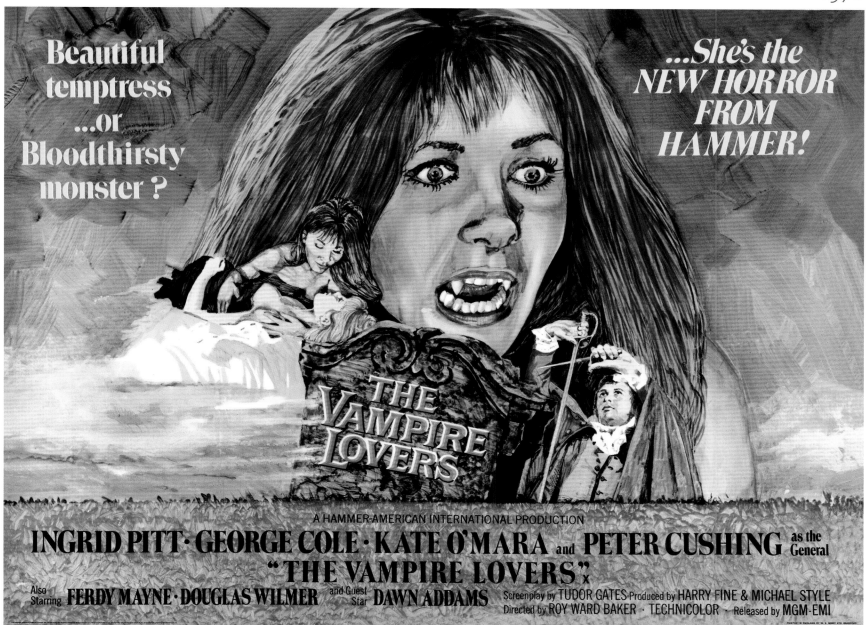

Beautiful
temptress
...or
Bloodthirsty
monster ?

...She's the
NEW HORROR
FROM
HAMMER!

A HAMMER-AMERICAN INTERNATIONAL PRODUCTION

INGRID PITT · GEORGE COLE · KATE O'MARA and PETER CUSHING as the General
"THE VAMPIRE LOVERS" X

Also
Starring FERDY MAYNE · DOUGLAS WILMER and Guest Star DAWN ADDAMS Screenplay by TUDOR GATES Produced by HARRY FINE & MICHAEL STYLE
Directed by ROY WARD BAKER · TECHNICOLOR · Released by MGM-EMI

✝ **The Vampire Lovers**
BRITISH 30 x 40 in (76 x 102 cm)
Illustration by Mike Vaughan

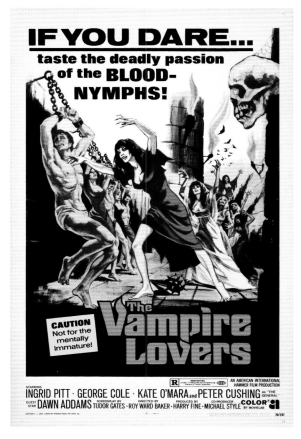

The Vampire Lovers ✈
US 41 x 27 in (104 x 69 cm)

From 1970 onwards most of Hammer's
American distribution was handled by
independents, as opposed to major studios.
The Vampire Lovers was released in the
US by grindhouse distributor American
International Pictures, whose
one-sheet resembled an explicit version of
the drive-in posters from the 1950s.

✈ **Taste the Blood of Dracula**
GERMAN 34 x 22 in (85 x 56 cm)
Illustration by Bruno Rehak

157

71/161

Enter an age of unknown terrors, pagan worship and virgin sacrifice...

From the creators of "One Million Years B.C.", their most gigantic spectacle...

Warner Bros. presents
A Hammer Film Production

"WHEN DINOSAURS RULED THE EARTH"
starring
VICTORIA VETRI

ROBIN HAWDON · PATRICK ALLEN · IMOGEN HASSALL

Music Composed by Mario Nascimbene · Special Visual Effects by Jim Danforth · Written for the Screen by Val Guest
Produced by Aida Young · Directed by Val Guest · Technicolor® FROM **Warner bros.** A **Kinney** company G ALL AGES ADMITTED General Audiences

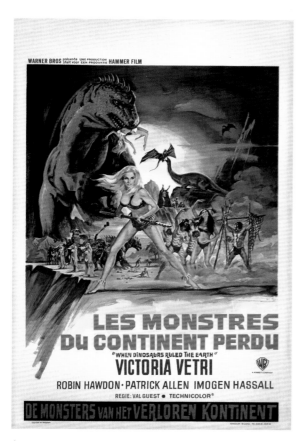

✝ When Dinosaurs Ruled the Earth
BELGIAN 22 x 14 in (55 x 36 cm)

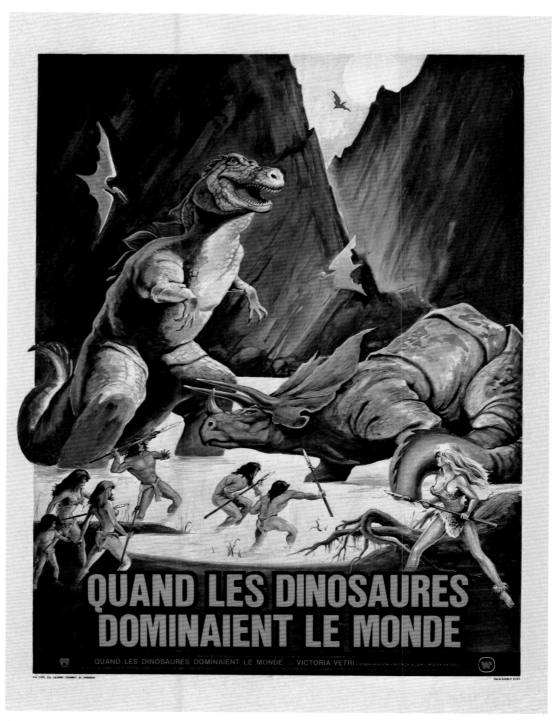

✝ When Dinosaurs Ruled the Earth
FRENCH 32 x 24 in (80 x 60 cm)

✤ When Dinosaurs Ruled the Earth
US 41 x 27 in (104 x 69 cm)

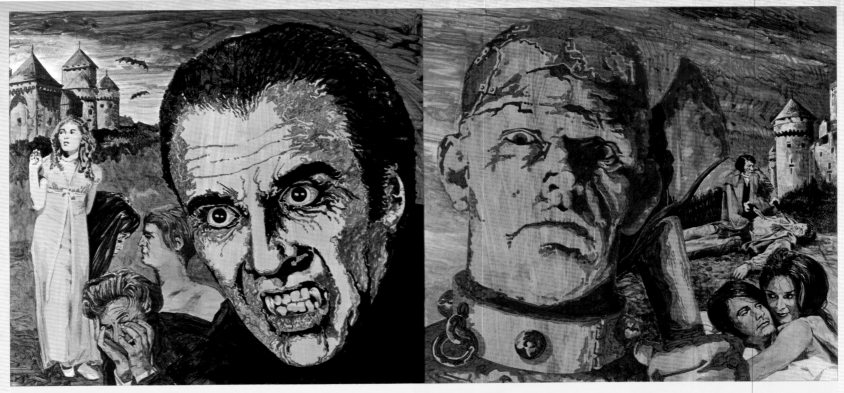

✝ **Scars of Dracula/The Horror of Frankenstein**
BRITISH 30 x 40 in (76 x 102 cm)
Illustration by Mike Vaughan

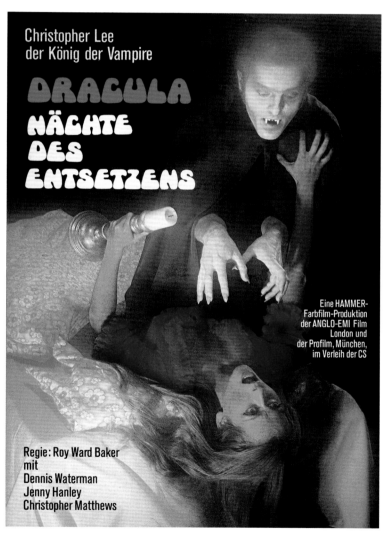

✝ **Scars of Dracula**
GERMAN 34 x 22 in (85 x 56 cm)

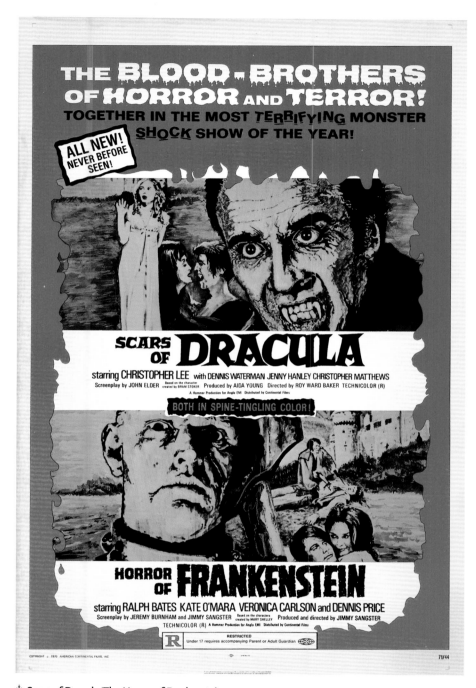

✝ **Scars of Dracula/The Horror of Frankenstein**
US 41 x 27 in (104 x 69 cm)

EXCELSIOR FILMS

LusT for a VAMPiRE

RALPH **BATES**
SUZANNA **LEIGH**
BARBARA **JEFFORD**
MICHAEL **JOHNSON**
EN ET YUTTE **STENSGAARD**

LA SOIF DU VAMPIRE | DORST NAAR BLOED

DRUK. LICHTERT - 1070 Brussel

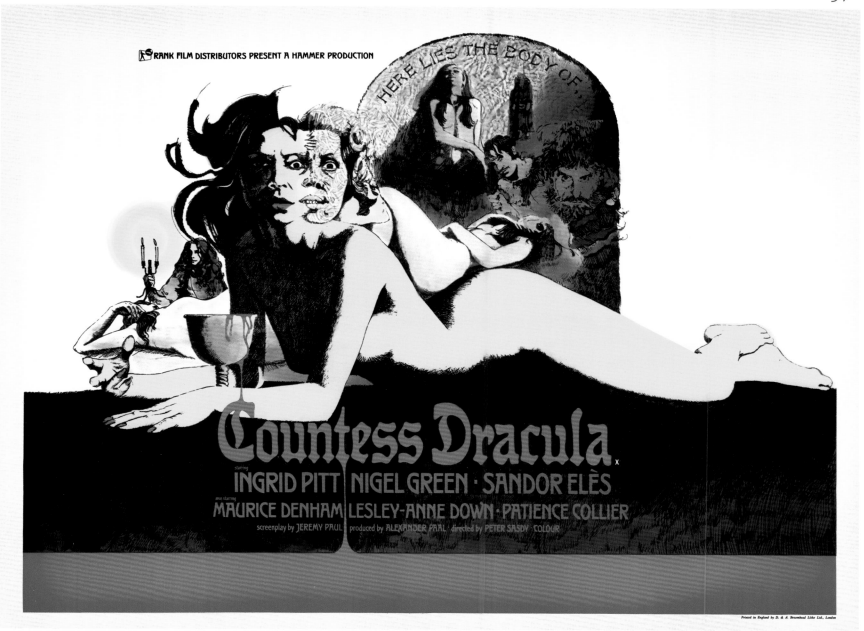

RANK FILM DISTRIBUTORS PRESENT A HAMMER PRODUCTION

HERE LIES THE BODY OF...

Countess Dracula

starring INGRID PITT · NIGEL GREEN · SANDOR ELÈS
also starring MAURICE DENHAM · LESLEY-ANNE DOWN · PATIENCE COLLIER
screenplay by JEREMY PAUL · produced by ALEXANDER PAAL · directed by PETER SASDY · COLOUR

✝ **Countess Dracula**
BRITISH 30 x 40 in (76 x 102 cm)
Illustration by Vic Fair

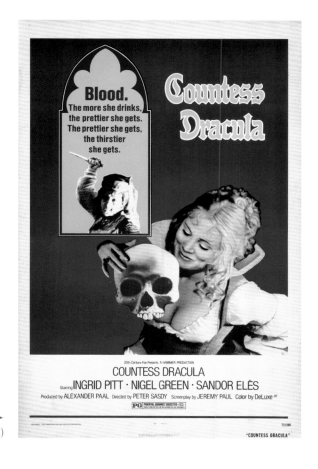

Blood.
The more she drinks,
the prettier she gets.
The prettier she gets,
the thirstier
she gets.

Countess Dracula

COUNTESS DRACULA
Starring INGRID PITT · NIGEL GREEN · SANDOR ELÈS
Produced by ALEXANDER PAAL Directed by PETER SASDY Screenplay by JEREMY PAUL Color by DeLuxe

✥ **Lust for a Vampire**
BELGIAN 21 x 14 in (54 x 36 cm)

Countess Dracula ✥
US 41 x 27 in (104 x 69 cm)

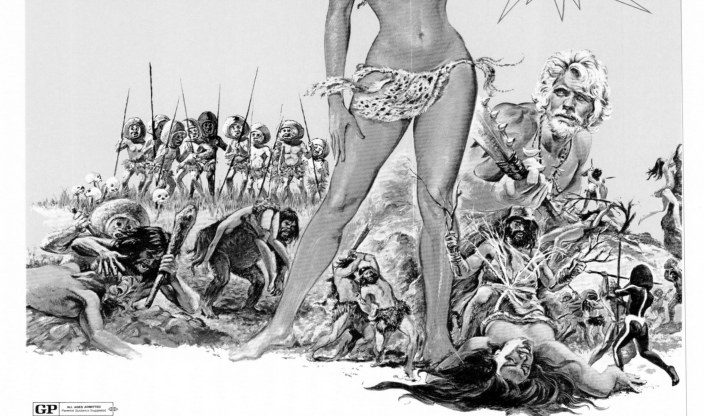

71/118

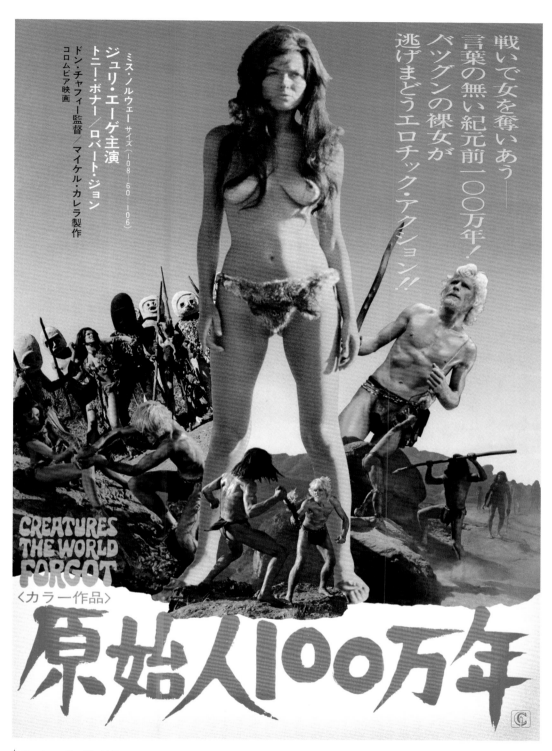

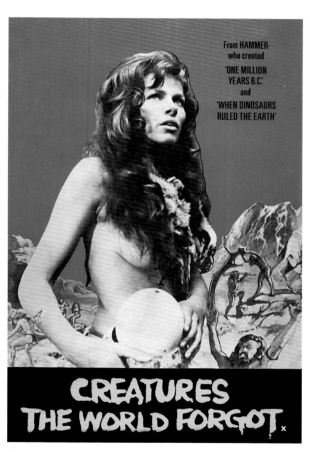

✝ **Creatures the World Forgot**
BRITISH 30 x 20 in (76 x 51 cm)

✝ **Creatures the World Forgot**
JAPANESE 30 x 20 in (76 x 51 cm)

✝ **Creatures the World Forgot**
US 41 x 27 in (104 x 69 cm)

FROM TELLY LAUGHS TO BELLY LAUGHS

ON THE BUSES

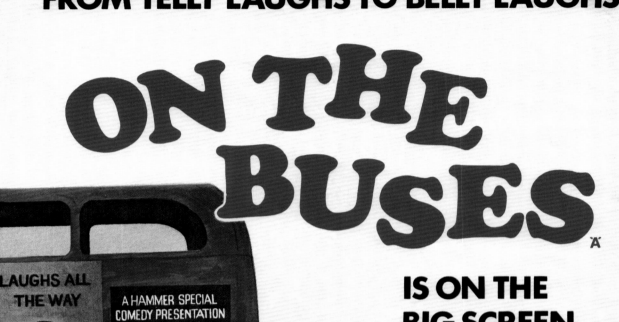

LAUGHS ALL THE WAY

A HAMMER SPECIAL COMEDY PRESENTATION

IS ON THE BIG SCREEN

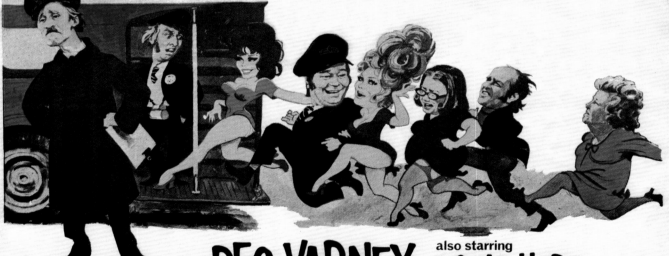

REG VARNEY · also starring DORIS HARE
STEPHEN LEWIS · MICHAEL ROBBINS
BOB GRANT · ANNA KAREN

PLUS *Old Tyme Variety* **TOP OF THE BILL** .U.

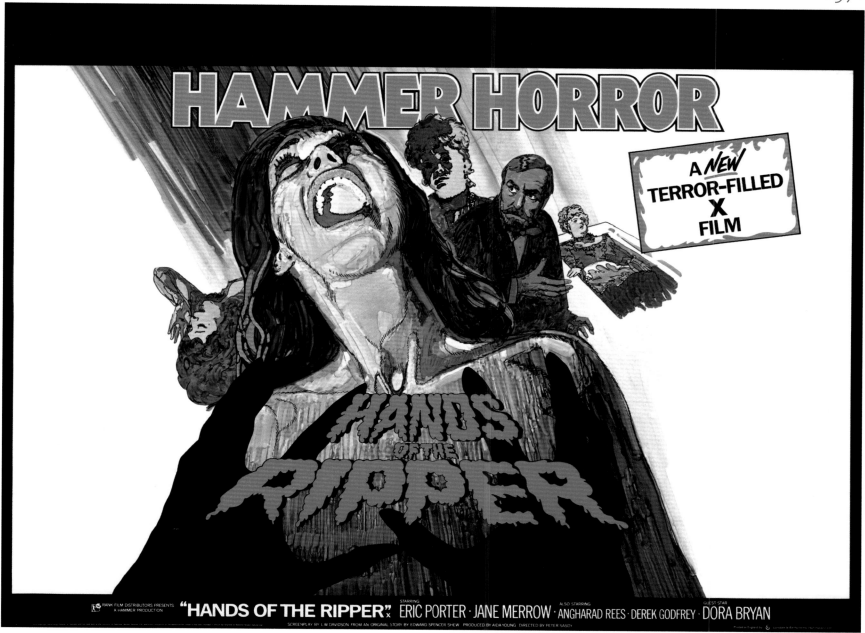

✝ **Hands of the Ripper**
BRITISH 30 x 40 in (76 x 102 cm)
Illustration by Mike Vaughan

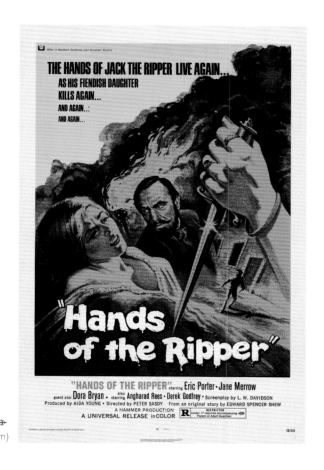

⚜ **On the Buses/Top of the Bill**
BRITISH 30 x 20 in (76 x 51 cm)
Illustration by Arnaldo Putzu

Hands of the Ripper ⚜
US 41 x 27 in (104 x 69 cm)

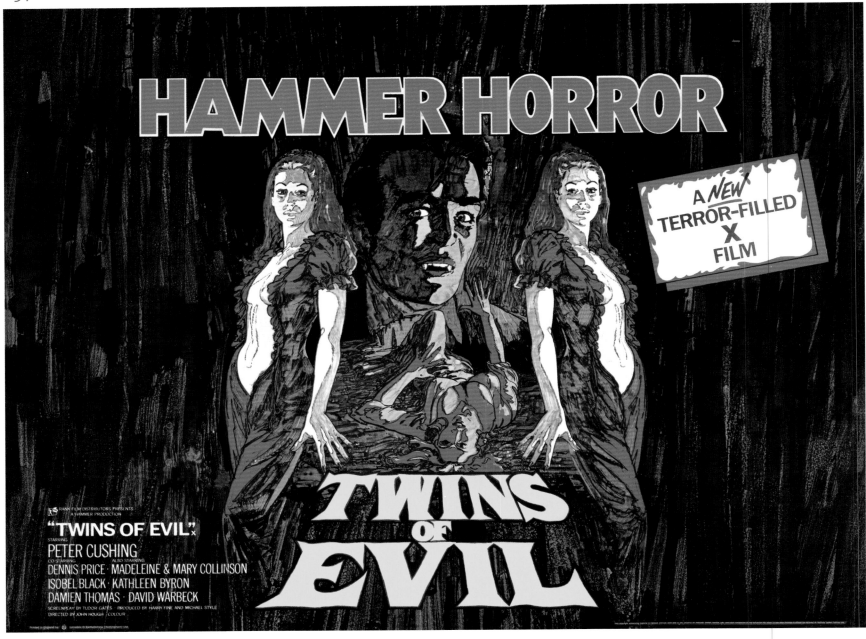

✝ **Twins of Evil**
BRITISH 30 x 40 in (76 x 102 cm)
Illustration by Mike Vaughan

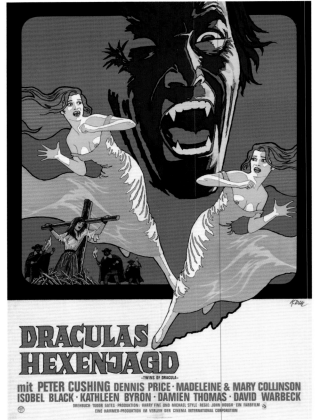

Twins of Evil ⟶
GERMAN 34 x 22 in (85 x 56 cm)
Illustration by Klaus Dill

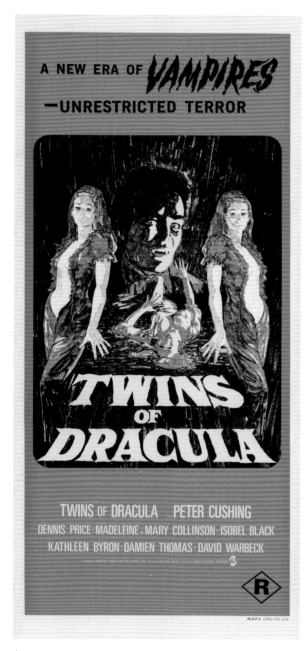

✝ **Twins of Evil** (aka **Twins of Dracula**)
AUSTRALIAN 30 x 13 in (76 x 33 cm)

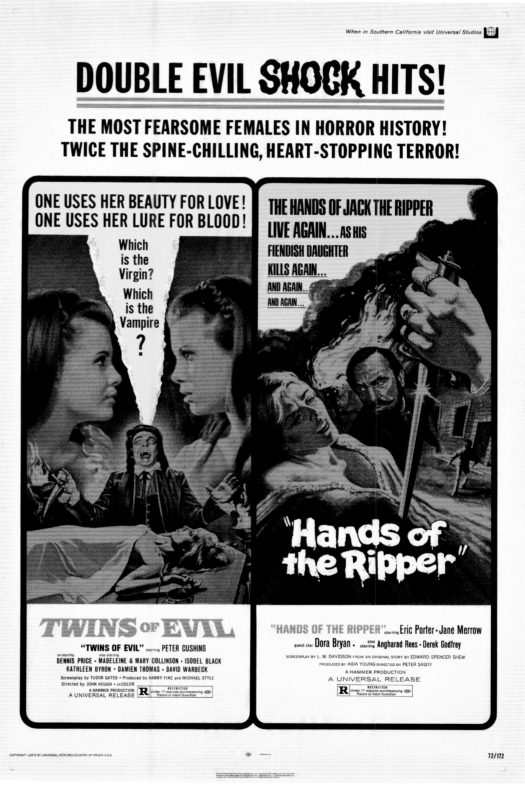

✝ **Twins of Evil/Hands of the Ripper**
US 41 x 27 in (104 x 69 cm)

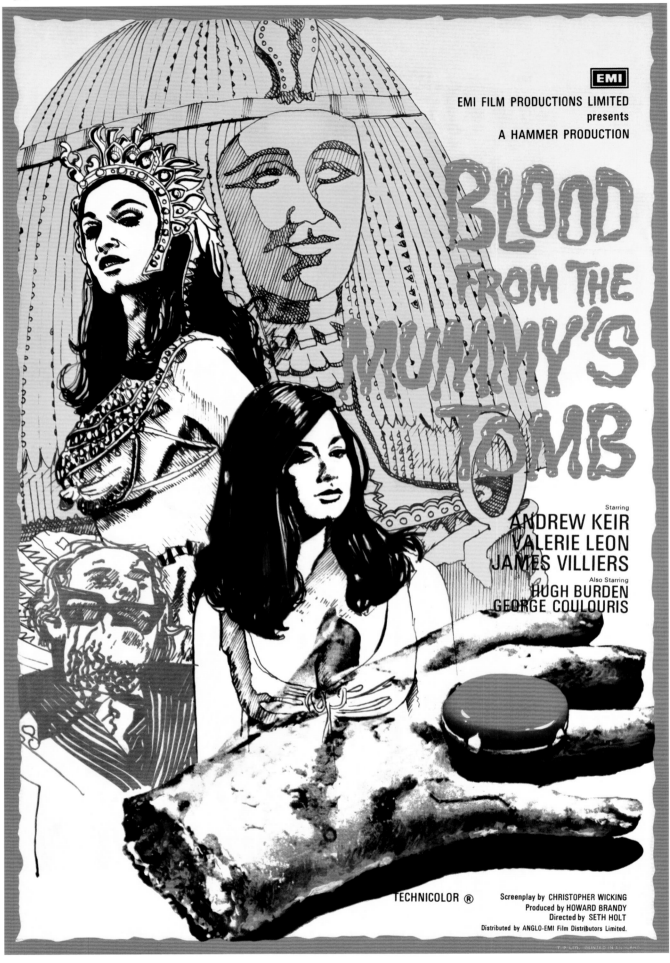

✝ **Blood From the Mummy's Tomb**
Bʀɪᴛɪsʜ 40 x 27 in (102 x 69 cm)
Illustration by Mike Vaughan

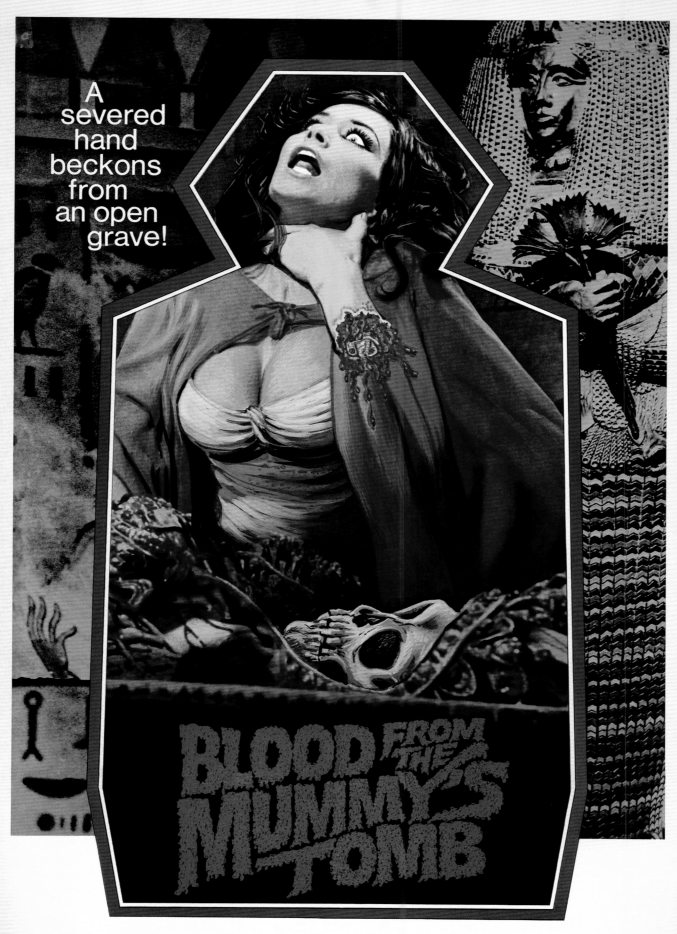

A
severed
hand
beckons
from
an open
grave!

BLOOD FROM THE MUMMY'S TOMB

STARRING
ANDREW KEIR · VALERIE LEON · JAMES VILLIERS · Also Starring HUGH BURDEN · GEORGE COULOURIS
SCREENPLAY BY
CHRISTOPHER WICKING · PRODUCED BY HOWARD BRANDY · DIRECTED BY SETH HOLT **COLOR** EMI Film Productions Limited presents A Hammer Production

COPYRIGHT ©1972 AMERICAN INTERNATIONAL PICTURES, INC.

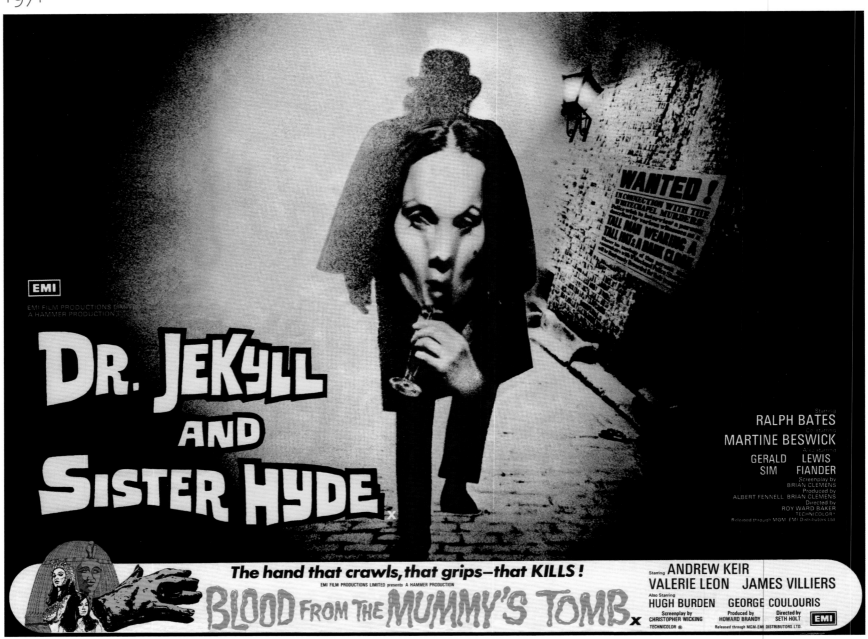

✞ **Dr Jekyll & Sister Hyde/Blood From the Mummy's Tomb**
BRITISH 30 x 40 in (76 x 102 cm)

Dr Jekyll & Sister Hyde ⤞
US 41 x 27 in (104 x 69 cm)

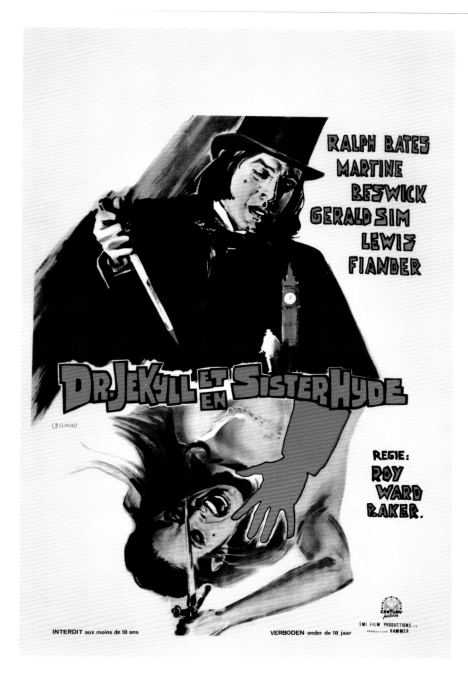

RALPH BATES
MARTINE
BESWICK
GERALD SIM
LEWIS
FIANDER

REGIE:
ROY
WARD
BAKER.

INTERDIT aux moins de 18 ans VERBODEN onder de 18 jaar

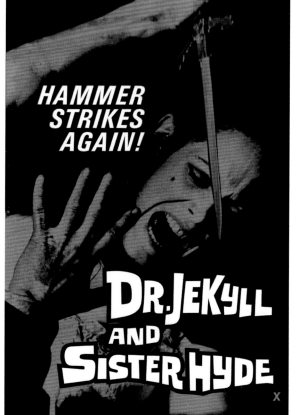

✝ Dr Jekyll & Sister Hyde
BELGIAN 21 x 14 in (54 x 36 cm)
Illustration by Constantin Belinski

✠ Dr Jekyll & Sister Hyde
BRITISH 30 x 20 in (76 x 51 cm)

✝ Dr Jekyll & Sister Hyde
ITALIAN 28 x 13 in (70 x 33 cm)
Illustration by Nicola Piovano

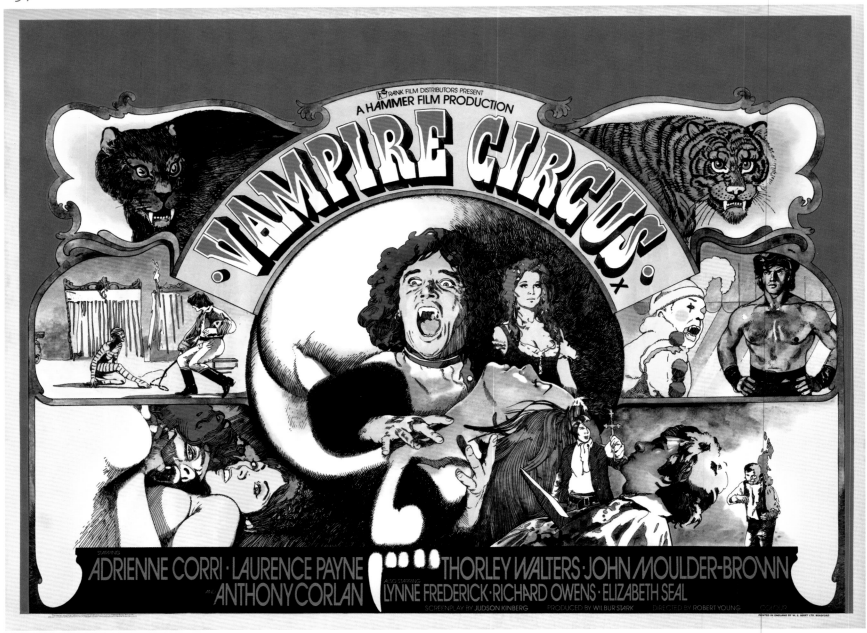

✝ **Vampire Circus**
BRITISH 30 x 40 in (76 x 102 cm)
Illustration by Vic Fair

A highlight among Hammer's later British posters, *Vampire Circus* is notorious for the phallic shapes hidden at the sides and the centre of the design.

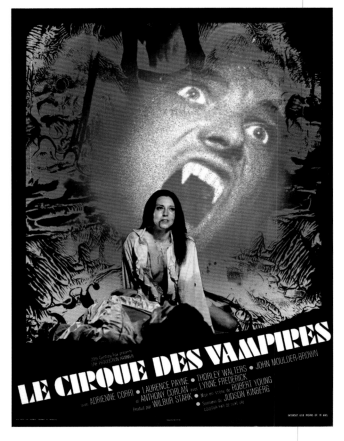

Vampire Circus ✈
FRENCH 32 x 24 in (80 x 60 cm)

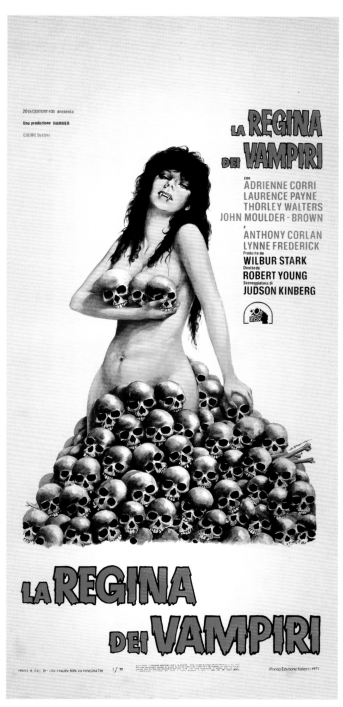

✝ **Vampire Circus**
ITALIAN 28 x 13 in (70 x 33 cm)
Illustration by D. Spagnoli

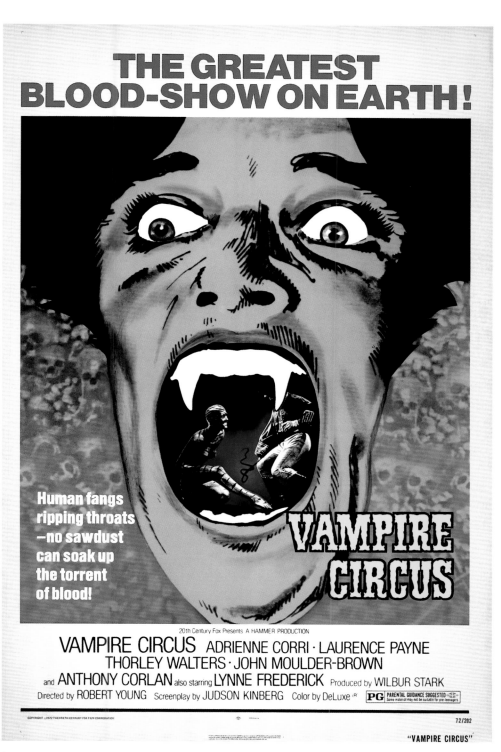

✝ **Vampire Circus**
US 41 x 27 in (104 x 69 cm)

STRAIGHT ON TILL MORNING

Anglo-EMI Film Distributors Ltd. present
A HAMMER PRODUCTION
starring

Rita Tushingham in

"STRAIGHT ON TILL MORNING"

also starring

Shane Briant

James Bolam · Annie Ross
and

Tom Bell

Screenplay by **JOHN PEACOCK** Produced by **MICHAEL CARRERAS** Directed by **PETER COLLINSON**

TECHNICOLOR*

Distributed by Anglo **EMI** Film Distributors Ltd.

T. P. LTD. PRINTED IN ENGLAND.

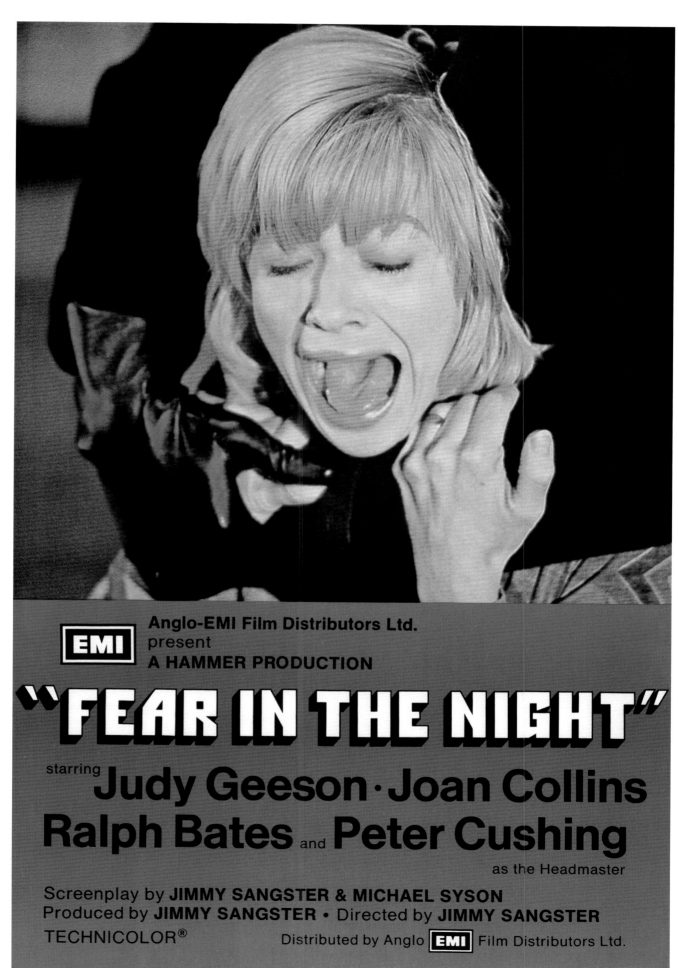

Anglo-EMI Film Distributors Ltd.
EMI present
A HAMMER PRODUCTION

"FEAR IN THE NIGHT"

starring **Judy Geeson · Joan Collins**
Ralph Bates and **Peter Cushing**
as the Headmaster

Screenplay by **JIMMY SANGSTER & MICHAEL SYSON**
Produced by **JIMMY SANGSTER** · Directed by **JIMMY SANGSTER**
TECHNICOLOR® Distributed by Anglo **EMI** Film Distributors Ltd.

Printed by R.J WALLMAN LTD. England

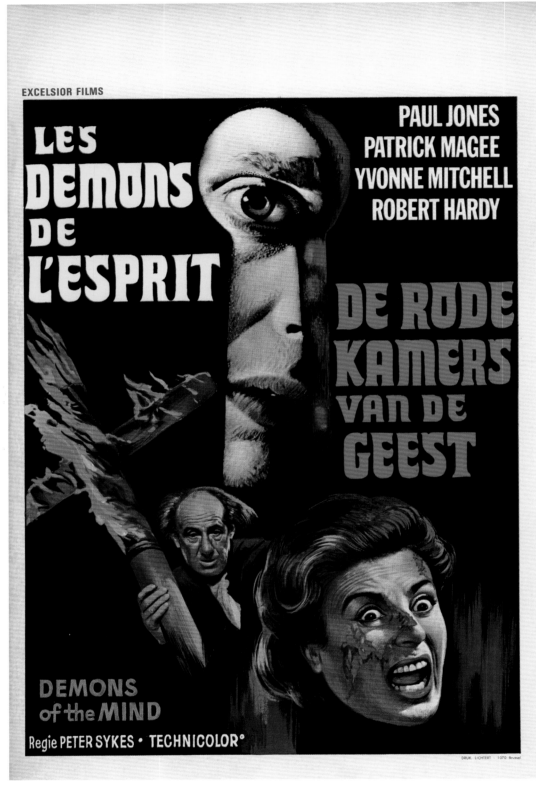

✞ **Demons of the Mind**
BELGIAN 21 x 14 in (54 x 36 cm)

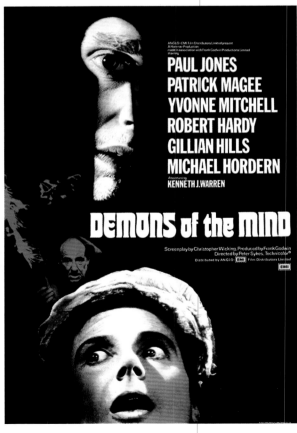

✞ **Demons of the Mind**
BRITISH 30 x 20 in (76 x 51 cm)

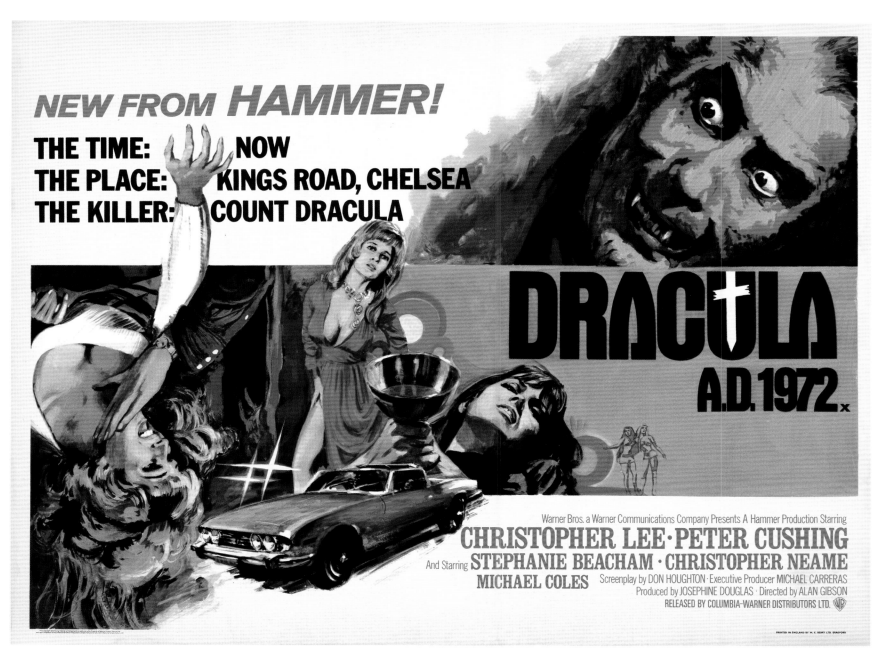

NEW FROM HAMMER!

THE TIME: NOW
THE PLACE: KINGS ROAD, CHELSEA
THE KILLER: COUNT DRACULA

DRACULA A.D. 1972 x

Warner Bros. a Warner Communications Company Presents A Hammer Production Starring
CHRISTOPHER LEE · PETER CUSHING
And Starring **STEPHANIE BEACHAM · CHRISTOPHER NEAME**
MICHAEL COLES Screenplay by DON HOUGHTON · Executive Producer MICHAEL CARRERAS
Produced by JOSEPHINE DOUGLAS · Directed by ALAN GIBSON
RELEASED BY COLUMBIA-WARNER DISTRIBUTORS LTD.

✝ **Dracula A.D. 1972**
BRITISH 30 x 40 in (76 x 102 cm)
Illustration by Tom Chantrell

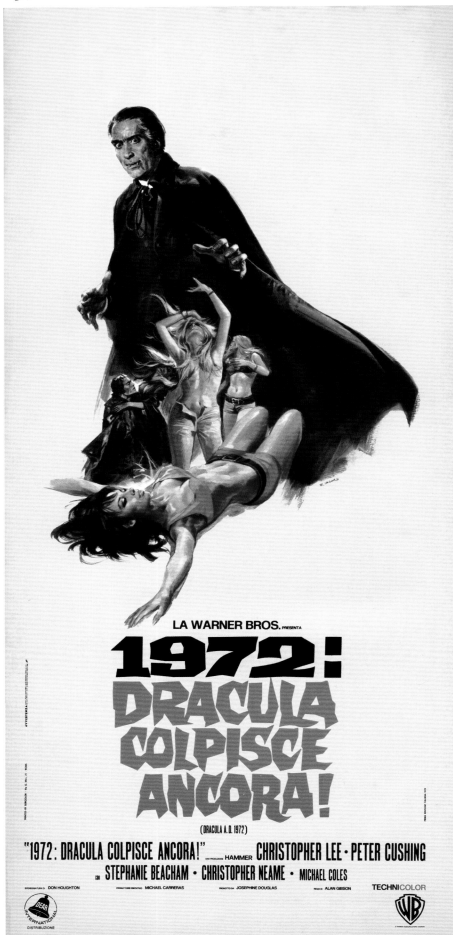

✠ Dracula A.D. 1972
ITALIAN 28 x 13 in (70 x 33 cm)
Illustration by Renato Casaro

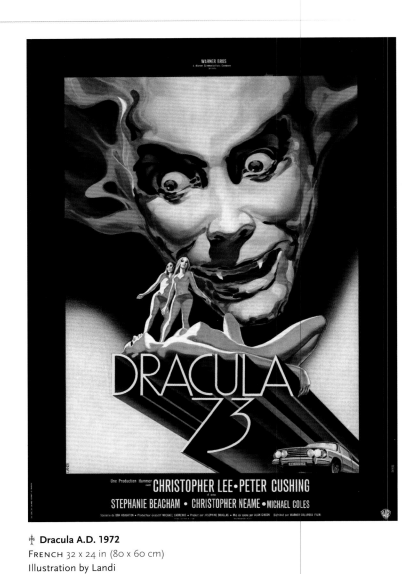

✠ Dracula A.D. 1972
FRENCH 32 x 24 in (80 x 60 cm)
Illustration by Landi

Dracula A.D. 1972/Crescendo ✈
US 41 x 27 in (104 x 69 cm)

† Man at the Top
BRITISH 40 x 27 in (102 x 69 cm)
Illustration by Arnaldo Putzu

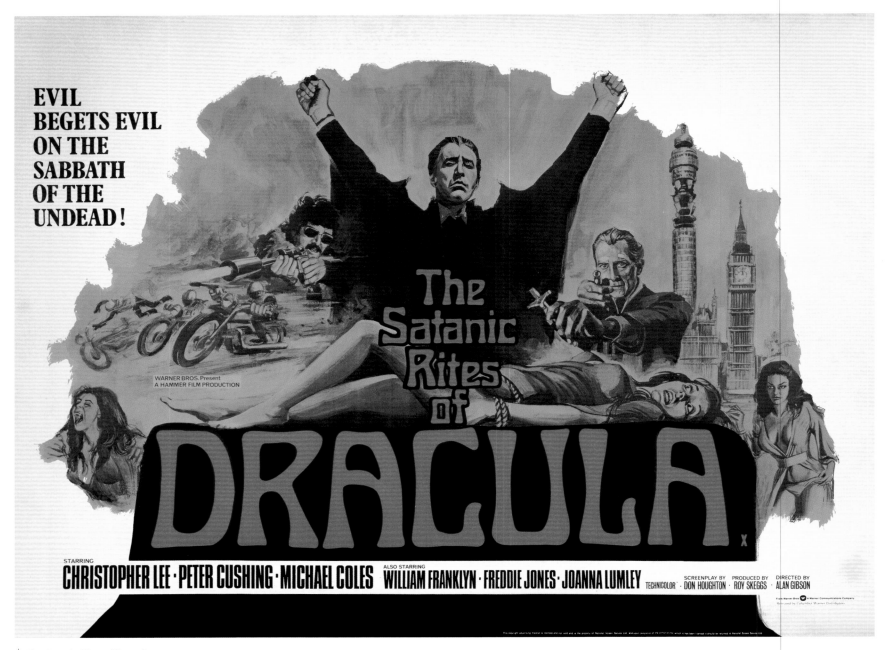

EVIL
BEGETS EVIL
ON THE
SABBATH
OF THE
UNDEAD!

☦ **The Satanic Rites of Dracula**
BRITISH 30 x 40 in (76 x 102 cm)
Illustration by Tom Chantrell

A DayGlo version of this Quad Crown, which
was also produced in a dark green colour wash.
Chantrell's original illustration depicted Dracula
holding aloft a knife and a dead cockerel.
Hammer asked Chantrell to censor the painting,
and he considered that the result made it look
as if the Count had just scored a goal.

The Satanic Rites of Dracula ☦
(aka **Count Dracula and his Vampire Bride**)
US 41 x 27 in (104 x 69 cm)
Illustration by Neal Adams

Although he worked on posters for several other
films during this period (including Michael
Crichton's *Westworld*), Neal Adams is best known as
a comic book artist. His cover for Marvel's *Dracula
Lives!* Issue 3 (October 1973) featured a similar
composition to the illustration for this one-sheet.

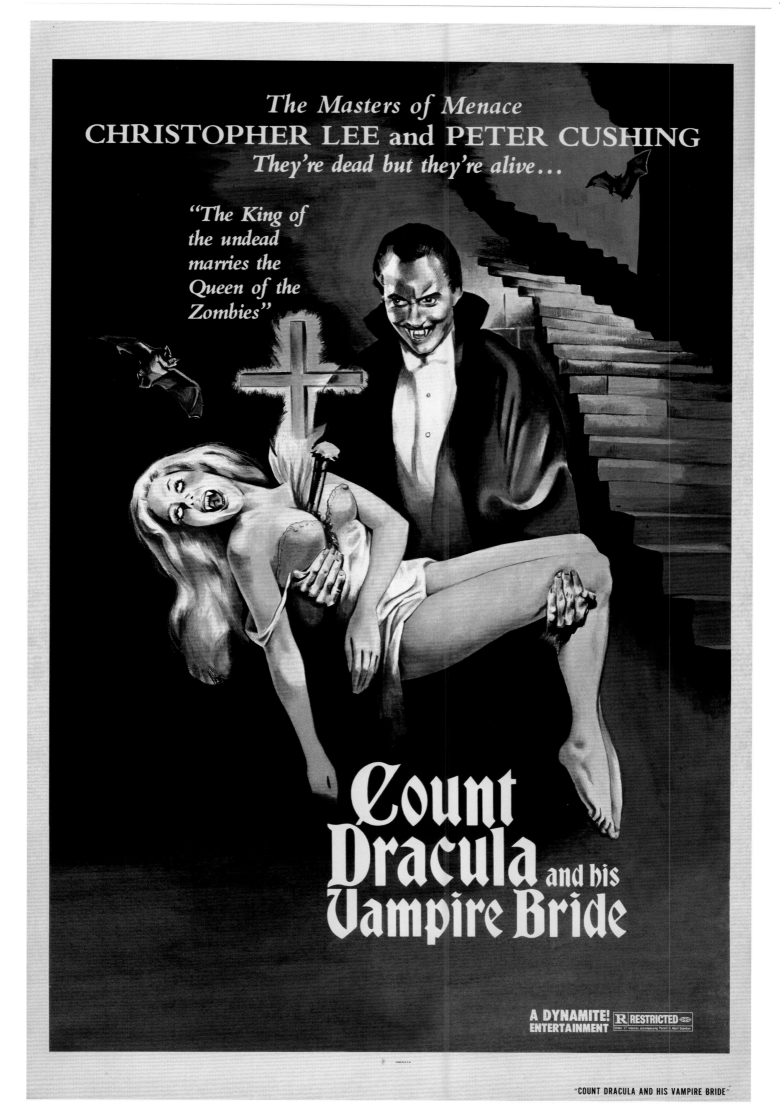

† **The Satanic Rites of Dracula**
BELGIAN 22 x 15 in (55 x 37 cm)

✠ **The Satanic Rites of Dracula**
FRENCH 32 x 24 in (80 x 60 cm)
Illustration by Landi

✠ **The Satanic Rites of Dracula**
JAPANESE 30 x 20 in (76 x 51 cm)

✠ **Captain Kronos Vampire Hunter**
US 41 x 27 in (104 x 69 cm)

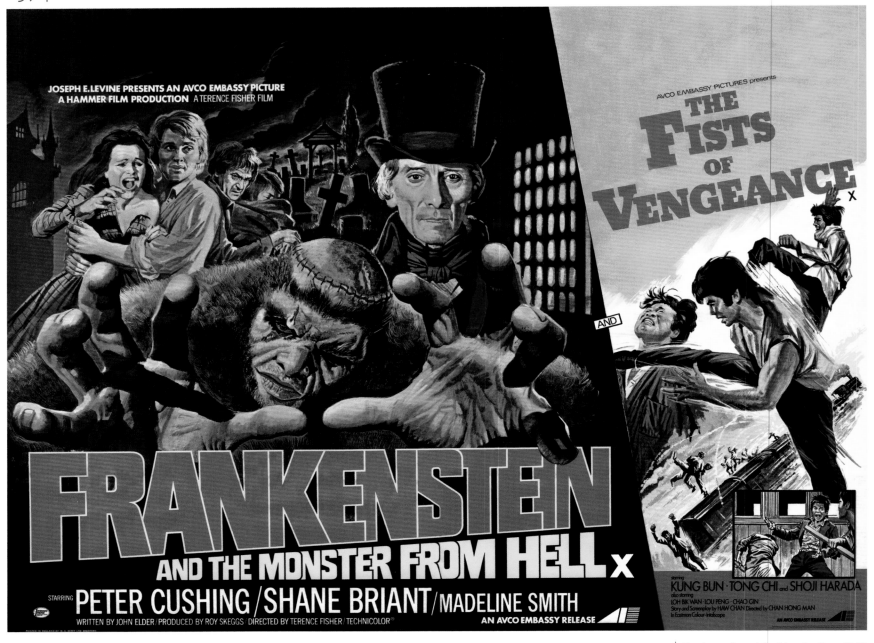

✝ Frankenstein and the Monster From Hell/
The Fists of Vengeance
BRITISH 30 x 40 in (76 x 102 cm)
Illustration by Bill Wiggins

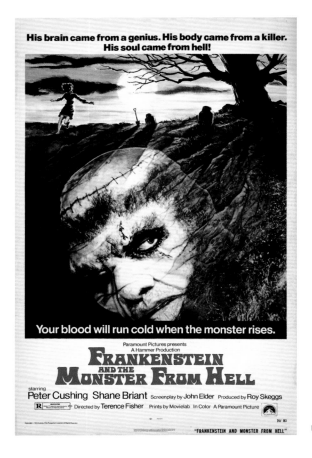

⚔ Frankenstein and the Monster From Hell
US 41 x 27 in (104 x 69 cm)

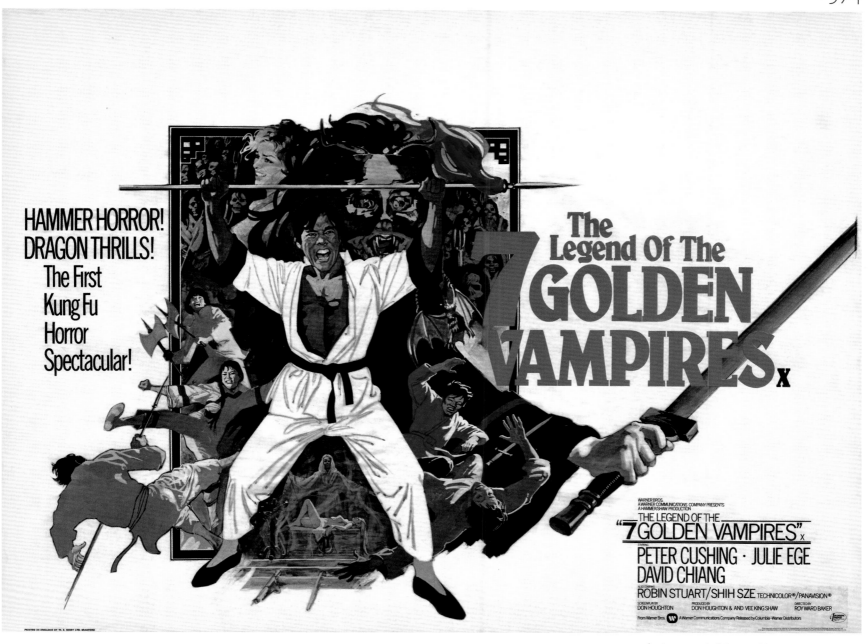

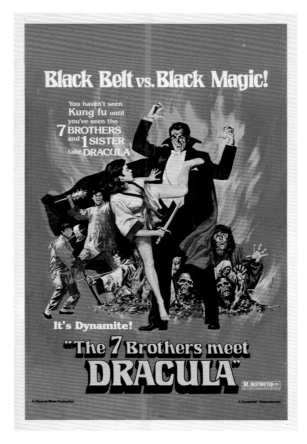

✝ **The Legend of the 7 Golden Vampires**
BRITISH 30 x 40 in (76 x 102 cm)
Illustration by Arnaldo Putzu

Hammer's Michael Carreras originally
commissioned Tom Chantrell for *The Legend of
the 7 Golden Vampires*, but the finished article
was illustrated by Arnaldo Putzu from a design
by either Vic Fair or Eric Pulford.
 Most copies of this poster have a
replacement credit block stuck on the bottom
right hand corner, correcting a misspelling of
actor Robin Stewart's surname. The sticker has
been removed on this example.

↞ ↞ ↞ **The Legend of the 7 Golden Vampires**
JAPANESE 30 x 20 in (76 x 51 cm)

↞ **The Legend of the 7 Golden Vampires**
(aka **The 7 Brothers Meet Dracula**)
US 41 x 27 in (104 x 69 cm)

✠ **Man About the House**
BRITISH 30 x 40 in (76 x 102 cm)

Shatter (aka **Call Him Mr Shatter**) ✈
US 41 x 27 in (104 x 69 cm)

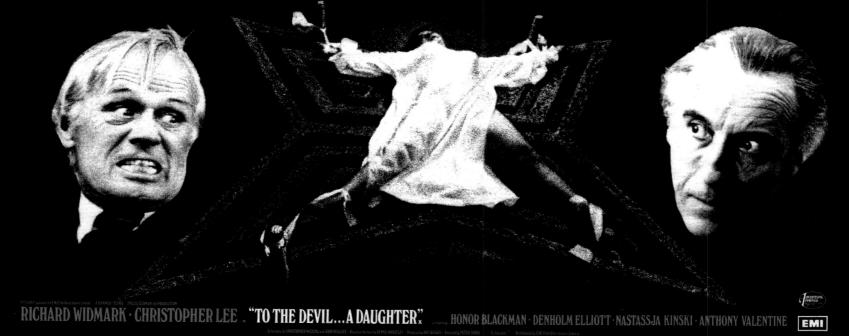

The evil power of black magic has fascinated millions of cinema-goers. First... "Rosemary's Baby." Then... "The Exorcist." And now a motion picture that probes further into the mysteries of the occult than any has dared before!

Dennis Wheatley's
"TO THE DEVIL...A DAUGHTER"x

RICHARD WIDMARK · CHRISTOPHER LEE "TO THE DEVIL...A DAUGHTER" HONOR BLACKMAN · DENHOLM ELLIOTT · NASTASSJA KINSKI · Anthony Valentine **EMI**

✝ **To the Devil a Daughter**
BRITISH 30 x 40 in (76 x 102 cm)

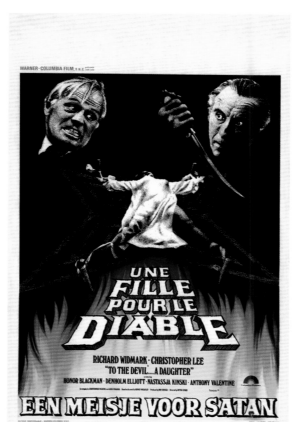

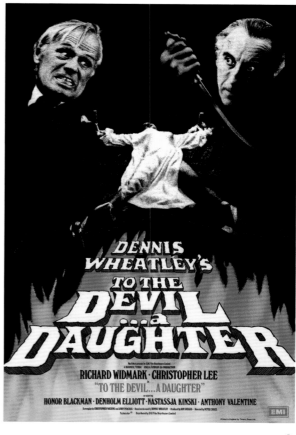

To the Devil a Daughter ✈
BELGIAN 21 x 14 in (54 x 36 cm)

To the Devil a Daughter ✈ ✈
BRITISH 40 x 27 in (102 x 69 cm)

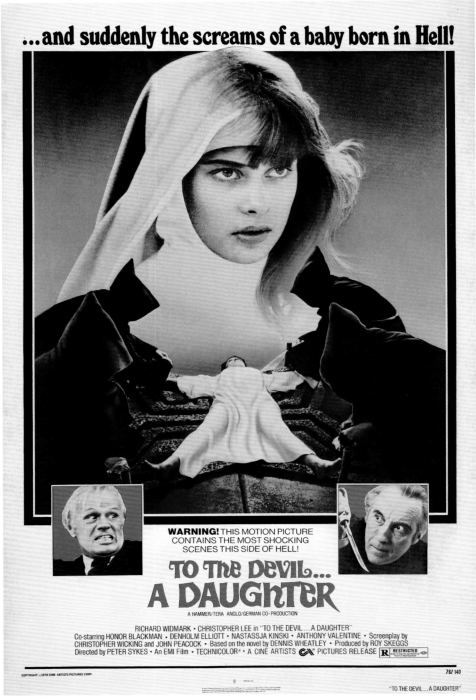

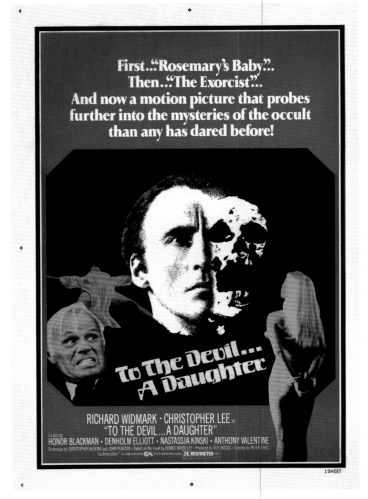

✝ **To the Devil a Daughter**
US 41 x 27 in (104 x 69 cm)

✝ **To the Devil a Daughter**
US 41 x 27 in (104 x 69 cm)

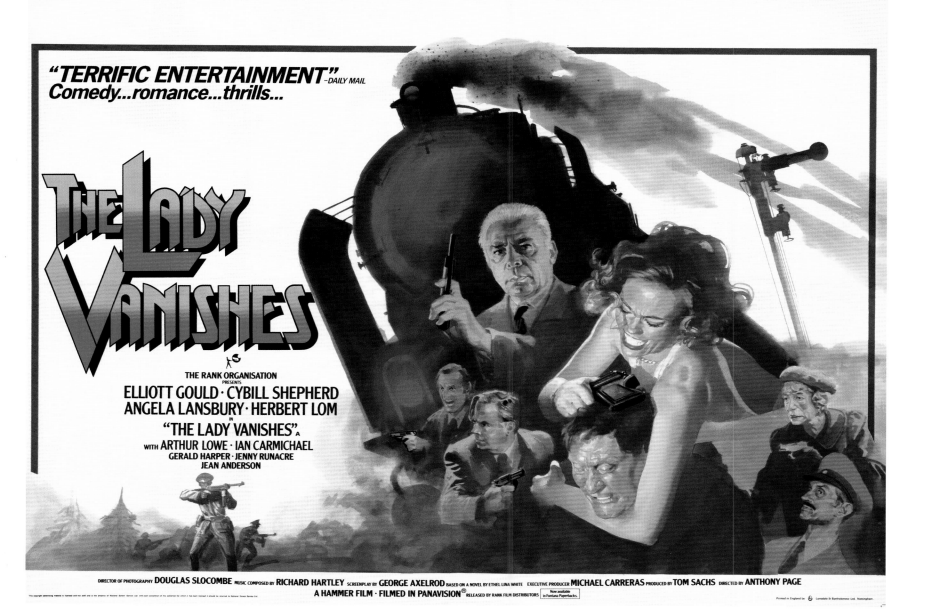

✝ **The Lady Vanishes**
BRITISH 30 x 40 in (76 x 102 cm)
Illustration by Arnaldo Putzu

This was the second Quad Crown prepared for this troubled 1979 release. The first version, illustrated by Eric Pulford, is much more common.

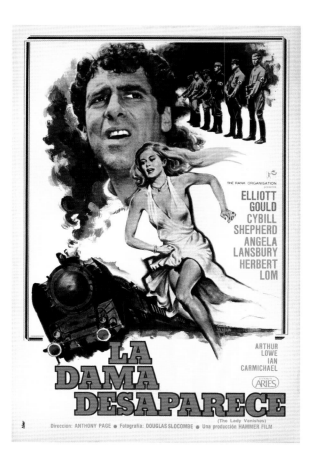

The Lady Vanishes ✝
ARGENTINIAN 43 x 29 in (109 x 74 cm)

This one-sheet poster took its inspiration from Eric Pulford's design, but added a portrait of leading man Elliott Gould alongside Cybill Shepherd.

The Lady Vanishes was the final Hammer film to be accompanied by such posters until the 2010 release of *Let Me In.*

2010-2015

✝ **Let Me In**
BRITISH 30 x 40 IN (76 x 102 CM)

Hammer's new logo was a welcome addition to the posters for *Let Me In*, the first theatrical release from the company since *The Lady Vanishes* in 1979. In common with most modern film marketing, illustrations for Hammer's recent posters have generally been prepared using Photoshop and other computer techniques.

Let Me In ✳
US 40 x 27 IN (102 x 69 CM)

Let Me In ✳ ✳
US 40 x 27 IN (102 x 69 CM)

This one-sheet was specially prepared to promote the film's US première at Fantastic Fest in Austin, Texas.

✝ **Wake Wood**
BRITISH 30 x 40 in (76 x 102 cm)

The Resident ⤳
BRITISH 30 x 40 in (76 x 102 cm)

⚜ **The Woman in Black**
BRITISH 30 x 40 in (76 x 102 cm)

⚜ **The Woman in Black**
BRITISH 30 x 40 in (76 x 102 cm)

Illustration by Graham Humphreys

The Woman in Black was Hammer's first period Gothic horror since the early 1970s. Hammer suggested to distributor Momentum that one of the British Quad Crowns should feature a painted illustration and recommended Graham Humphreys, considered by many to be the last of the British cinema poster artists still working in the traditional style. This design received a limited print run and was primarily reserved for marketing purposes.

† **The Woman in Black**
US 40 x 27 in (102 x 69 cm)

† **The Woman in Black**
US 40 x 27 in (102 x 69 cm)

The Woman in Black ✈
BRITISH 30 x 40 in (76 x 102 cm)

✝ The Quiet Ones
US 41 x 27 in (104 x 69 cm)

✝ The Quiet Ones
US 40 x 27 in (102 x 69 cm)

✝ The Quiet Ones
British 30 x 40 in (76 x 102 cm)

SHE NEVER
FORGIVES.

SHE NEVER
FORGETS.

SHE NEVER
LEFT.

THE
WOMAN
IN BLACK
ANGEL OF DEATH

#SHENEVERLEFT
2015

✞ **The Woman in Black: Angel of Death**
BRITISH 30 x 40 in (76 x 102 cm)

The Woman in Black: Angel of Death ✈
US 40 x 27 in (102 x 69 cm)

The Woman in Black: Angel of Death ✈ ✈
US 40 x 27 in (102 x 69 cm)

TITLE INDEX